BUDDHISM
A JOURNEY THROUGH ART

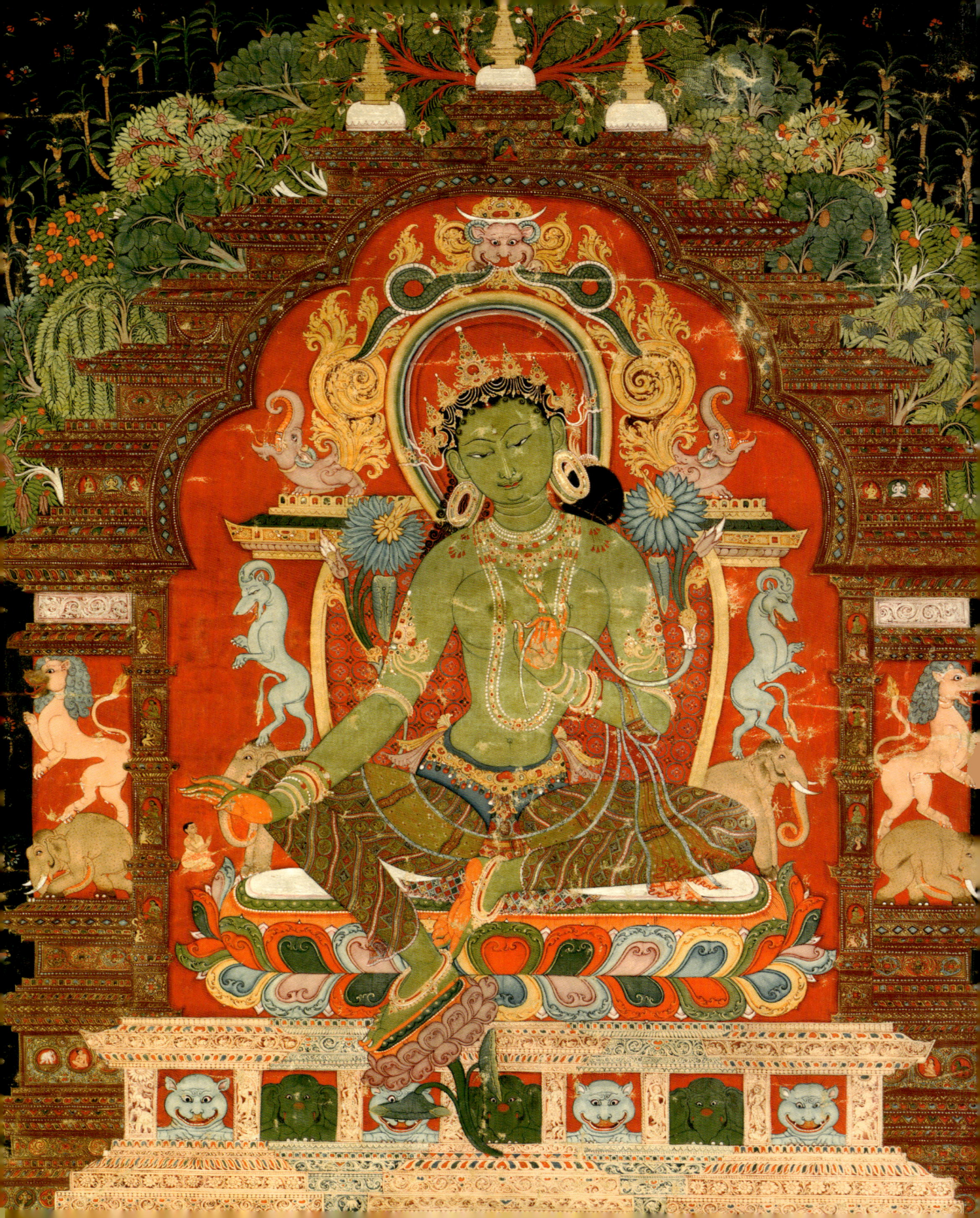

BUDDHISM
A JOURNEY THROUGH ART

TEXT
R.M. WOODWARD

Interlink Books
An imprint of Interlink Publishing Group, Inc.
www.interlinkbooks.com

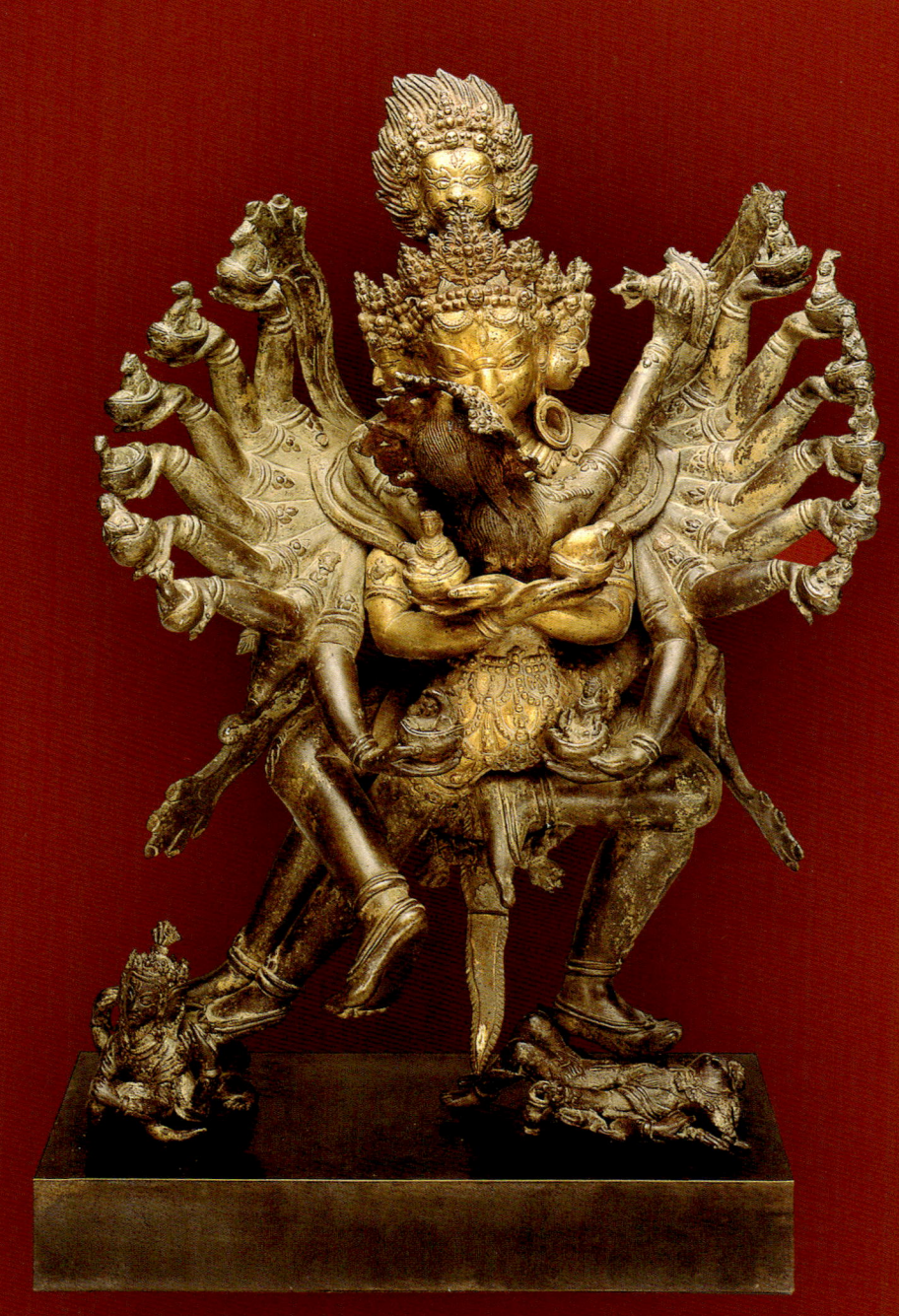

CONTENTS

INTRODUCTION
6

TANTRIC AND ESOTERIC BUDDHIST ART
14

GANDHARAN SCULPTURE
104

DEPICTIONS OF BUDDHA
138

BODHISATTVAS
204

MONKS, LAMAS, AND ARHATS
252

TEMPLES AND ARTEFACTS
310

GLOSSARY
342

PHOTO CREDITS
351

INTRODUCTION

Buddhism originated in India over 2,500 years ago and has had a profound influence on art across Asia. The artistic expressions of Buddhism have evolved over the centuries, reflecting the diverse cultural, historical, and geographical contexts in which the religion has taken root. During the Buddha's lifetime, disciples transmitted his teachings orally – this spread of knowledge led to independent monastic groups known as 'sanghas'. The Buddhist philosophy continued its expansion long after the historical Buddha's death, reaching new heights when early trade-route developments led to the inter-cultural exchange of Buddhism between India, Southeast Asia, Central Asia, and China. As Buddhism grew, different traditions and locations influenced one another whilst adding their own distinct mark to the region's artistic culture. A melting pot of blended imagery grew across the generations, and as a result, we have a plethora of diverse mysticism, sculpture, and iconography stemming from the numerous Buddhist groups worldwide. Art has always had a myriad of essential functions within the Buddhist faith depending on the sect, period, and culture – these functions can be narrowed down to learning doctrine, chronicling history, and practical use within the temple and privately. Stupas, sculpture, paintings, thangkas, mandalas and other artistic manifestations play a critical role in the participation of meditation, rituals, and ceremony.

The Buddha

A 'Buddha' is one who has attained enlightenment and numerous Buddhist traditions believe in many buddhas, past and future. The historical Buddha and founder of the Buddhist movement was Siddhartha Gautama who was born in about 560 BCE as a prince in Kapilvastu, Nepal, to a royal family. According to traditional accounts, it was predicted at birth that Gautama would become either a buddha or a powerful monarch. His father, King Suddhodana, with the hope of steering Gautama away from the path of Buddhahood, shielded his son from all worldly sufferings by confining him within the luxury of the palace. Gautama went on to lead a life of comfort and was ignorant of worldly afflictions such as old age, disease, and poverty. Upon leaving the confines of the palace at age twenty-nine, he witnessed the elderly, sick, poor, and the dead – he was moved by the profound

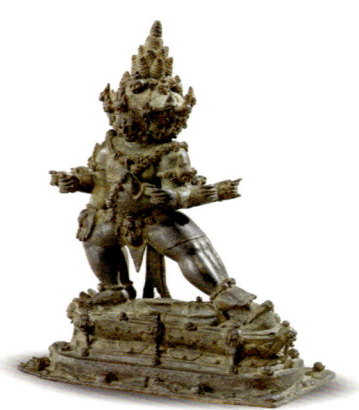

realization that to be a human was to suffer and that life is a series of conditions that perpetuate this suffering. This was the beginning of what is known as the great departure when Gautama renounced palace life and went on to live as an ascetic. It took him six years of various trials with several teachers before conquering the inner carnal desires that opposed true wisdom. Buddhahood was eventually achieved under the Bodhi tree when Gautama confronted and defeated the demon Mara, who was the embodiment of all things antagonistic to enlightenment. The rest of his life was then devoted to sharing with others the practices that had brought him to this enlightened state. Buddha spread the philosophy of living in balance, also referred to as 'The Middle Way/Path', which is achieved by shunning excessive pleasures or austerity in favour of moderating both. After the death of Buddha, believed to be in about 483 BCE, these teachings would become the fundamental principles of what would later be referred to as 'Buddhism'.

Schools of Buddhism

As the Buddhist community grew, sanghas became separated geographically and the differing interpretations of early Buddhist texts/oral transmissions began natural divisions within the faith. Over time, a once unified Buddhism separated into different schools, each varying in practice. The three main sects were Theravada, Mahayana, and Vajrayana. The core foundations of the three schools remain the same in that all follow the four noble truths, the eightfold path, and believe in the cycle of karma and rebirth.

THERAVADA

Theravada, literally meaning 'Way of the Elders', is widely credited with being the earliest form of Buddhism and believed to be the closest of the sects to Siddhartha Gautama's original teachings. Theravadins believe enlightenment can only be attained by closely following the historical Buddha's path and as such, place importance on the earliest Buddhist texts, known as the Pali canon. Salvation is limited to only those who follow a monastic approach to Buddhism and obtained by the practitioner's own merit. In this way, nirvana can be achieved through an individual journey of practice, reflection, and self-realization. These ancient practices are the foundation for many modern-day mindfulness

INTRODUCTION 9

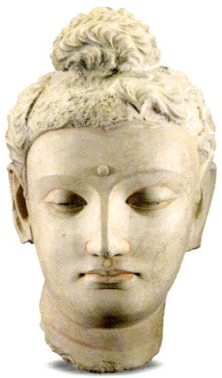

and meditation techniques. When a Theravadin gains insight into the true nature of reality they become what is known as an 'Arhat' and is thus liberated from the cycle of samsara (life, death, and rebirth). Theravada is seen as conservative in comparison to other sects as it is more analytical, less ritualized, and the teachings focus solely on the historical Buddha. Theravada Buddhism recognizes past incarnations of the historical Buddha but not the contemporary buddhas or much of the large pantheon of bodhisattvas and deities acknowledged within the other schools of thought. The leading school of Buddhism, Theravada is mostly practiced in Sri Lanka, Burma, Thailand, Laos, and Cambodia where the majority of the population is Buddhist.

MAHAYANA

Mahayana or 'great vehicle' has a wider interpretation of what constitutes teachings from the Buddha and incorporates doctrine and text that are not recognized by the Theravada tradition whose core is the Pali canon. The Mahayana branch of Buddhism focuses less on individual salvation and more on the liberation of all sentient beings, and in this way, Mahayana can be seen as a more inclusive school of Buddhism. Mahayana practitioners, with the objective of enlightening many, strive to become a bodhisattva. Bodhisattvas are enlightened individuals who are close to Buddhahood but choose to delay entering nirvana in order to help others also reach enlightenment, and for this reason, bodhisattvas play an integral role in the Mahayana tradition. In order to become a bodhisattva, the Mahayana practitioner must cultivate compassion which is a feeling, when meditated on and mastered, that is believed to lead one on the path to seeing the ultimate truth of reality. Mahayana believes that this enlightened quality, which is free from illusion, resides in all sentient beings and is called 'Buddha Nature'. The main idea of this philosophy is to access an innate ineffable wisdom that is free from cultural and personal variations. Mahayana believes in a more complex pantheon of buddhas and bodhisattvas than the Theravada tradition. There are many buddhas, not just Siddhartha Gautama and these buddhas exist in different realities. Mahayana is practiced in China, Korea, Vietnam, and Japan. The country with the largest Buddhist population is China although Buddhists still make a relatively small percentage within the overall population.

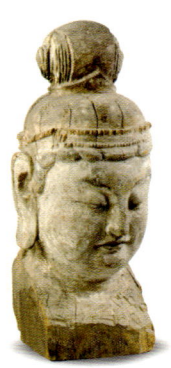

VAJRAYANA

Vajrayana, meaning 'diamond vehicle', is the most esoteric branch of Buddhism and was originally derived from the Mahayana tradition. Vajrayana has roots in ancient Indian tantra but largely took root in the Himalayas, namely Tibet. Vajrayana aims to assist the practitioner in reaching enlightenment within one lifetime. This 'fast track' to enlightenment can be seen as an intense path, and for this reason, only an established teacher or guru is able to pass on the knowledge of Vajrayana to a new practitioner. It employs ritual initiations, visualization techniques, exercises, and mantras as tools to assist the practitioner in breaking the bondage of the self in order to transcend to their original buddha nature. The mystical essence of tantra is believed by some to be far removed from the origins of Buddhism and this leads to much misinterpretation and dispute between Buddhist scholars. Tantric Buddhism evolved from ancient Indian tantra texts, Shaivism, and Yogins. Modern-day yoga in the West was loosely inspired by these early tantric disciplines albeit in a different and disconnected way. This school of Buddhism is often referred to as Tibetan Buddhism due to its dominant legacy in Tibet. Vajrayana is also practiced in Nepal, Mongolia, Bhutan, India, China, and Japan.

The History of Buddhist Art

The first images of the Buddha appeared hundreds of years after his death. This early phase of Buddhist art did not depict the historical Buddha as a physical being but rather hinted at his presence through symbols and objects – such as a set of footprints, stupas, a vacant throne, or an empty seat beneath a parasol. Theories differ on why the Buddha was reflected aniconically. Historically, divine imagery for many religions has or is still aniconic, and it is believed that the early Buddhist schools most likely prohibited the image of a physical Buddha. The earliest depictions of the iconic Buddha, as we know today, took root in narrative tales of his life portrayed through stone friezes around the first century BCE. It is believed much of early Buddhist art would have been created in perishable material such as wood, resulting in an incomplete picture of this early history. Gandhara, Amaravati, and Mathura are regarded as the regions where the first iconic image of the Buddha was created.

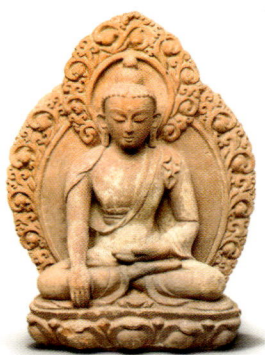

Gandhara was a crossroad of cultures, and sculpture from this region exhibited affinities with classical Roman and Greek statues. Although the iconography of Buddha remained sternly Indian, details such as the heavy drapery of his robe mirrored the Roman toga and it was this type of stylistic consideration that propagated the theory that the first Buddha image was inspired by Hellenistic art. Both Mathura and Gandhara influenced each other and it is debatable whether the anthropomorphic images of the Buddha were a natural progression of art in Mathura or the mixing of Greek and Buddhist ideas in Gandhara. Southern India approached the Buddha image in a more graphic and imposing way, with a robe that spanned over one shoulder, and this popular style spread across the Southeast region of Asia.

Undisputedly, one of the more intriguing subcategories of Buddhist art is the tantric movement. Tantric Buddhism had humble origins in medieval Eastern India as a small cult following before the movement grew and infiltrated Central Asia, experiencing huge expansion. By the eighth century, the Tantric school had become the leading sect in Tibet, and the artwork that developed in this region also inspired the artisans of India, Nepal, and China. Tantra is a Western term that was coined in the 1790s when tantric works were discovered by missionaries in India, an umbrella description for a very vast subject of different religious traditions. Tantric Buddhism, also known as Vajrayana uses art for teaching, healing, and meditation. In tantrism, art is seen as a powerful instrument for aiding spiritual development through rituals. Paintings of deities are used as a tool to evoke the subject or in some cases make contact directly. Tantric Buddhist art grew from a number of inspirations including Brahmanic rituals – mandala art, for example, is a significant aid to Buddhist practice and forms an intrinsic role within the tantric (Vajrayana) tradition. In Tibetan Buddhism, external objects and artistic symbolism are used to embody important attributes necessary for assisting ritual. Method and wisdom are personified by the physical representations of the vajra and bell which serve as the most important ritual tools.

Northern India from the fourth to the sixth centuries during the Gupta period is noted as the 'Golden age' of Buddhist art due to the creation of an 'idealistic' image of the Buddha. This Buddha can be distinguished by an ornate and ethereal quality that wasn't present in

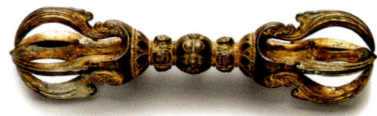

previous representations. A signature floral-patterned nimbus and elegant diaphanous robes established an aesthetic for the Buddha that spread and persisted throughout Southeast Asia.

Buddhism spread to Central Asia along the Silk Road before reaching Korea and Japan. Buddhist missionaries who travelled through the Silk Road were believed in part to be responsible for the artistic secretion between the Kushan Empire and China. This creative style is known as Serindian art, which is a mixture of Gandharan, Indian, Chinese, and Western ideals.

China started to make sculptures in the round (to be seen from all angles) from the fourth century and many design elements were inspired by India where the first round sculptures originated. Chinese customs were portrayed through slender bodies and thicker robes as opposed to the Indian equivalents, which had larger proportions and sheerer clothing. These sculptures, which were also brightly painted, were made of materials like sandstone, limestone, wood, earthenware, gilded bronze, and copper alloy.

The Northern Dynasties of China developed a formal-looking Buddha created with heavy geometric structure. This image, from the fifth to sixth centuries, was less personal and more abstract compared to earlier renditions. This approach softened towards the Tang dynasty, which saw a shift to a more sensuous and natural-looking Buddha. The Qing dynasty showed particular support of Tibetan art; the Emperor Changxi claimed to be a human embodiment of the bodhisattva Manjushri and practiced Tibetan Buddhism. The second Qing dynasty emperor, Shunzhi, chose to follow Chan Buddhism, and the third Qing ruler, who was responsible for the largest commission of Buddhist art, favoured the Tibetan style of artistry.

Japan encountered Buddhism through Korea, China, and Central Asia before India. The Buddhist art of Japan can be traced back to the sixth century when Buddhist missionaries travelled to the islands and left a cultural exchange in their wake. Japan played a critical role in preserving facets of Buddhism when its popularity was waning in India and being suppressed in Central Asia. Japanese Buddhist art has a unique quality that was inspired by the amalgamation of cultures that had come before. Japan is perhaps most recognized for the Zen art movement

INTRODUCTION 13

which began in the twelfth and thirteenth centuries following the transmission of the faith by the Japanese Buddhist priest Eisai after journeying from China. The most important parts of Zen art are original paintings and poetry which form an intrinsic part of the Zen practice. Some art forms of Zen, in particular painting and calligraphy, can be seen as a meditation in order to see the true reality of existence through spontaneous and non-dualistic representations.

Art played an integral part in the early dissemination of Buddhist philosophy across Asia, painting and sculpture paradoxically being the best advert for a faith that does not encourage the practice of proselytization. The role of art in Buddhism is intrinsically connected to the practice, functioning as a practical aid to assist the practitioner with the ultimate goal of gaining insight and wisdom. Leaving an impression on the mind, whether through meditation or visualization, Buddhist art was created to be particularly visually stimulating. The image of the Buddha has had such success throughout history, that today, thousands of years after the inception of Buddhism in India, the iconography of the meditative Buddha is recognized as an international symbol of peace and wisdom.

Categorizing the broad subject of Buddhist art could be a limitless endeavour in terms of sect, date, style, and region. The subjects of this book serve as a general overview of the past 2,000 years, including artefacts from Southeast Asia, India, Pakistan, Afghanistan, Nepal, China, Korea, and Japan. Buddhism has changed the artistic landscape of all of these countries or what is commonly cited as Asia where the stylistic expression of Buddhism varied with culture and traditions. Tibetans primarily engaged with tantric art, strengthening their meditation upon buddhas and bodhisattvas in a ritualized way. Thus, most examples are highly abstract and symbolic in essence. Gandhara, which is an ancient region in what is now northwestern Pakistan, on the other hand, focused on the historical Buddha and the documentation of events of his life via friezes and sculpture. It is also necessary to consider the numerous buddhas, bodhisattvas, deities, and historical figures – their role within the faith and the legends that surround them to understand the nature of the artwork and why it was created. This book is intended to be an introduction into the world of painting, sculpture, and ritual objects employed within the Buddhist faith, the function of which was for veneration, historical documentation, and instruments of enlightenment.

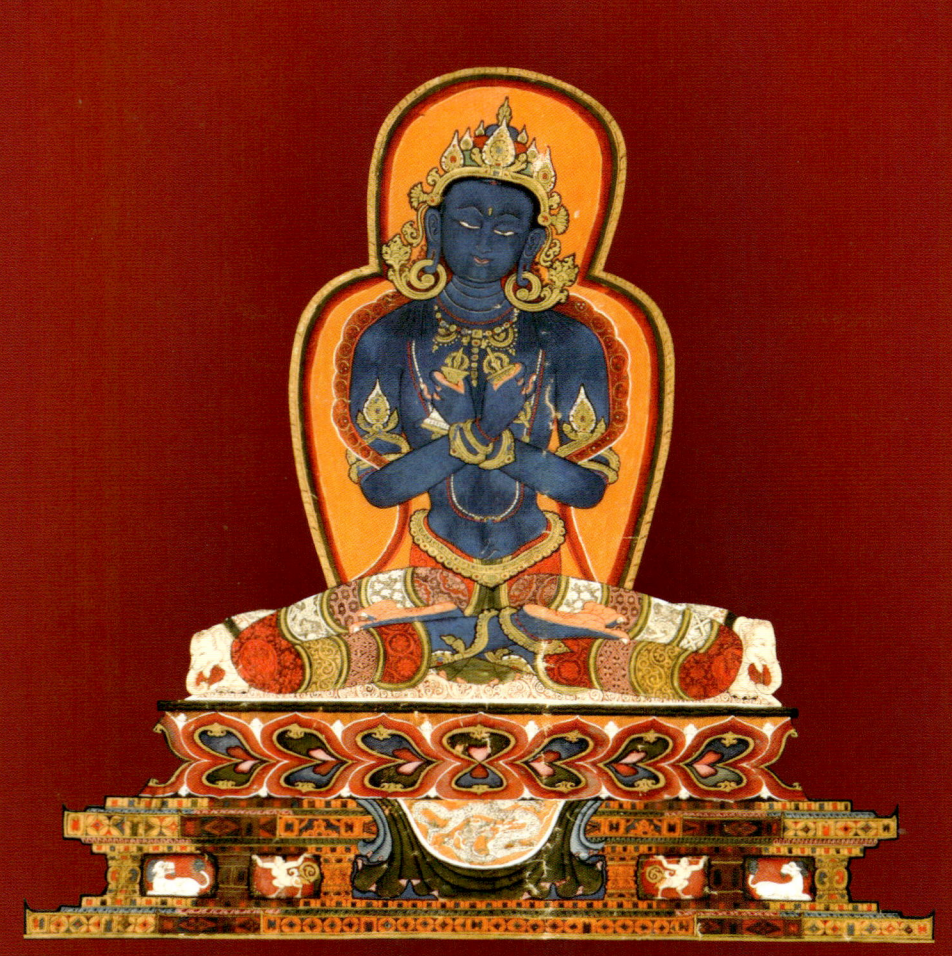

TANTRIC AND ESOTERIC BUDDHIST ART

16 BUDDHISM: A JOURNEY THROUGH ART

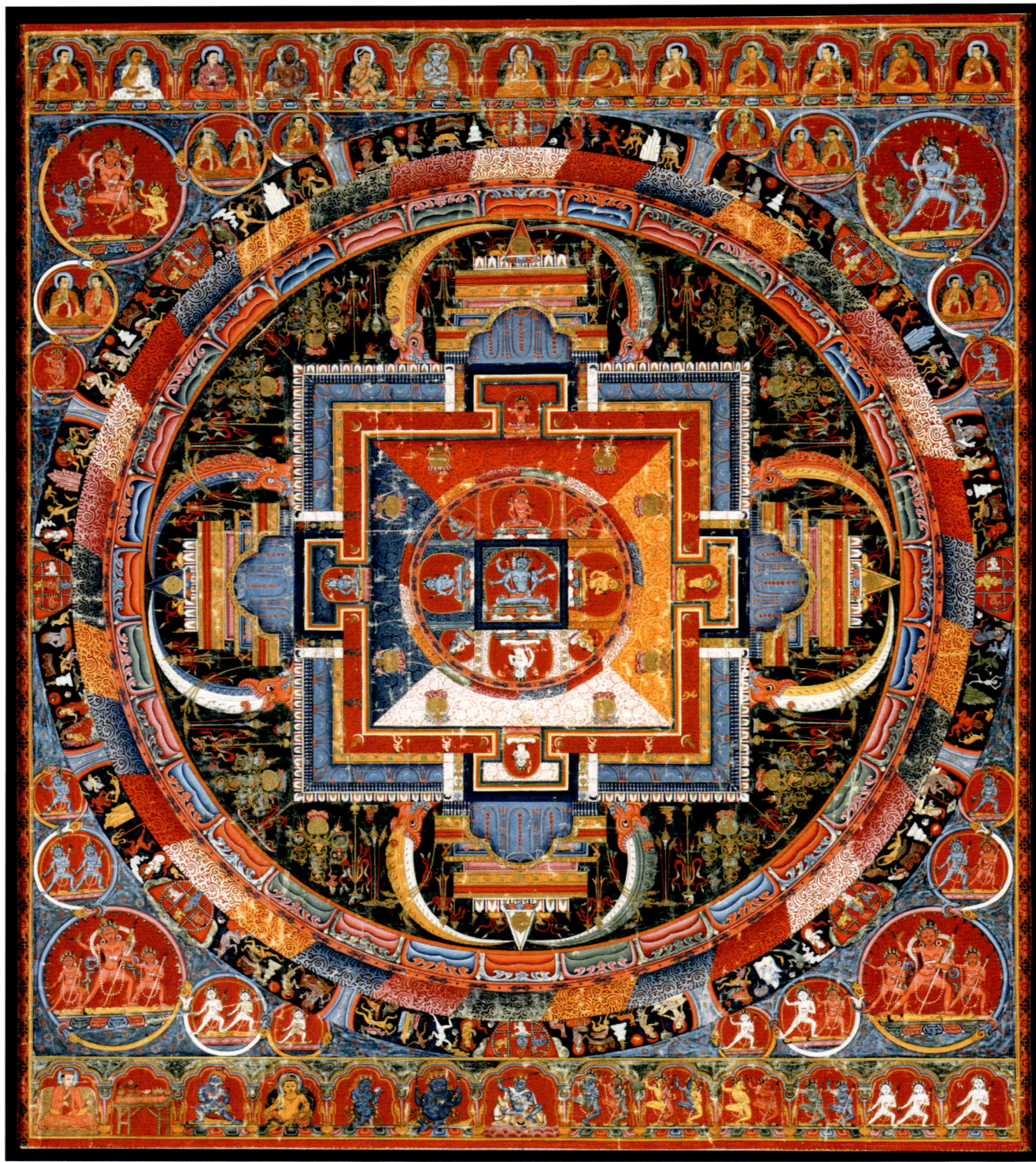

Mandala of Jnanadakini

This rare fourteenth-century Mandala would serve as a diagram or tool, representing the theoretical form of the meditation deity, 'Jnanadakini'. The beautiful shading of this mandala gives a depth to the painting that would help the Buddhist Vajrayana practitioner to visualize a three-dimensional realm. The competence of the artist is evident by the hypnotizing and optically acute method of geometric elements that seem to leap out from the painting's surface.

The idealized and colourful environment of Jnanadakini's palace and surroundings give form to an intangible tantric manifestation that assists the practitioner in meditation and ultimately aids one's progress to enlightenment. The female counterpart of Jnanadaka, who represents the Buddha Vajrasattva and rules over the five Tathagatas, is known as Jnanadakini. Here, she occupies the central position of the mandala without her counterpart. Eight emanations of guardianship surround the central goddess and are enclosed within a larger central sphere which include gates to the heavenly realm, auspicious symbols, lotus petals, protective fire, and tales from the eight charnel grounds. The circumference of this sphere is then further surrounded by a group of celestial beings and lamas with each occupying their own circle to signify their integral part towards the practitioner's enlightenment on earth.

A popular subject of Buddhist art, the six-armed goddess Jnanadakini, is blue in colour, with three faces, each with three eyes, and sits upon a colourful lotus and lions. Mandalas painted on cloth scrolls were traditionally used by monks and lamas and easily transported to communities far away from the monastery.

―――――

Late 14th century • Tibet • Distemper on cloth
H. 83.8 × W. 74.9 cm

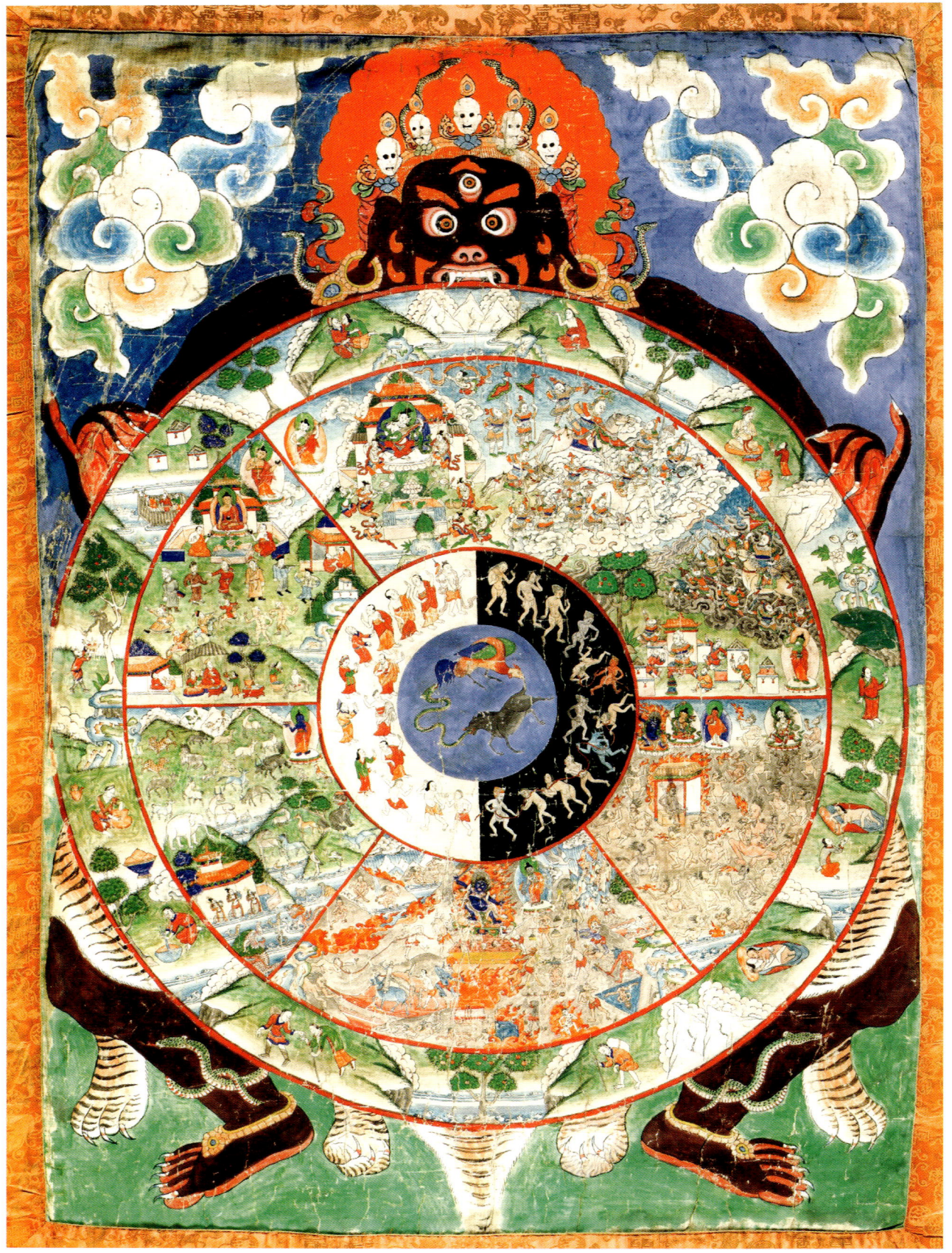

TANTRIC AND ESOTERIC BUDDHIST ART 19

FACING PAGE

Bhavacakra, the Wheel of Existence

Bhavacakra, also known as the Wheel of Life or Existence, is an exciting visual representation of the cycle of birth and rebirth. These creative mandalas feature a cock, a snake, and a pig in the centre, symbolizing greed, hatred, and ignorance. The White Path and the Dark Path are depicted in the circle surrounding the centre. Bodhisattvas on one side assist beings in ascending to the higher realms of devas, gods, and humans. The lower realms of hungry ghosts, hell beings, and animals, on the other hand, are led by demons. The monstrous-looking figure holding the Wheel of Life is Yama, the lord of the underworld.

───────

19th or early 20th century • Central Tibet • Painting

H. 110.5 × W. 80 cm

FOLLOWING PAGE LEFT

Four Hevajra Mandalas of the Vajravali Cycle

This thangka depicts the mandalas of the Vajravali cycle, esoteric teachings assembled by the Indian master Abhayakaragupta in the eleventh century. During China's cultural revolution, the Ngor Monastery which was famed for its outstanding collection of Sanskrit manuscripts and fifteenth-century Newar paintings, was mostly destroyed. This thangka, and the others in the collection, were the few surviving paintings suspected to be commissioned by the influential Buddhist master Ngorchen Kunga Zangpo in honour of his teacher, Sazang Phakpa Shonnu Lodro. The style of this thangka points to a Newar artist who travelled to Tibet.

───────

15th century • Tibet • Colour on cloth

H. 89.5 × W. 73.7 cm

FOLLOWING PAGE RIGHT

Buddha Vajradhara, Originating Deity of the Sakya Lineage

This rich and vibrant thangka depicts Vajradhara in his usual deep blue form. Blue signifies the attainment of enlightenment and essence of the Buddha. Vajradhara is sumptuously adorned like a bodhisattva. He wears a gold crown and heavy gold earrings which embody the listening and realization of the Dharma. Vajradhara sits with two arms crossed over his heart in the union gesture, holding a vajra and a bell symbolizing method and wisdom. He sits upon a lotus throne, which within Buddhist iconography, reflects his divine nature. The Buddhist tantric scriptures are said to have originated from Vajradhara, who is a manifestation of the Buddha's teachings. He is the ultimate primordial Buddha, and to be in the 'state of Vajradhara' is synonymous with complete awareness and enlightenment.

───────

Early 15th century • Central Tibet • Colour on cloth; cloth mounting

H. 86.4 × W. 78.7 cm

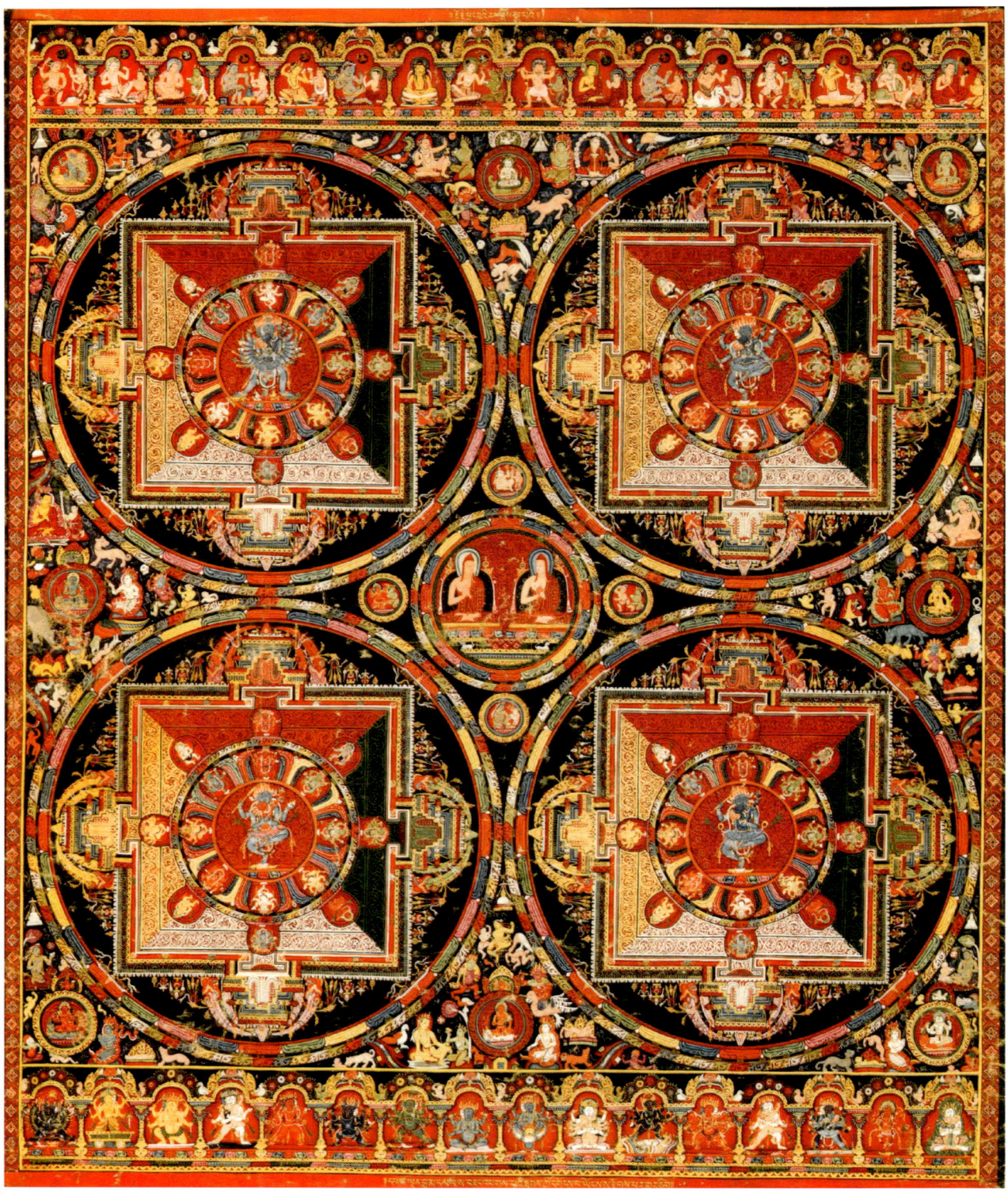

TANTRIC AND ESOTERIC BUDDHIST ART

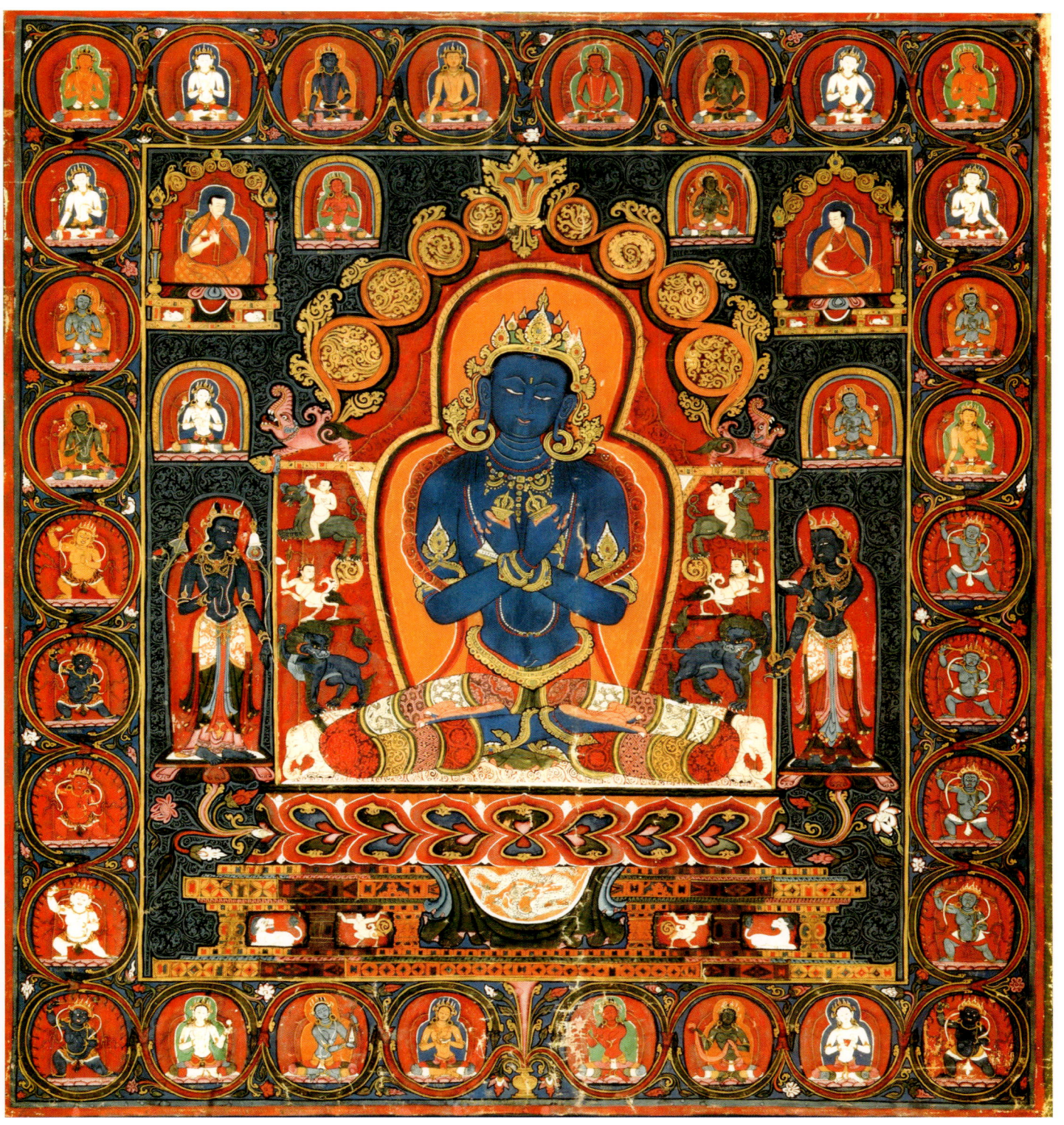

Twelve-armed Chakrasamvara and his Consort Vajravarahi

This meticulously carved sculpture conveys an energetic and dynamic Chakrasamvara embracing his consort Vajravarahi. Phyllite was a popular medium for sculpture due to its workable nature and durability. Chakrasamvara is the main meditation deity of the Kagyu Schools of Tibetan Buddhism as well as other traditions. Tantric Buddhist deities are often shown in the yab-yum (intercourse) position. The union of skilful means and knowledge, represented by the masculine and feminine, is believed to lead to awakening. Here, Chakrasamvara and his consort Vajravarahi, stand on a lotus throne while trampling the wrathful Hindu deities, Bhairava and Kalaratri. Enclosed in a fiery prabhamandala representing the great fire of knowledge, Chakrasamvara wields a number of weapons and ceremonial instruments.

———

ca. 12th century • India (Bengal) or Bangladesh • Phyllite

H. 12.7 × W. 7.9 × D. 3.8 cm

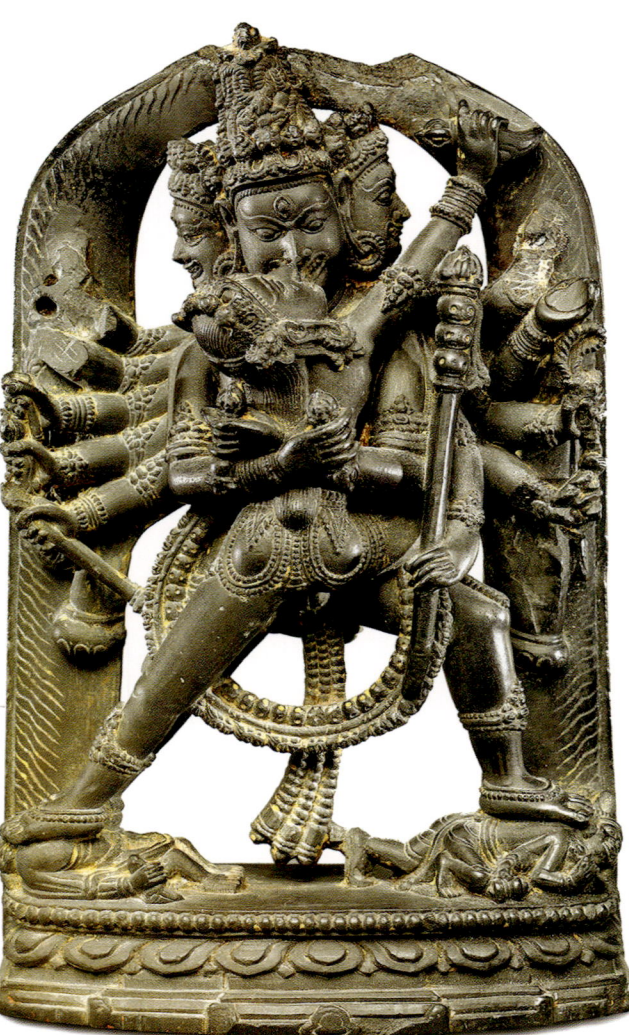

FACING PAGE

Chakrasamvara and Vajravarahi

The bold colourways and animated decoration used in this painting create a feeling of movement and cosmic energy. Chakrasamvara ('Circle of bliss') is very prominent in Tibetan Buddhist traditions and one of the most popular deities in Tantric Buddhism. The deity is depicted here locked in an electrifying embrace with his bright red consort Vajravarahi, who holds a curved knife in her hand, a ritual object used symbolically to destroy forces that stand in the way of enlightenment. Considered one of the finest representations, Chakrasamvara here holds a vajra in his right hand and a bell in his left. The vajra and bell, representing method and wisdom, are the most important ritual objects of Tibetan Buddhism. The garland of severed heads Chakrasamvara is wearing around his neck is something Vajrayana Buddhism adopted from Hindu iconography.

———

Mid-15th–16th century, Sakya Order • Central Tibet • Distemper on cotton cloth

H. 40.6 × W. 33.7 cm

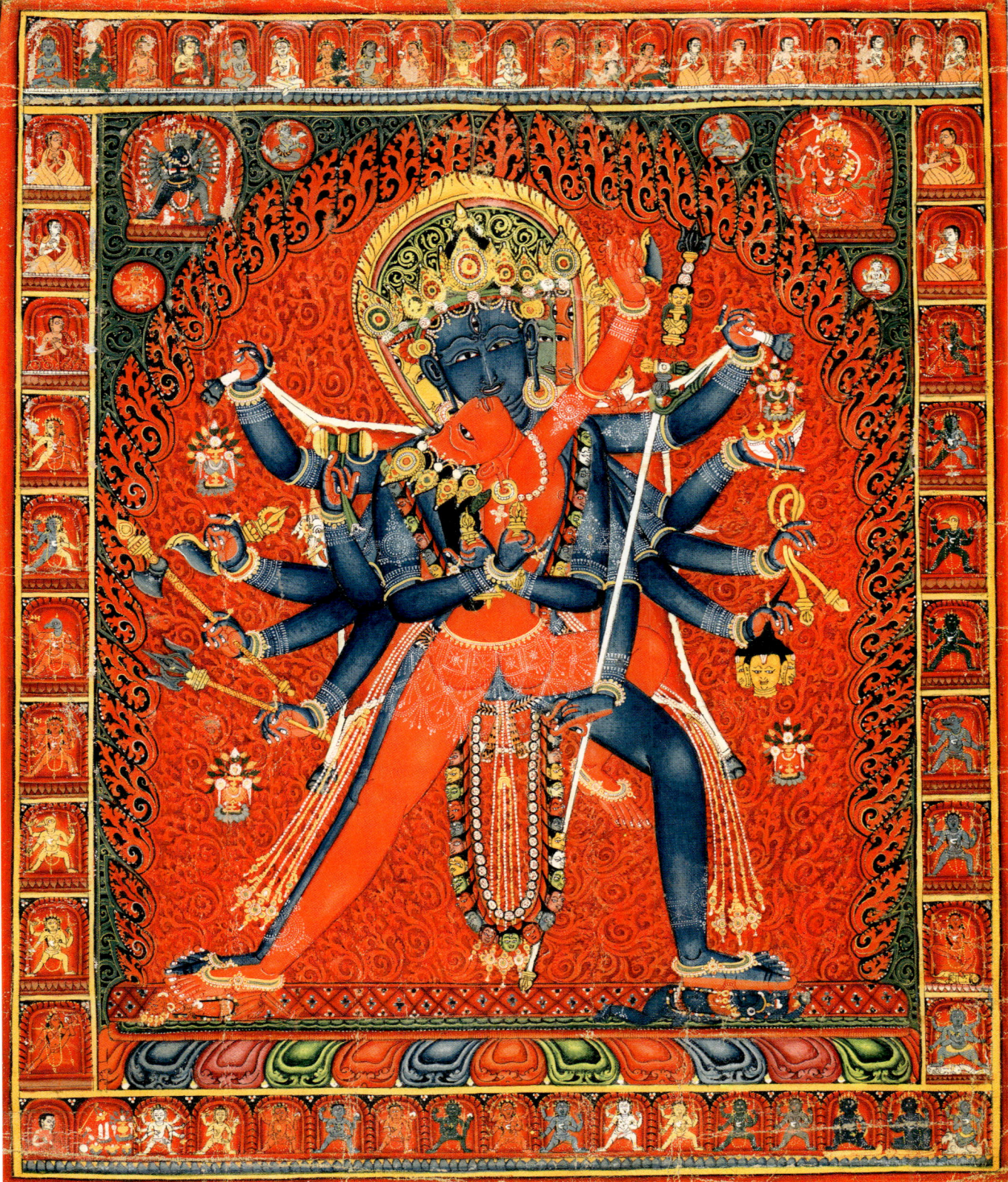

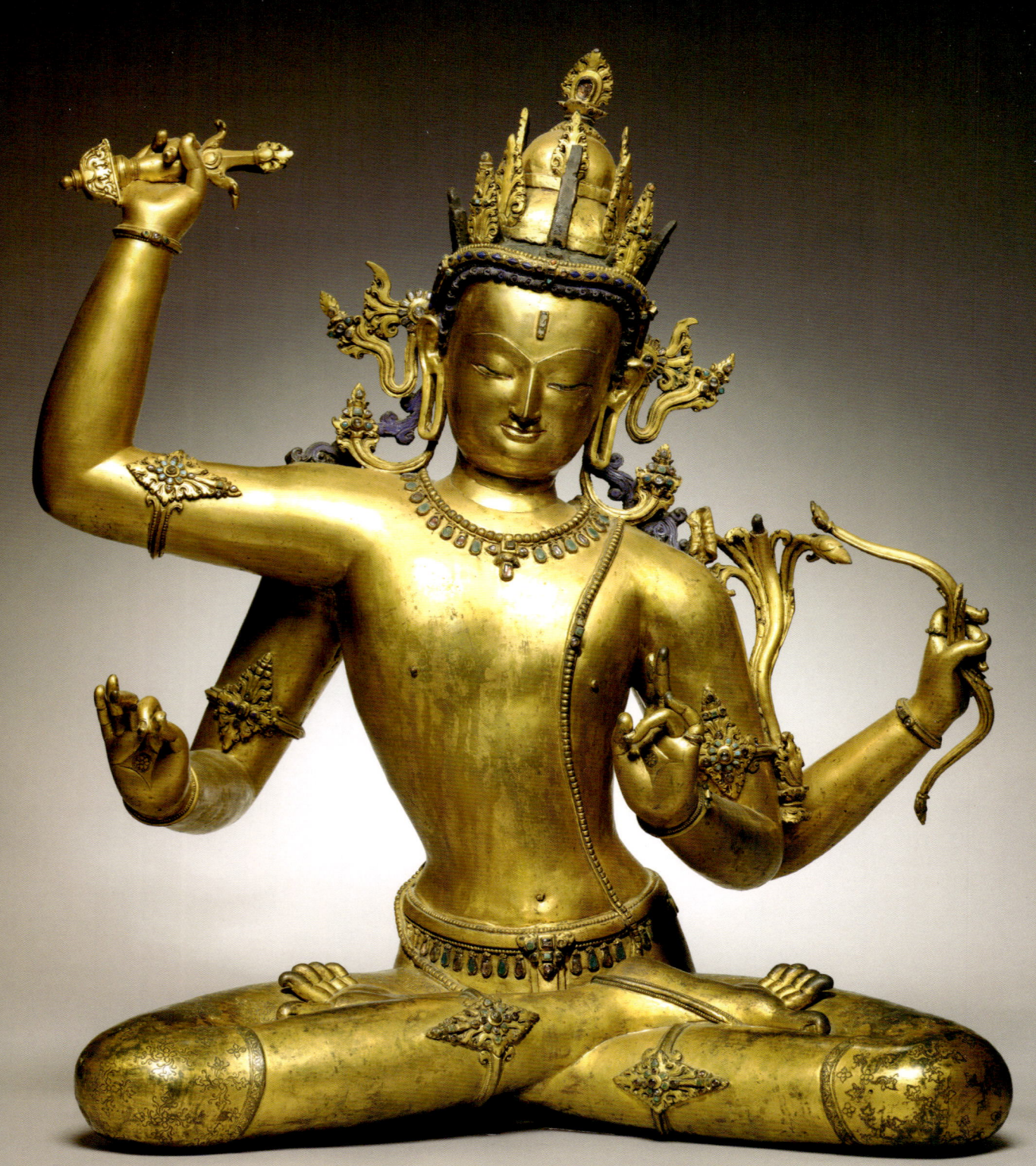

TANTRIC AND ESOTERIC BUDDHIST ART 25

FACING PAGE

Bodhisattva of Wisdom (Manjushri)

The heavily gilded aspect of this sculpture of Manjushri with the inlay of semiprecious stones and fine ornamental flourishes is typically Nepalese in style. Manjushri is worshiped as the 'Meditational Deity' in Tantric Buddhism and is one of the most iconic figures in Mahayana, known as the bodhisattva of great wisdom. This stunning metal cast sculpture displays the attributes of a master craftsman with an artistic eye for beauty. Manjushri brandishes a sword which is symbolic of cutting through the egoic mind. In Nepal, this bodhisattva of wisdom is credited with creating the Kathmandu Valley, a bowl-shaped canyon located in the Himalayan mountains by cutting through the surroundings with his divine sword. Bodhisattvas commonly display emblems on lotuses. In this sculpture, a Prajnaparamita Wisdom text would have been kept in the lotus stem that rises from the left elbows of Manjushri.

15th century • Nepal • Gilt Bronze

H. 78.1 × W. 67.6 cm

FOLLOWING PAGE LEFT

Wisdom King of Great Awe-inspiring Power (Daiitoku Myoo)

The Edo period was well known for illustrative expression and this image of Daiitoku Myoo, also known as 'The Wisdom King of Awe-Inspiring Power', perfectly captures the splendour and whimsy of the time. A wisdom king is a wrathful deity in East Asian Buddhism, and Daiitoku Myoo is fearsome in appearance. Depicted with six arms, six legs and six faces, he brandishes an assortment of weapons backed by an aura of fire. The fire symbolizes purification of the practitioner. As is common in the iconography of wisdom kings, Daiitoku is shown here adorned with skulls, snakes, and animal skins.

Mid-19th century, Edo period (1615–1868) • Japan • Hanging scroll; ink, colour, and gold on silk

H. 250 × W. 143 cm

FOLLOWING PAGE RIGHT

Guru Dragpo

In the 'Revealed Treasure' tradition of the Nyingma School of Tibetan Buddhism, Guru Dragpo is a wrathful meditational manifestation of Padmasambhava. Red in colour, he is shown here in his most basic form with one face and two arms. Guru Dragro has different forms in Buddhist iconography depending on the particular traditions and date in history. He is depicted here with a grimacing face and wild hair adorned with a crown of skulls. He holds a vajra and a nine-headed black scorpion. Padmasambhava has a special relationship with the scorpion who is said to have equipped him with the knowledge of the ritual dagger. This explains why some forms of Guru Dragpo are seen wielding a scorpion in the left hand.

18th century • Tibet • Distemper on cotton

H. 61 × W. 44.5 cm

26 BUDDHISM: A JOURNEY THROUGH ART

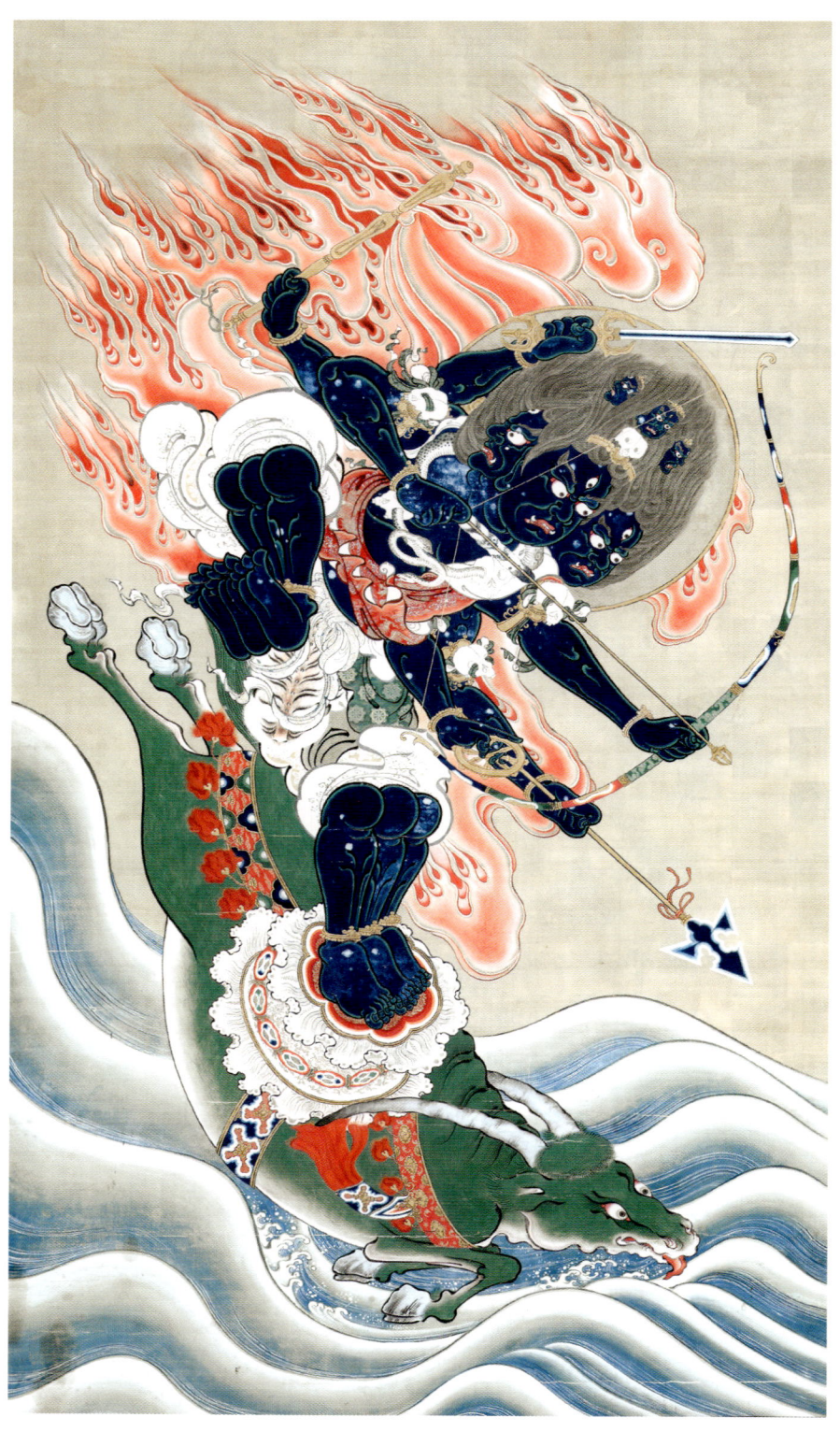

TANTRIC AND ESOTERIC BUDDHIST ART 27

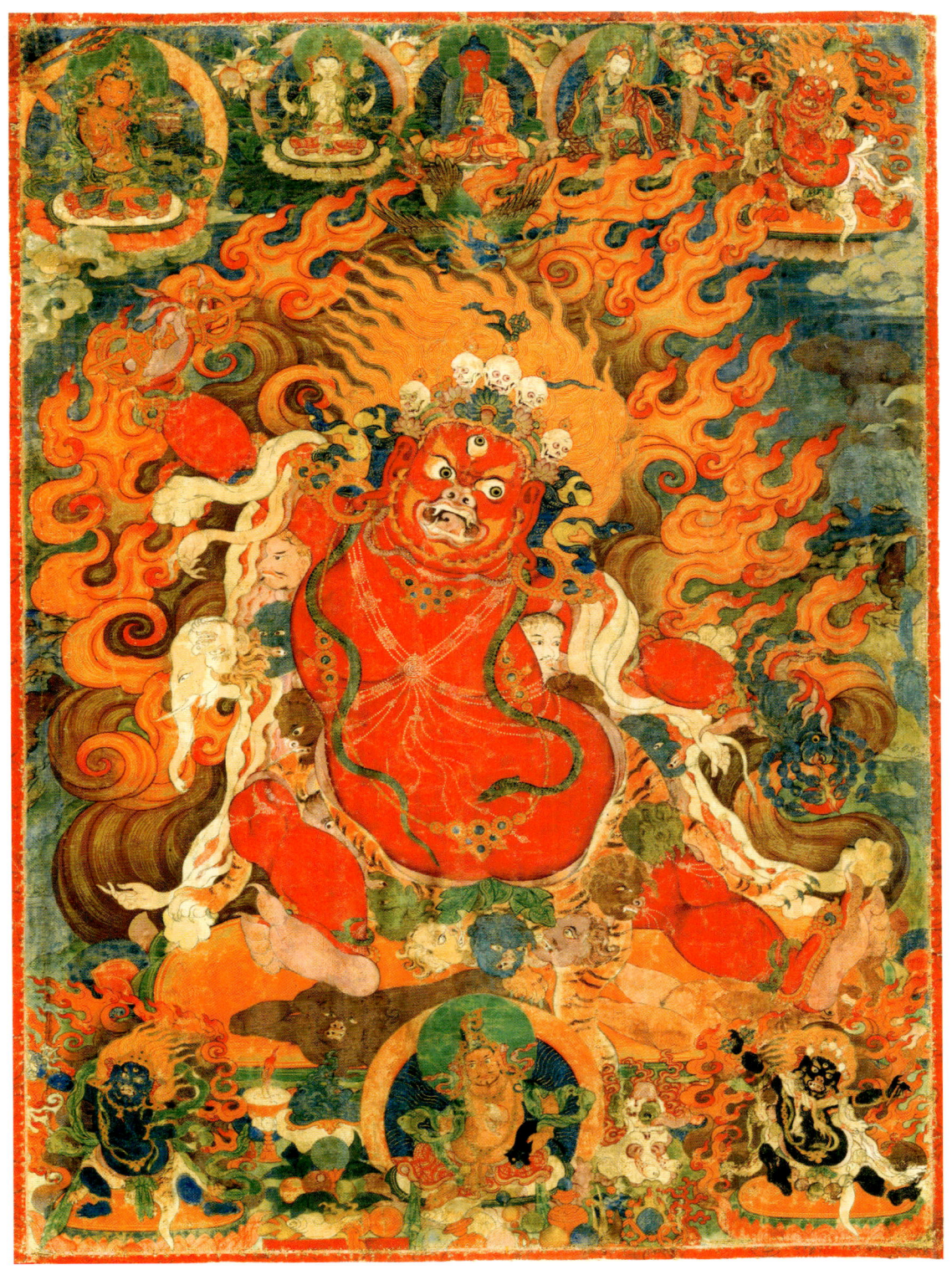

Dainichi, the Cosmic Buddha (Mahavairocana)

Dainichi Nyorai, meaning 'Great Sun' in Japanese, is the central deity of Esoteric Buddhism. Dainichi appears here as Ichiji Kinrin, or 'One-Syllable Golden Wheel'. The deity's hands are in the fist of the wisdom mudra, formed by holding the raised forefinger with a clenched right fist, the tip of the right forefinger touching the left forefinger symbolizing the unity of worldly elements with consciousness. The double round halo, one for the head attached to that for the body, represents the light of Buddha.

———

12th century; Heian period (794–1185) • Japan • Wood with lacquer and gold leaf

H. 92.4 × W. 69.9 × D. 49.8 cm

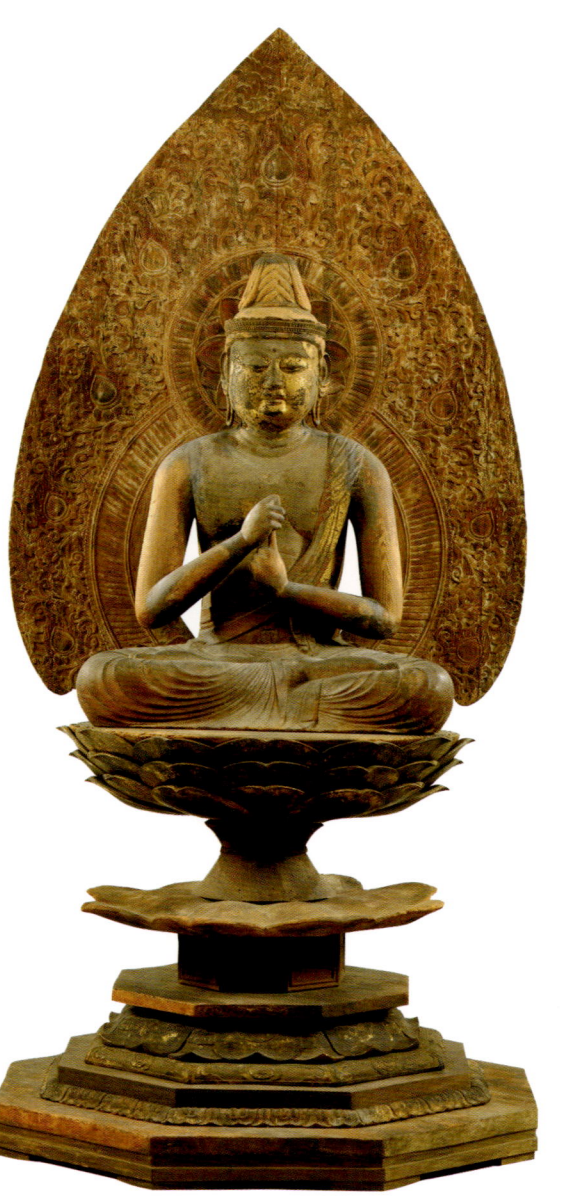

FACING PAGE

Twenty-three Deity Nairatma Mandala

Mandala, literally meaning 'circle' in Sanskrit, is a meditation tool used in Buddhist tantrism and often consists of one or more circles around a square. The mandala gives form to the mental construct of abstract ideas, helping the viewer to see beyond their illusionary perceptions. The four-armed manifestation of the enlightened being Nairatma, the embodiment of *sunyata* (emptiness), can be seen at the mandala's centre. She is carrying the ritual staff, vajra, skull cup, and flaying knife that are distinctive to her iconography. She dances on a corpse while wearing a skull crown. Protecting her divine palace are three borders of lotus petals, purifying fire, and the eight charnel grounds which are filled with tantric beings and wrathful deities.

———

Late 14th century, Central Tibet, Sakya-affiliated monastery • Opaque watercolour, gold and ink on cloth

H. 82.5 × W. 72.4 cm

TANTRIC AND ESOTERIC BUDDHIST ART 29

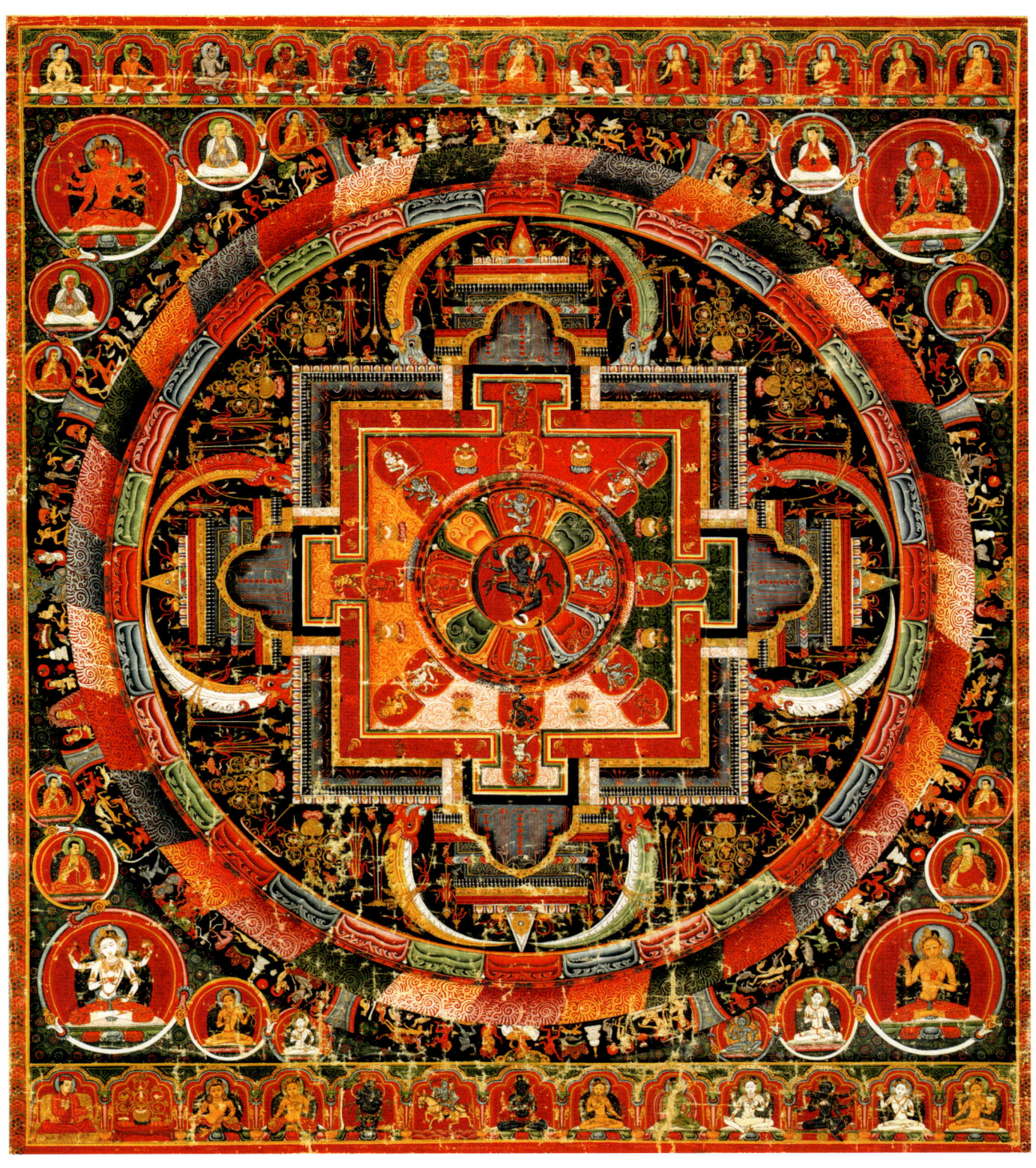

BUDDHISM: A JOURNEY THROUGH ART

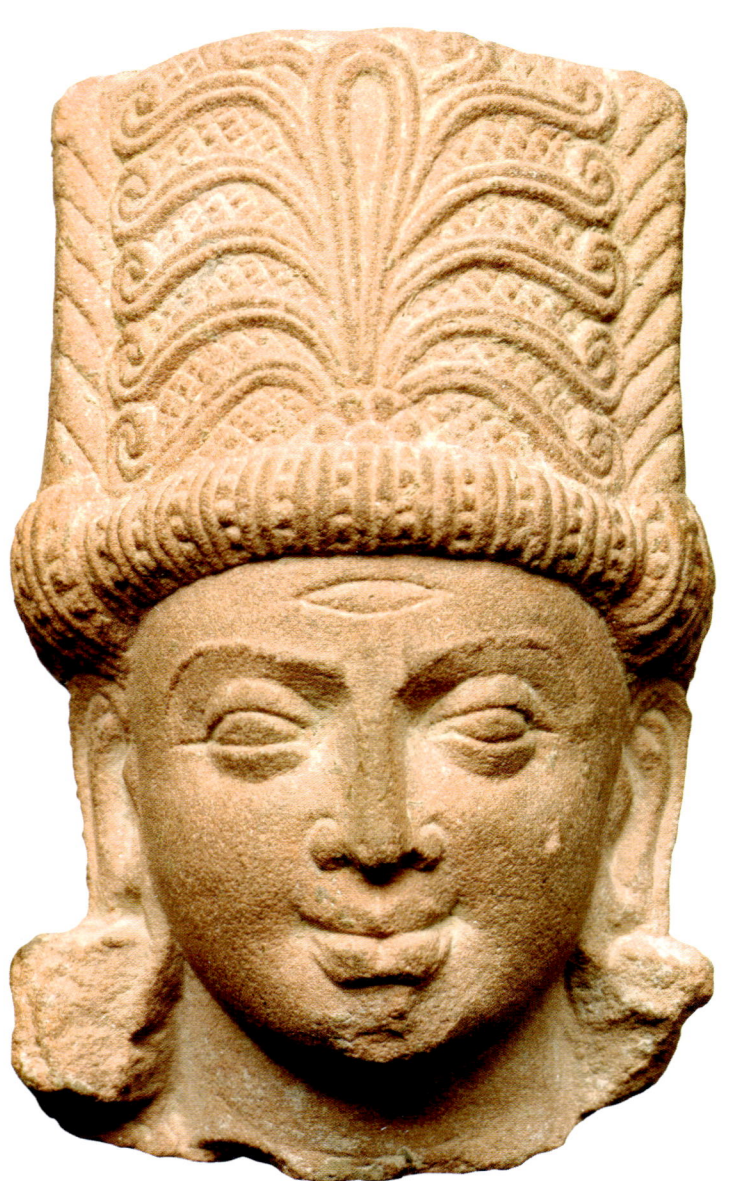

Standing Indra

Despite being made from sandstone, a material that is vulnerable to damage over time, this beautiful sculpture of Indra from the second century is in good condition. Buddhism adopted Indra from Vedic mythology where he is associated with the sky, storms, and battle. In Buddhism, Indra is its defender and often referred to as Sakra, the Sanskrit word for mighty. First used in the Rigveda, the oldest known Vedic text, Sakra became the popular name carried over into Buddhist tradition. Sakra, like all deities, has a long life yet is mortal. When a Sakra dies, another divinity takes his place and becomes the new Sakra.

ca. 2nd century • India
(Uttar Pradesh, Mathura or Ahicchatra) • Sandstone

Head: H. 9.4 cm
Body (lower waist down): H. 28.9 cm

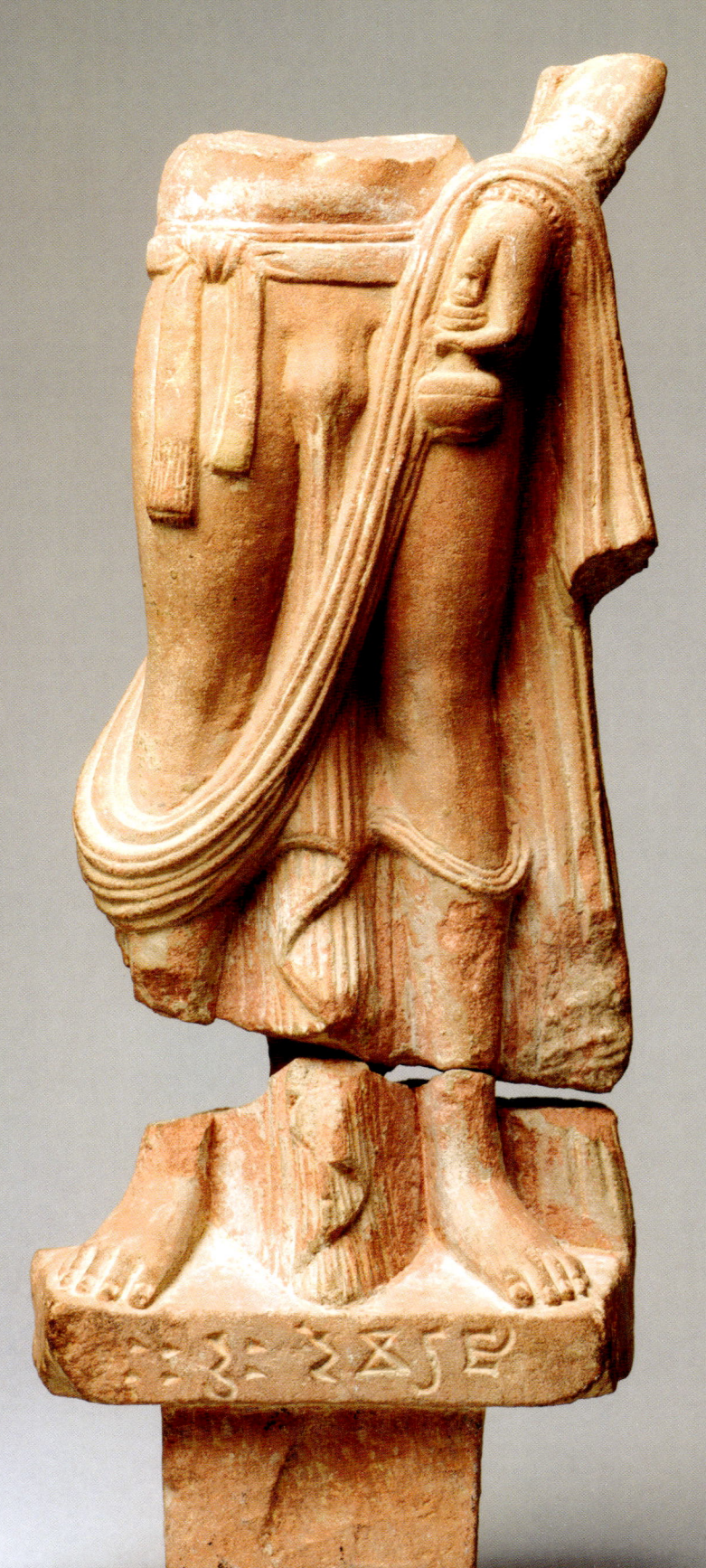

32 BUDDHISM: A JOURNEY THROUGH ART

RIGHT

Ritual staff

This tantric staff, or 'khatvanga' starts with the lotus, on which rests a vajra. The vajra supports a golden vase and above are three heads, a freshly severed head, a decomposing head, and a skull that is topped by the other end of the vajra. The various states of decay are attractively portrayed through the iron being damascened with gold and silver. The three heads symbolize the impermanence of the flesh and death of the three root poisons – desire, ignorance, and hatred. This elaborate version of the ritual staff was made at the court of Ming emperor Yongle, who favoured Tibetan Buddhism. Yongle's high standards of court art remained unparalleled throughout the rest of the Ming dynasty. In Tibetan Buddhist rituals, the ceremonial staff is used as a symbolic remover of barriers to attain enlightenment.

———

Ming dynasty (1368–1644), Yongle mark and period (1403–24) • China • Iron damascened with gold and silver

H. 43.2 × W. 7.6 × D. 7.6 cm

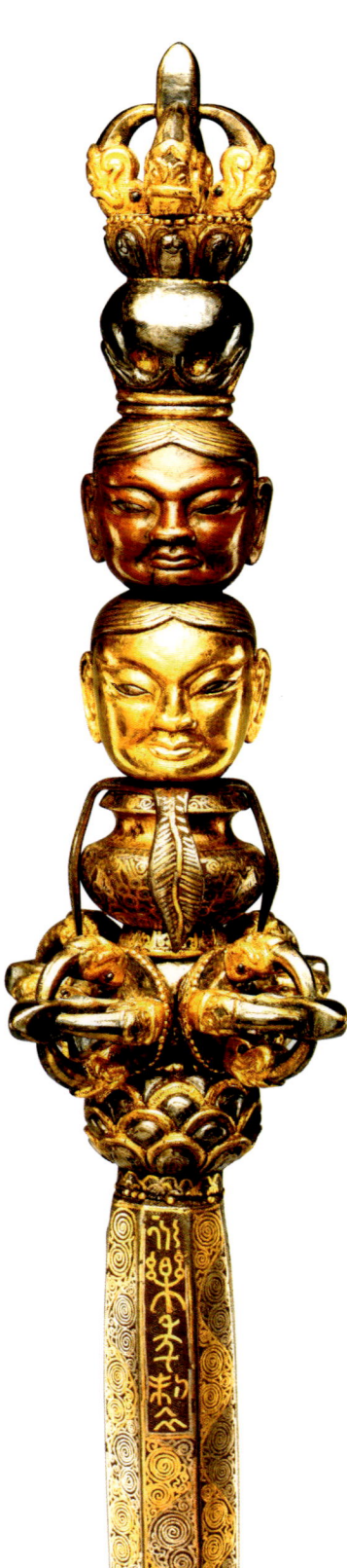

FACING PAGE

King Songten Gampo as the incarnate Avalokiteshvara

The Buddha's presence is symbolized here by the footprints in the centre of the painting. The Buddha's footprints typically have equal-length toes and other distinguishing features, such as a dharma wheel in the middle of the sole. Carved stone footprints, known as 'buddhapada', are among the oldest-known works of Buddhist art and faith, and footprints of revered lamas appear on painted thangkas in Tibet, where they are frequently placed next to the subject's patron deity or an image of the lama himself. This is one of the first Tibetan silk paintings to be documented, and the subject of this artwork is Songten Gampo, the seventh-century Tibetan king, who appears as an incarnation of his spiritual instructor, Avalokiteshvara, who rules above him.

———

10th–11th century • Tibet • Painting on silk

H. 53.3 × W. 53.3 cm

TANTRIC AND ESOTERIC BUDDHIST ART 33

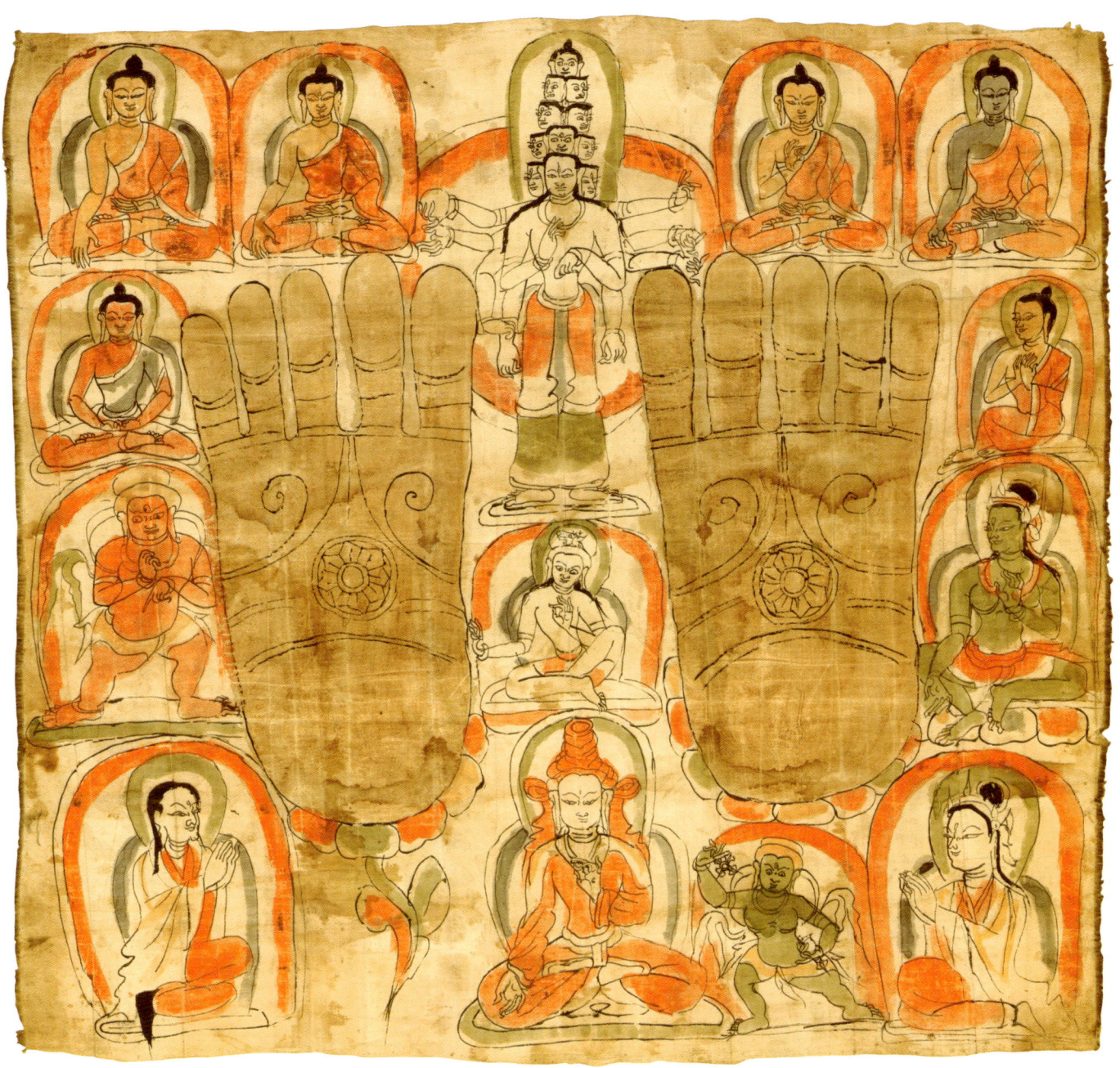

Virupa

According to legend, in the ninth century, a monk called Virupa left the monastery and started wandering as nomad in search of enlightenment. One day, as he was meditating in the countryside, he had a vision of the deity Nairatmya, an embodiment of the wisdom of the buddhas, and she explained to him the meaning of a text called the Hevajra tantra. This tantra taught him how to achieve enlightenment within one lifetime. In this exquisite sculpture, Virupa's right hand originally held a skull bowl, and his left hand is pointing at the Sun, which relates to an old folk tale about Virupa using his tantric powers to halt the Sun. Although closely related to Tibetan designs, the lavish decorations, specific gilding method, and direct casting of ornamentation onto the body without the use of inlay are distinctively Chinese.

———

Early 15th century • China • Gilt bronze

H. 43.6 cm

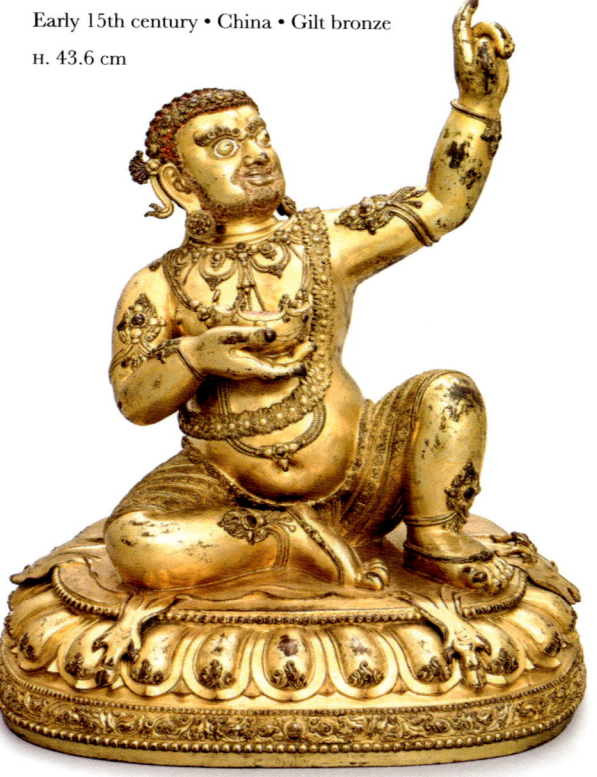

FACING PAGE

The Deity Vajrabhairava, Tantric Form of the Bodhisattva Manjushri

This stunningly intricate and vibrant embroidered silk depicts Vajrabhairava, the tantric form of the Bodhisattva Manjushri. Vajrabhairava belongs to Vajrayana Buddhism and is an advanced tantric deity. In Buddhist iconography, Vajrabhairava has many different forms but is usually shown to have nine faces, thirty-four arms, and sixteen legs. Vajrabhairava's different forms depend on the tradition, location, time period, and artist's preferred style. This silk, with the heads set in a row and the arms and legs individually fanning outward, point to the Gelug school of Tibetan Buddhism. A guardian and destroyer of death, he is represented by brandishing an array of weapons, while trampling birds, dogs, and deities. Vajrabhairava is adorned with a coiled snake, jewellery, and a garland of severed heads. As noted by artist and author Robert Beer in *The Handbook of Tibetan Buddhist Symbols*, the garland of severed heads usually indicates the wearer to be of masculine form and can be seen to represent purification of speech as it hangs from the throat chakra. Here, Vajrabhairava sits upon the enlightenment throne and at the very top of this throne is the red-winged Garuda who is grasping two Naga kings who have serpent tails. Garuda's red form represents the burning of obstacles to enlightenment, while his two wings symbolize wisdom and compassion.

———

Early 15th century, Ming dynasty (1368–1644) • China • Embroidery in silk, metallic thread, and horsehair on silk satin

H. 146.1 × W. 76.2 cm

TANTRIC AND ESOTERIC BUDDHIST ART 35

36 BUDDHISM: A JOURNEY THROUGH ART

ABOVE

The Buddhist Guardian Mahabala

This spectacular sculpture of Mahabala is an important and rare find among the remains of the Javanese period. The ancient art of Java had a number of cultural influences due to its proximity to important maritime ports. Arguably its biggest influence was India, where Buddhism first originated. According to Tantric Buddhism, Mahabala can be identified by his unusual snake-nest hair, sharp teeth, and loincloth. He stands with his left leg extended in a poise of intimidation as defender of the Dharma.

11th century, Eastern Javanese period • Indonesia (Java) • Bronze

H. 16.5 cm

FACING PAGE

Vajradhara, Nairatmya, Mahasiddhas Virupa, and Kanha

Paintings that depict a lineage of masters are revered in Tantric Buddhism as the image assists practitioners with certain rituals. This highly-pigmented Tibetan painting begins in the upper left with the dark blue Vajradhara, who represents the essence of all buddhas. Nairatmya, the female enlightened one and consort of Hevajra, is seated in the upper right. Virupa, the brown-skinned Indian yogi, in the lower left, was her student; his disciple Kanha is pictured in the lower right.

ca. 1450 • Central Tibet, Ngor monastery • Gum tempera and gold on cotton

H. 57.5 × W. 50.2 cm

TANTRIC AND ESOTERIC BUDDHIST ART

Tantric Female Enlightened Being (Vajrayogini) Holding a Skull Cup

Vajrayogini has many forms but here, as points her iconography, she represents the Naropa tradition. She stands with her two legs on the ground, head turned to the left looking upon her upraised left hand holding a skull cup. Resting on the right shoulder is a katvanga staff. Adorned with jewels and bone ornaments, she wears a garland of severed skulls. *The Handbook of Tibetan Buddhist Symbols* by Robert Beer describes the skull garland as symbolizing the feminine principle of emptiness. The skulls are strung along a corpse's hair which represents the death of illusion. Naropa Vajrayogini is clutching prayer beads which are often held by deities and lineage masters in Buddhist iconography. Her prayer beads are made of skulls or human bones fashioned as skulls. Wrathful deities are sometimes depicted as holding a rosary made of human skulls, and the number of skulls on the rosary can sometimes decipher its purpose.

1701–1800 • Tibet • Silver, gilt silver, and gilt copper alloy

H. 66.1 × W. 46.4 × D. 22.9 cm

Conch Shell with a Figure of Hevajra

The symbolic use of the right-turning white conch was first discovered/started in ancient India. The conch creates a meditative sound when used as an instrument. In Buddhist tradition, this reflects the flawless and unadulterated form of universal sound. As blowing the conch signals the beginning of auspicious work, it is customary to do so prior to the beginning of any ritual or ceremony. The shell's bronze ornamentation depicts the dancing form of Hevajra, a Buddhist deity of enlightenment with eight heads, sixteen arms, and four legs. Hevajra was elevated to a prominent position in Angkorian-era Buddhism as the typical figure representing the observance of rituals outlined in the Hevajra-tantra.

———

12th century • Cambodia, Angkor • Shell and bronze

H. 35 cm

40 BUDDHISM: A JOURNEY THROUGH ART

TANTRIC AND ESOTERIC BUDDHIST ART

FACING PAGE

Kurukulla Dancing in Her Mountain Grotto: Folio from a Manuscript of the Ashtasahasrika Prajnaparamita (Perfection of Wisdom)

In Tibetan Buddhism, Kurukulla is a peaceful or semi-wrathful deity associated with enchantment and magical dominance. She can appear in a range of colours, although red is her typical form. She holds a bow made of flowers which was originally an attribute of the Vedic god Kamadeva, and became part of Buddhist iconography when it was absorbed into the Vajrayana sect as Kurukulla's main weapon. To demonstrate that she is the remover of evil, the goddess dances atop a corpse while adorning a flaming halo.

―――

Early 12th century, Pala period • India, West Bengal or Bangladesh • Opaque watercolour on palm leaf

Folio: H. 7 × w. 41.8 cm; Image: H. 6.4 × w. 4.9 cm

FOLLOWING PAGE LEFT

The Wrathful Protector Mahakala, Tantric Protective Form of Avalokiteshvara

There are many variations and forms of Mahakala but he is typically wrathful in appearance. Mahakala, the furious manifestation of the bodhisattva Avalokiteshvara, is shown here in a fiery aureole; his six hands clutching ceremonial tools such as the trident. The three points of his trident represent the three jewels in Buddhism – the Buddha, the Dharma, and the Sangha. A skull with silks and a red yak tail is mounted below this. The fly-whisk has long been a symbol of spiritual sovereignty within Buddhist iconography, and when depicted with a skull reflects the death of the egoic mind.

―――

Early 18th century • Tibet • Distemper on cloth

H. 121 × w. 185.7 cm

FOLLOWING PAGE RIGHT

Mahakala, Protector of the Tent

Mahakala or 'Great Black One' is one of the most popular guardians in Tibetan Buddhism. An amalgamation of all colours, in Buddhism, black can represent absolute reality. Mahakala tramples a body while carrying a skull cup and curved knife in front of his heart, symbolizing wisdom and compassion. He holds a 'gandi' gong in the crooks of his elbows which is a specific attribute of Mahakala. Palden Remati and Palden Lhamo, his main comrades, are on his left, while Legden Nagpo and Bhutadamara are on his right. In the lower left corner, Brahmarupa is blowing a thighbone horn, an auspicious instrument that produces sound to ward off evil. This thangka, one of the earliest and grandest of its kind, may be traced back to murals in the fifteenth-century Kumbum at Gyantse monastery in central Tibet, and was most likely created under Newari supervision.

―――

ca. 16th century • Central Tibet • Distemper on cloth

H. 162.6 × w. 134.6 cm

Seated Brahma

Brahma is most recognized as the Hindu god of creation but he also has a Buddhist counterpart. In Buddhism, Brahma is a powerful heavenly ruler who is revered as a defender of the Buddhist teachings. In Buddhist belief, it was the god Brahma Sahampati, who appeared before the Buddha after he attained enlightenment and invited him to teach. Brahma rules Brahmaloka, the Buddhist rebirth realm and is usually depicted as a four-faced, four-armed god in Mahayana Buddhist iconography.

———

Late 12th–early 13th century (Bàyon) • Cambodian (Artist) • Bronze

H. without tang: 29.5 × W. 27.4 × D. 14.3 cm; H. with tang: 31.5 × W. 27.4 × D. 14.3 cm

Aizen Myoo

Aizen Myoo is one of the Five Kings of Wisdom and the ferocious guardian of Esoteric Buddhism said to transform lust into enlightenment. He has six arms and one head wearing a lion headdress, which symbolizes the lion's roar and the strength to overcome obstacles. This figure's main right arm previously held a vajra – in the hands of wrathful deities, the vajra is said to be a profound symbol of the impenetrable state of the enlightened mind and capable of destroying all illusions. The primary left arm still holds the vajra bell which is used as a tool for awakening.

———

Early 14th century, Kamakura (1185–1333) • Japan • Wood with black lacquer and red pigment

H. 75 × W. 59 × D. 35 cm

Eleven-headed Guanyin

The bodhisattva is an enlightened being devoted to the spiritual enlightenment of all on earth. In Chinese Buddhism, the Bodhisattva Guanyin, in a variety of incarnations, is likely the most revered. This standing Guanyin has a total of eleven heads stacked on top of one another, with smaller ones positioned atop the largest head. According to one Buddhist legend, Guanyin vowed to never rest until all sentient beings were freed from samsara. Despite his best efforts, he discovered that there were still many people in need of help. Guanyin's head broke into eleven pieces after struggling to comprehend the needs of so many people. After realizing Guanyin's predicament, Amitabha Buddha bestowed upon him eleven heads so that they may listen to the cries of all those who were suffering. Guanyin changes sex depending on the time in which the sculpture was created; here, he is in male form but is often also depicted as a female. The gender-fluid nature of the bodhisattva is due to the necessary masculine or feminine attributes that may be more in demand in different social climates.

Early 8th century, Tang dynasty (618–907) • China • Gray sandstone

H. 129.6 × W. 63.6 × D. 25.4 cm

Vajrapani, the Thunderbolt-bearing Bodhisattva

Vajrapani is one of the oldest bodhisattvas in the Mahayana Buddhist pantheon. Popular in Buddhist iconography, he can be identified by his main attribute, the vajra, which he holds in his left hand, corresponding with his name Vajrapani, the 'vajra holder'. He is believed to be the protector of the nagas which corresponds to the snake-like torque jewellery adorning his arms.

7th–early 8th century • Eastern India (Bihar, probably Nalanda) • Stone

H. 78.4 × W. 60.5 × D. 15.2 cm

Hevajra

In Buddhist iconography, Hevajra has many different forms and artistic styles depending on the date and location of the sculpture or painting. The typical form of Hevajra has eight faces, sixteen arms, and four legs and he is often shown in the yab-yum form with his consort Nairatmya. Here, Hevajra is a bit more unusual with two legs, with his right leg elevated and his left leg on the ground surrounded by dancing dakinis. This multi-armed and two-legged version of Hevajra depicted without his female consort, points to its origin in Thailand. Hevajra's legs are in the dance pose which symbolizes the process of enlightenment. This sculpture is exceptionally rare as few as elaborate as this one survived.

ca. 13th century • Northeastern Thailand • Bronze

H. 46 × W. 23.9 cm;
Wt: 14.6 lbs (6.62 kg)

Bust of Hevajra

This huge stone sculpture was identified as Hevajra due to the arrangements of the eight heads with one missing atop. Small bronze sculptures of Hevajra found nearby and from the same time period are comparable, with similar facial features and artistic style. This sculpture is believed to be in the dancing position due to the fact that one shoulder is tilted slightly higher than the other. However, as the sculpture is in fragments with much missing, the original form is not definitive.

Late 12th–early 13th century,
Angkor period • Cambodia • Stone

H. 132.1 × W. 73.7 cm

Thangka with the Medicine Buddha (Bhaishajyaguru)

Bhaishajyaguru is also known as the Medicine Buddha. He is revered by many Mahayana Buddhists due to his bodily and spiritual healing abilities, and is nearly always attended by the bodhisattvas of the Sun and Moon (Suryaprabha and Chandraprabha). Bhaisajyaguru is a deep vibrant blue and dressed in a splendid robe; his left hand rests in his lap in the mudra of meditation. Sometimes deities have both hands in the lap when gesturing to meditation, but Bhaishajyaguru holds a branch of the healing myrobalan plant in his right hand instead. The myrobalan plant is the main attribute of the Medicine Buddha and highly esteemed for its healing properties.

———

14th century • Tibet • Pigment and gold on cotton
H. 104 × W. 82.7 cm

TANTRIC AND ESOTERIC BUDDHIST ART 51

Thangka with Bejewelled Buddha Preaching

In this thangka, the Buddha wears a crown and jewellery and therefore, according to some scholars he evokes Sakyamuni Buddha. Sonya Quintanilla, the George P. Bickford curator of Indian and South East Asian Art describes this thangka as unusual because of the depiction of the Buddha in an atypical teaching gesture with one leg crossed over the other. In the heavens above, celestial beings gather to honour him whilst a relic and tantric manifestations are below. The benefactors of this thangka, a family from Nepal whose names are etched at the bottom of the painting, are depicted in the painting standing in two rows in front of the Buddha whilst he is teaching.

1648 • Nepal • Colour on cloth

H. 109.5 × W. 82.5 cm

Gilt Figure of Marichi

Marichi (from Sanskrit 'beam of light') is a Buddhist Dawn Goddess and celestial warrior. Her Tibetan name, Oser Chenma, literally translates to 'Great Light Goddess'. She is venerated as a heavenly warrior and guardian who removes doubt and fear. Marichi is a Buddhist and Taoist deity in China. She is venerated by Chinese Buddhists as the defender of all nations from the devastation of war. She has three eyes in each of her four faces and four arms on each side. The goddess is depicted with multiple faces, one of which is a boar. This boar face represents the goddess' aggressive and protective attributes. Her peaceful middle face contrasts with her other angry face, indicating her gentle yet vigilant nature. Her two clasped hands hold a Sun, Moon, bell, and golden seal. The Sun represents the feminine aspect of wisdom and the Moon the male aspect of compassion.

———

18th century, Qing dynasty • China • Bronze with traces of gilding

H. 91.4 × W. 94 × D. 55.9 cm

Vajravarahi

There is something utterly mesmerizing about this gilt bronze sculpture of Vajravarahi, who embodies esoteric divination. In all of the traditions of Tibetan Buddhism, Vajrayogini, who takes the form of Vajravarahi, is considered to be one of the most revered and well-known tantric female deities. In this appearance, she has a single boar's face protruding from her right ear. Vajrayogini is usually holding a skull cup and a ritual flaying knife with a half-vajra shaped handle. This knife is also known as the 'knife of dankinis'. Vajravarahi has her right leg folded in and the left one slightly bent in a dancing posture.

———

14th century • Tibet • Gilt bronze with turquoise inlay
H. 36 cm

54 BUDDHISM: A JOURNEY THROUGH ART

TANTRIC AND ESOTERIC BUDDHIST ART

FACING PAGE

Thangka with Guru Dragpur or Vajrakila, a Wrathful Form of Guru Padmasambhava

This compelling painting portrays the wrathful meditational deity Guru Dragpur, who is an aspect of Guru Dragpo and an incarnation of Padmasambhava. The upper part of his body is formed of three wrathful heads and six arms whilst his lower half is shaped like a ritual dagger. The triple-edge blade represents the severance of the three root poisons – ignorance, greed, and anger. The fearsome monster atop the dagger is the Kirtimukha. Guru Dragpur wears a tiger skin around his waist, an iconography quite common in wrathful deities, and three of his six arms wield severed hearts. Hearts can be symbolic of the death of desire when they are consumed by wrathful deities. His other three arms wield cross-vajra sceptres, the tip of each points towards the four cardinal directions and symbolizes the pinnacle of absolute stability. He wears a human hide on his back, a garland of severed heads, a skull crown, and jewellery.

———

18th/19th century • Tibet • Pigment on Silk

H. 56 × w. 44 cm

FOLLOWING PAGE LEFT

Acala, the Buddhist Protector

Acala can be depicted in different forms depending upon the geographical location of the artist. Nepalese iconography depicts Acala standing astride or kneeling on his left knee conveying a protective quality of movement and a readiness to spring into action. Acala is usually a rich blue colour and adorned with jewels. He carries a sword to slay ignorance, and a noose to entrap adversaries. Surrounded by a fiery aureole in an ornate gateway between two pillars (*torana*), he is topped by Garuda fighting two nagas. In a number of registers, numerous protecting emanations surround him; in the lower level, a Vajracharya priest performs rituals for the benefit of the donor family seated across from him.

———

1322, Early Malla period • Nepal, Kathmandu Valley • Distemper and gold on cloth

H. 81.3 × w. 67.3 cm

56 BUDDHISM: A JOURNEY THROUGH ART

Initiation Cards (Tsakalis)

Tibetan Buddhist art is a fusion of artistic cultural influences from its neighbours India, Nepal, Burma, and China. From the thirteenth century onwards, Nepalese artists dominated the creative scene in Tibet. These initiation cards, for example, were most likely created by a Nepalese artisan for a patron of the Nyingma school of Tibetan Buddhism. Art was flourishing and also very important in Buddhism at this time as paintings were used as meditational or teaching tools. The physical image assisted the practitioner in visualizing the divinity in their mind's eye, visualization being an integral part of worship. The belief that commissioning Buddhist art brought merit to the donor was another reason Buddhist art continued to prosper. It is noteworthy that these cards, which may be the earliest set of tsakali that has survived in its entirety, can be assembled to make a mandala that is appropriate for the ritual of initiation. They were easily portable and an important resource for travelling teachers and monks.

Early 15th century • Tibet • Opaque watercolour on paper

H. 16 × W. 14.5 cm each

Tara, the Buddhist Saviour

The utpala lotus springing from the figure's shoulder is commonly attributed to Sitatara, the white Tara. She is making the gesture of bestowing boons, and a third eye is indicated on her forehead. Tara is commonly depicted as the consort to Avalokiteshvara. Her arms and hands are unnaturally large in this sculpture, and these attributes were seen to be an indication of divinity. A huge surge of Buddhist art was produced in the Malla period due to the ruler's patronage at the time. Newar artists were highly skilled in their metal casting, and their individual style came to dominate the art world.

14th century, Malla period • Nepal (Kathmandu Valley) • Gilt copper alloy with colour, inlaid with semiprecious stones

H. 59.1 × W. 26.7 × D. 12.7 cm; WT. 23 lbs (10.4 kg)

TANTRIC AND ESOTERIC BUDDHIST ART

Bodhisattva Manjushri as Tikshna-Manjushri (Minjie Wenshu)

The sword is the primary emblem of wisdom and therefore the main attribute of Manjushri, the bodhisattva of wisdom, as well as the Perfection of Wisdom Sutra text. In this sculpture, he also holds a bow and arrow, the union of which represents wisdom and compassion. The iconography of Manjushri sitting in the Vajra posture with the sword, the Perfection of Wisdom Sutra text, bow and arrow point to this sculpture being of Tikshna Manjushri. His other forms include Simhanada Manjushri, Arapacana Manjushri, Vital Manjushri, and Jnanasattva Manjushri.

Ming dynasty (1368–1644), Yongle period (1403–24) • China • Gilt brass; lost-wax casting

H. 19.1 × W. 12.1 × D. 8.9 cm

60 BUDDHISM: A JOURNEY THROUGH ART

TANTRIC AND ESOTERIC BUDDHIST ART　61

FACING PAGE

Gautama Buddha Calling the Earth to Witness

Gautama calling the earth to witness has doctrinal importance as the moment of his enlightenment and is frequently depicted in Buddhist art. Whilst under the bodhi tree, the Buddha touched the ground with the *bhumisparsha* mudra, calling upon the earth to witness his victory over Mara, a demon who embodies everything contrary to enlightenment. Buddha is venerated in this painting and sits across from an altar on which rests ritual objects such as the wheel, treasure vase, and lotus. On either side stands a model pair of disciples called Sariputra and Maudgalyayana. They each hold an alms bowl and *khakkhara*.

―――

ca. 1750 • Tibet • Colours on cloth

H. 88.6 × w. 61.6 cm

FOLLOWING PAGE LEFT

Buddha Amoghasiddhi with Eight Bodhisattvas

One of the five celestial buddhas, Amoghasiddhi, rules over the northern heaven and has a number of distinctive traits usually shown in his iconography. He is green in colour, which represents nature's harmony. His right hand is pointed upwards, palm facing outwards in the mudra of protection, or *abhaya* mudra. Amoghasiddhi's throne is supported by a dancing *kinnara* and he is depicted with a bodhisattva-like appearance. He is surrounded by his eight primary bodhisattvas, who look upon him lovingly with reverence. Below him are five emanations of Tara, each represented by the five colours of white, green, yellow, red, and blue. Each colour represents an important devotional aspect of the goddess Tara.

―――

ca. 1200–50 • Central Tibet • Distemper on cloth

H. 68.9 × w. 54 cm

FOLLOWING PAGE RIGHT

The Jina Buddha Ratnasambhava

Ratnasambhava means 'born of jewels', and Jambhala, the god of prosperity and wealth, is one of his emanations. Ratnasambhava, the Buddha of the South, is one of the buddhas of the five cardinal directions. As is characteristic of Tibetan paintings of this theme and era, he is lavishly bejewelled. The exquisite shading of this painting makes this a more unusual rendition compared to earlier examples which have no shading and appear flat in nature. There are specific guidelines with regards to sacred Tibetan painting and the artist was not afforded much freedom in expression. The overall execution of this painting, including the additions of fine embellishments and patterns, makes this a particularly beautiful and rare piece of art.

―――

ca. 1150–1225; Kamakura period (1185–1333) • Tibet • Mineral pigments on cotton cloth

H. 121.92 × w. 92.08 × D. 4.45 cm

62 BUDDHISM: A JOURNEY THROUGH ART

TANTRIC AND ESOTERIC BUDDHIST ART 63

Amida, the Buddha of Infinite Light

The typical iconography of Amida Buddha, until the twelfth century, was Buddha seated in a lotus flower as seen here. After the twelfth century, his form became more dynamic and changed to a number of different poses and styles. The Amida Buddha presides over the Western Pure Land and promises salvation and rebirth in this paradise for anybody who evokes his name. Works of art were fundamental in the Western Pure Land doctrine as sculpture or paintings were used as meditational tools. Meditating on Amida was a necessary part of gathering spiritual merit.

ca. 1250, Kamakura period (1185–1333) • Japan • Wood with gold leaf

H. 154.9 × W. 99.1 × D. 99.1 cm

Buddha Vairocana (Dari)

In Mahayana and Vajrayana Buddhism, the Five Dhyani are celestial buddhas who have existed since the beginning of time. In Tantric Buddhism, these buddhas of transcendence are particularly important for meditation. Akshobhya, Amitabha, Amoghasiddhi, Ratnasabhava, and Vairocana constitute the five buddhas.

Buddha Vairocana has many different forms but here, as common in Vajrayana iconography, he appears as youthful and highly adorned, wearing an extravagant crown and jewellery. In Mahayana Buddhism, Vairocana is more likely to be shown in a simplistic Buddha form and unadorned. Vairocana often executes the 'wisdom fist' mudra as seen here, when he is depicted at the centre of the Womb World.

11th century, Liao dynasty (907–1125) • China • Gilt bronze; lost-wax cast

H. 21.9 × W. 11.1 × D. 10.8 cm

Flowers of a Hundred Worlds (Momoyogusa): God of Thunder (Raijin)

On tracing paper, Kamisaka Sekka drew preparatory sketches for his Flowers of a Hundred Worlds series, using coloured ink. The freehand sketches are significantly more spontaneous than the final, printed creations. The freedom of movement that is afforded when creating an informal draft gives us a great insight into the artist's mind and his artistic process.

In old Japanese Buddhist temples, images of the God of Thunder, 'Raijin', are common. Raijin is frequently represented as a muscular figure with gravity-defying hair and a menacing visage. He is surrounded by taiko drums, which he uses to make thunder sounds. He holds two big hammers, which he uses to play the drums. Raijin is depicted here with three fingers, which are believed to represent the past, present, and future.

───

By Kamisaka Sekka • 1909, Meiji period (1868–1912) • Japan • Ink and colour on paper

H. 27.3 × W. 39.4 cm

TANTRIC AND ESOTERIC BUDDHIST ART

68 BUDDHISM: A JOURNEY THROUGH ART

TANTRIC AND ESOTERIC BUDDHIST ART

FACING PAGE

Green Tara

Arguably one of the finest paintings of Tara to exist, most experts assume that this was created by Aniko, a renowned Nepalese artist who was invited to Tibet from Nepal for an artistic commission in 1260 by Phagspa (1235–1280), the Sakya hierarch. Green Tara, who epitomizes the feminine form of the flawless, enlightened mind, is one of the most important figures in Tibetan Buddhism. Green Tara's associated lotus is the blue lotus which she bears in both hands. Green Tara is often represented in a posture of royal ease sitting on a lotus. Emblems of *makara*, a Sanskrit term for sea monster, reside behind her on either side of her enlightenment throne, a common theme in temple doorways.

———

ca. 1260s • Tibet • Thangka; gum tempera, ink, and gold on sized cotton

H. 52.4 × W. 43.2 cm

FOLLOWING PAGE LEFT

Mandala of Rakta Yamari Attributed to Mikyo Dorje

Rakta Yamari embraces the goddess Svabha-Prajna, who represents his female manifestation in the centre of this mandala. Rakta Yamari is an important deity in Tibetan Buddhism and one of the manifestations of the protective deity Yamantaka, the destroyer of the Lord of Death. Yamari is also eminating in several colours radiating from the centre of the mandala. Each colour here represents a different attribute of Rakta Yamari, such as pacifying suffering or increasing good fortune.

———

Late 14th century • Central Tibet • Distemper on cloth

H. 95.3 × W. 76.2 cm

FOLLOWING PAGE RIGHT

Mandala of the One-syllable Golden Wheel

On a lotus pedestal borne by eight lions, the figural representation of sound, Buddha Dainichi sits at the heart of the mandala and performs the wisdom-fist mudra. The eight-sided golden wheel represents the Eightfold Noble Path and the transference of these teachings to the eight directions. The Buddha Dainichi in the centre of the wheel has a glorious multi-coloured halo which illustrates 'extended wisdom', and represents the personification of the Buddha's cranial protuberance.

———

18th century, Edo period (1615–1868) • Japan

H. 112.4 × W. 99.7 cm

Akshobhya, the Buddha of the Eastern Pure Land

The cosmic Buddha of the East, Akshobhya was once a monk who swore he would never foster any anger towards another sentient being. After considerable devotion, he followed his pledge and eventually became a Buddha.

The Eastern Paradise of Abhirati is ruled by Akshobhya, and those who keep Akshobhya's vow are reincarnated there. The ground-touching mudra seen here was used by the historical Buddha to call the earth to witness his enlightenment.

———

16th–17th century • Nepal • Terracotta

H. 50.8 × W. 37 5 × D. 16.5 cm

FACING PAGE

Fragment of a Prajnaparamita Sutra Manuscript Folio

Before the introduction of paper in the twelfth century, religious manuscripts and paintings were created on palm leaves with the earliest manuscripts being from the Jain and Buddhist faiths. Since palm leaves have a narrow surface area, these paintings were small. The viewer would have to hold the painting and look upon it as one would read a book to study the entirety of the painting. The process of looking closely at the painting and holding the delicate palm leaf would serve as a cherished moment between the viewer and the deity depicted. These examples from the Prajnaparamita Sutra, the perfection of wisdom manuscript are rare, and believed to be the oldest surviving illustrated manuscript in the Kashmiri style.

———

ca. 11th century • India, Ancient kingdom of Kashmir • Fragment; colours and black ink on paper

H. 20.5 × W. 16.5 cm

TANTRIC AND ESOTERIC BUDDHIST ART 73

Green Tara, Folio from a dispersed Ashtasahasrika Prajnaparamita (Perfection of Wisdom) Manuscript

Delicately painted on plam leaf, this is a beautifully preserved miniature of the enshrined figure of a seated Green Tara, revered as the saviour from *samsara* (the cycle of life, death, and rebirth). A blue lotus springs from her side, and she is flanked by two female attendants, one carrying a vajra and the other, Mahakali, wielding a flaying knife and skull cup (*kapala*); she is making the gesture of granting boons.

Early 12th century, Pala period • India (Bengal) or Bangladesh • Opaque watercolour on palm leaf

H. 7 × W. 41.9 cm

TANTRIC AND ESOTERIC BUDDHIST ART

The Bodhisattva Avalokitesvara Expounding the Dharma to a Devotee: Folio from a Ashtasahasrika Prajnaparamita Sutra Manuscript

The Prajnaparamita (the perfection of wisdom) texts which originated in India were thought to be composed between 100 BC and AD 600. The word Prajnaparamita combines the Sanskrit words prajna 'wisdom' with paramita 'perfect'. This text is considered one of the oldest sutras in Mahayana Buddhism, and prominent sutras such as 'Perfection of Wisdom' and the 'Diamond Sutra' are included in the collection. This twelfth-century manuscript was thoughtfully and meticulously produced with reverence for the sacred text in mind.

Mahavihara Master • Early 12th century,
Pala period • India, West Bengal or Bangladesh •
Opaque watercolour on palm leaf

Folio: H. 7 × W. 41.8 cm;
Image: H. 6.4 × W. 4.9 cm

Yaksha

The subject of this compelling sculpture is an interesting one. Male nature spirits, known as yakshas, are personifications of the natural world and usually ugly in appearance due to transgressions in their past lives. This example of a rotund and short-looking ogre was typical of early depictions and is often found in temple architecture, particularly in doorways. These strange beings are mentioned in Hindu, Buddhist, and Jain texts. Yakshas are sometimes worshipped as minor gods associated with wealth but conversely can be seen as mischievous imps who can cause needless harm.

———

ca. 50 BC, Shunga period • India, Madhya Pradesh • Sandstone

H. 88.9 × W. 45.7 × D. 33 cm; WT. 509.3 lbs (231 KG)

Fudo Myoo
(Acalanatha)

Fudo Myoo is the most frequently depicted of the Buddhist deities known as Myoo, or Kings of Light. He is a direct emanation of the Buddha Dainichi Nyorai, the principal buddha of Esoteric Buddhism, and a fierce-looking protective deity in Vajrayana Buddhism. Fudo Myoo had relatively humble origins within the Buddhist pantheon but over time turned into a powerful deity within his own right, particularly in Japan, where he amassed a cult-like following. Japan adopted Fudo Myoo as an emblem for protection over the whole country and its inhabitants. His protective power was utilized by samurai soldiers who often bore the insignia of Fudo Myoo on their armour. In Japan, the first sculptures of Fudo were seated, but beginning in the eleventh century, sculptures standing erect, such as this one, were prevailing. The face of Fudo Myoo has a unique grimace, sometimes depicted bearing large fangs. He bites down on his bottom lip with deeply furrowed brows to reflect his wrathful protective qualities and has a youthful face which is subhuman in nature. Fudo employs his sword to slice through ignorance which he proudly holds whilst standing in a relaxed posture. In Tantric art, the depiction of deities brandishing weapons is a metaphor for destroying psychological obstacles.

———

Nanbokuchō period (1336–92) • Japan •
Painted and lacquered wood, with gold foil

H. 34.9 × W. 15.2 × D. 8.3 cm

Guardian King of the North
(Bishamonten)

Bishamonten, the Japanese name for Vaisravana is an important figure in Buddhism and one of the Four Heavenly Kings. He stands with a stupa in his left hand, representing the death of ego and the enlightened mind of the Buddha. He holds a three-pronged trident or spear in his right. The three-headed trident is sometimes interpreted in Buddhist iconography to convey the unity of body, speech, and mind. Standing in defiance against evils of the world, this Guardian King of the North crushes a demon beneath his feet.

———

Kamakura period (1185–1333) • Japan •
Wood with gold polychromy

H. 76.8 × W. 28.6 cm

Tantric Deities Hevajra and Nairatmya in Ritual Embrace (Yab-Yum)

Hevajra has many different forms in Buddhist iconography depending on the tradition, date, and geographical location of the artist. He is typically depicted as having eight faces, sixteen arms, and four legs. His consort also changes depending on the text or tradition used as inspiration for the sculpture. Here, we have Hevajra with his consort Nairatmya where he tramples deities beneath his feet. The more orthodox pose of Hevajra is a dancing posture, which means this sculpture was most likely used as an educational tool.

ca. 17th century • Nepal • Gilt bronze with pigments

H. 50.2 × W. 33 × D. 17.9 cm

Deer Mandala of Kasuga Shrine

A vibrant gilded disc which is held up by the branches of wisteria enclose five Shinto Buddhist deities of the Nara Kasuga Shrine. The disc which is a mirror symbolizes the reflection of light and therefore a perspective that is free from illusion. Beneath this, a celestial deer stands upon floating clouds. The deer is the steed to the deity Takemikazuchi, which is echoed by its ornate and extravagant saddle. The deer which has long been seen to be a sacred messenger has a special relationship with Buddhism and Shinto deities.

Late 14th century, Nanbokuchō period (1336–92) • Japan • Hanging scroll; colour on silk

H. 86.2 × W. 35.2 cm

82 BUDDHISM: A JOURNEY THROUGH ART

TANTRIC AND ESOTERIC BUDDHIST ART 83

FACING PAGE

Mandala of Vajradhara, Manjushri and Sadakshari-Lokeshvara

Although there are many types of mandalas, broadly, they can be described as highly technical diagrams with layers of symbolism reflected within geometric patterns. They sometimes depict deities in an exceptionally idealized environment, giving form to an abstract concept in order to aid contemplation during meditation. The Buddha Vajradhara is seen above, along with Manjushri, the bodhisattva of wisdom, and Shadakshari-Lokeshvara in the lower left. They are surrounded by thirty-nine smaller deities. Painted in rich colours on a cloth background, natural dyes were used, and the last pigment laid down was gold.

———

1479, Ming dynasty (1368–1644) • China • Thangka; ink, opaque watercolour, and gold on cotton cloth

H. 147.3 × W. 95.3 cm

FOLLOWING PAGE LEFT

Mountain God with Tiger and Attendants

During the Joseon dynasty, Confucianism had a greater impact than Buddhism, yet Buddhist ideas in art persisted. The Mountain Spirit is revered as a guardian of Buddhism, and shrines to him may be found in most Korean Buddhist temple complexes. The typical iconography of the Mountain God is an elderly man in royal robes accompanied by a tiger and a Korean red pine tree.

———

1874, Joseon dynasty (1392–1910) • Korea • Ink and colour on silk

H. 90.2 × W. 59.7 cm

FOLLOWING PAGE RIGHT

The Tenth King of Hell

This animated and vibrant painting depicts a courtroom style scene, the large figure in the middle of the top register shows the Tenth King of Hell in his standard guise of a warrior. He has authority over the wheel of transmigration that carries the dead to their new existence in either the higher or lower dominions. The king looks straight ahead contemplating judgement whilst a flurry of underworld messengers, judges, and bureaucrats surround him. The lower half of the painting serves as a warning, humans are restrained in pillories whilst demons assist their descent to hell.

———

1798, Joseon dynasty (1392–1910) • Korea • Hanging scroll; ink and colour on silk

H. 116.8 × W. 91.4 cm

得入寂靜光明解脫察察開華主山大神位

第十五還轉輪大王 黑暗造獄 戊午甲

One of the Four Heavenly Kings

This carved wooden sculpture originally flanking the Cosmic Buddha Dainichi Nyorai as part of an ensemble of four, each representing one of the cardinal directions. The Four Heavenly Kings are guardians of Buddhism who fiercely protect the four directions. They include Jikokuten (east), Zōchōten (south), Kōmokuten (west), and Tamonten (north). As a general rule, the iconography of the Four Kings follow a Chinese or Central Asian style. The spirited facial expression and body language of this figure is typical of Fujiwara period sculpture which drew upon emotional appeal. Each figure is depicted wearing heavy and fine armour in the manner of a warrior whilst holding weapons. This sculpture was carved in a traditional style using a single piece of wood for body whilst the arms were carved separately.

12th century, Heian period (794–1185) • Japan • Wood with traces of colour

H. 83.8 × W. 27.6 × D. 20.5 cm

TANTRIC AND ESOTERIC BUDDHIST ART　　87

The Eight Hosts of Deva, Naga, and Yakshi

This exceptional painting displays the highest level of Ming dynasty artistry due to its important and sacred function. The 'Water and Land Ritual' was an expensive and complicated Buddhist ceremony. This is one of 36 Water–Land ceremonial paintings which would have been hung in the inner temple altars. The ritual is often cited as one of the grandest rituals in Chinese Buddhism and was intended to establish merit for both the living and the souls of the dead.

———

1454, Ming dynasty (1368–1644) • China • Hanging scroll, ink and pigment on silk

H. 140.2 × W. 78.8 cm

88 BUDDHISM: A JOURNEY THROUGH ART

TANTRIC AND ESOTERIC BUDDHIST ART 89

FACING PAGE

Mandala of Chandra, God of the Moon

The Moon god Chandra belongs to a number of Indian cultural traditions. Chandra is believed to possibly originate from the Hindu Vedic texts under the name 'Soma'. Accompanied here by two female archers who throw arrows of light to dispel darkness, she carries two lotuses and rides a chariot drawn by seven geese, similar to the images of Surya, the Sun deity, who rides a chariot drawn by horses. Chandra is enclosed in a blinding white circle representing the Moon, whose illuminating presence is able to reflect light to dispel darkness and which is an important spiritual Buddhist symbol.

―――

Late 14th–early 15th century, Early Malla period • Nepal, Kathmandu Valley • Distemper on cloth

H. 40.6 × W. 36.2 cm

FOLLOWING PAGE LEFT

Heavenly King Virudhaka

In China, Virudhaka's name refers to his capacity to teach sentient beings to develop and strengthen their compassion. In Chinese temples, Virudhaka is frequently enshrined in the Hall of Heavenly Kings. Each of the four Heavenly Kings is believed to look over one of the four cardinal directions of the universe. They serve a similar role to the ancient Four Heavenly Beasts in Chinese mythology. This king protects the south and he can be identified by his blue skin and sword, which he uses to protect the southern continent and Buddhist doctrine. He is clad in armour richly embellished with jewels, furs, and silks to signify his royal stature. He is flanked by two of his subjects, the strange celestial beings known as the *kumbhandas* (demons shaped like gourds).

―――

1368–1644, Ming dynasty (1368–1644) • China • Hanging scroll; colour on silk

H. 110 × W. 75.2 cm

FOLLOWING PAGE RIGHT

White Mahakala

This artwork is dedicated to Shadbuja Sita Mahakala, the White Mahakala, a Tibetan Buddhist deity worshipped to ensure prosperity. As noted by Jeff Watt, scholar of Tibetan art, there are numerous White Mahakala forms, However, in paintings, we generally find the White Mahakala from the Shangpa Tradition as seen here. Mahakala in this form wears luxurious jewellery to emphasize wealth, has three eyes, six arms wielding weapons, and is wrathful in appearance with a fiery aura. Surrounded by protective deities, he is an emanation of Bodhisattva Avalokiteshvara, and stands among twisted foliage.

―――

ca. 18th century • Tibet • Distemper on cotton

H. 53.7 × W. 35.2 cm

92 BUDDHISM: A JOURNEY THROUGH ART

TANTRIC AND ESOTERIC BUDDHIST ART 93

FACING PAGE

Ushnishavijaya Enthroned in the Womb of a Stupa

Ushnishavijaya has two main forms; she sometimes has one face and two arms or, such as this image, three faces and eight arms. This multi-limbed form can be commonly found seated inside of a stupa. The concept of Buddhist merit being multiplied is illustrated by a number of smaller stupas known as *chaityas*. Stupas are donated as part of the goddess' worship in Nepal, and each *chaitya* here represents the donation of one hundred thousand stupas. She is surrounded by guardians of the eight directions as well as images of goddess Tara.

———

1510–19 • Nepal • Distemper on cloth

H. 73.3 × W. 58.7 cm

Chunda

This is an incredibly rare bronze of the goddess Chunda, the embodiment of the Cunda *dharani mantra*. A goddess with one face and four arms, she is mentioned in one of the earliest and most important tantric scriptures, the Gukyasamaja-tantra and was worshipped in what is now modern-day Bangladesh.

———

800–850 • Java • Bronze metal

H. 12.5 × W. 7.0 × D. 5.2 cm; WT. 0.82 lbs (372 g.)

The Goddess Kurukulla

The Vajrayana goddess Kurukulla has different forms but she is depicted here as the popular red-skinned goddess with four arms. A flower bow and arrow are typical weapons of Kurukulla and Tara in Buddhist iconography and the red utpala lotus flowers are symbolic of her seductive qualities. The red of her skin can be associated with the Amitabha Buddha; however, she can also be depicted in various other colours depending on her form. She is in a dancing posture, crushing male corpses beneath her feet in an animated display reflecting destruction of the egoic mind. The medium of embroidered silk and applique is still a technically challenging, time-consuming, and impressive mode of artistry making this piece all the more spectacular.

———

19th century • Tibet • Appliqued satin, brocade and damask, embroidered silk and painted details

H. 142.2 × W. 119.4 cm

The Lotus-blossom Petal Canopy

The canopy is a traditional symbol of Indian royalty and wealth; so, great care went into its decorative appeal. This stunning example is typically Indian in its style of pattern and bright colours and features cultural elements of Hindu, Buddhist, and Muslim iconography. The lotus design expands attractively from the centre in a circular mandala. The lotus was a sacred symbol in many ancient cultures, from Asia to Africa, and widely incorporated into much religious art. The beauty of the embroidery of this work is testament as to why Indian art played such an influential role in the decorative patterned arts of Europe and the rest of the world.

16th–early 17th century • India • Lampas: Silk

H. 186.7 × W. 175.7 cm

Aizen Myoo

Aizen Myoo is one of the kings of wisdom (Myoos) venerated in Esoteric Buddhism as the transformer of carnal desires to enlightenment. Rituals are dedicated to him whereby followers write their wishes on paper, and a Buddhist monk then burns these paper messages at the altar to help remove negative obstacles for the practitioner and wider world. Aizen Myoo was a common emblem on the armour and weapons of samurai soldiers due to his power as a protective deity. The flaming halo of Aizen Myoo represents the purifying flames that consume evil. Below him are an abundance of precious jewels – some are falling from an overflowing vase, scattered to the ground, others are perched upon a moon disc lotus emitting radiant light. Precious jewels are an auspicious symbol that possesses a number of mystical attributes including the ability to help a practitioner overcome suffering. The three jewels of Buddhism express the Buddha, Dharma, and Sangha.

14th century, Nanbokucho period (1336–92) • Japan • Hanging scroll; ink, colour, gold, and cut gold leaf on silk

H. 135.4 × W. 82.4 cm

TANTRIC AND ESOTERIC BUDDHIST ART 97

Twenty-one Emanations of the Goddess Tara

Buddhist saviour Tara has numerous forms and is frequently surrounded by her twenty-one emanations, coloured white, red, and yellow. It is believed, the original (green) Tara, in the centre, was created from a single tear of Avalokiteshvara. Tara is believed to be a buddha and the mother of buddhas in Tibet. The enthroned form of Tara is said to bestow blessings on those who pray to her and she is encircled by emanations that share her iconography. In the practice of worship, each Tara is represented as the bringer of a unique set of blessings, such as the remover of suffering and the destroyer of attachments.

14th century • Tibet • Stone with polychrome

H. 38.7 × W. 26 × D. 8.9 cm; WT. 21 lbs (9.5 kg)

Ōtsu-e of Uhō Dōji

There is something incredibly charming about the simplicity and naivety of this print. The Edo period was famous for its sophisticated woodblock printing and illustration methods; however, this has been created quickly suggesting a cheaper and more commercially viable option. These pieces appear to be more intimate and personal due to the fast-paced spontaneity of the artist. The 'rainmaking youth', Uho Doji is often depicted with a five-tiered pagoda on her head, a jewel in her left hand, and a staff in the right, believed to ward off bad luck. Uho Doji is believed to be either a manifestation of Buddha Dainichi Nyorai or Amaterasu, the Shinto deity.

17th century, Edo period (1615–1868) • Japan • Hanging scroll; ink, colour and woodblock print on paper

H. 56.2 × W. 29.1 cm

TANTRIC AND ESOTERIC BUDDHIST ART 99

Maruami Goro Saved by Fudo's (Acala) Attendant Seitaka from Narita Shrine

Fudo has two attendants that can often be found in his iconography known as Kongara Doji and Seitaka Doji. The subject of this print, which is part of a larger set of three, depicts Fudo's attendant Seitaka being played by an actor as part of a wider scene. Utagawa Kunisada was the most well-known, prolific, and commercially successful creator of ukiyo-e woodblock prints in Japan throughout the nineteenth century. China had been using the method of woodblock printing since the Tang dynasty, but it did not gain widespread popularity in Japan until the Edo period. Woodblock printing was initially used to produce low-cost books from standard hand-scrolls but developed into a respected and sophisticated artform with the refinement of the Edo period.

By Utagawa Kunisada • 19th century, Edo period (1615–1868) • Japan • Woodblock print; ink and colour on paper

H. 36.5 × W. 25.1 cm

Zao Gongen

Zao Gongen guards Mount Kinpu, south of Nara in Yoshino. The deity combines Buddha Sakyamuni, thousand-armed Kannon, and Miroku. These three deities were considered past, present, and future world protectors.

His right foot is raised in a bounding leap as he uses his right hand to brandish a vajra. His hair frames his face with tufts that resemble flames. The powerful expression, with a furrowed brow and an open roaring mouth emphasize his wrathful presence. This sculpture was carved from a single piece of wood. James T. Ulak, the senior curator of Japanese Art from the Freer Gallery of Art, suggests that the importance of this technique with regards to Zao Gongen could have a deeper meaning. Seen as sacred, large trees are found all over the mountains where Zao Gongen was thought to reside, therefore one could conclude that the deity was carved from a sacred tree, remaining whole so that the power of the wood remained intact.

1185–1333 • Japan, Kamakura • Wood
H. 106.7 cm

TANTRIC AND ESOTERIC BUDDHIST ART

Avalokiteshvara in a Multiarmed Tantric Form

Avalokiteshvara, the bodhisattva of infinite compassion and mercy, is the most popular bodhisattva in Buddhist legend, revered throughout all traditions. Avalokiteshvara has many forms in Buddhist iconography depending on the period or geographic location of the artist. The Sun, the Moon, a vajra, and a bell are among the usual twenty-four properties held by an esoteric manifestation of Avalokiteshvara. This stunning gilt bronze sculpture has all of the sacred markings of the bodhisattva's divine iconography. In order to cast the hands holding the many auspicious symbols, the artist would have to have been extraordinarily skilled and a master of metalwork.

11th–12th century, Dali kingdom (938–1253) • China, Yunnan Province • Gilt arsenical bronze

H. 21 × W. 17.8 × D. 11.1 cm

Altarpiece with Buddha Enthroned

Over time, this bronze has formed an attractive green patina and depicts the transcendental Buddha. The broad face and the style of his headdress is typical of Cambodian artistry. Small, easily portable, and pocket-sized bronzes were very popular early Buddhist sculptures; travelling practitioners could use them to meditate with the help of a light portable shrine. This sculpture is on the small side, yet not small enough to be easily portable. Therefore, we can surmise it may have been used as a personal meditational tool rather than for use within a temple. The pointed shape of the shrine in which the Buddha sits is akin to the stupa which is an ancient and sacred form of Buddhist reverence.

———

Mid-12th century • Cambodia, found in Vietnam, near Ho Chi Minh City, Reign of Suryavarman II, Angkor Wat period (1st half of 12th century) • Bronze

H. 21 × W. 17.8 × D. 11.1 cm

TANTRIC AND ESOTERIC BUDDHIST ART 103

Ritual Flaying Knife

This ritual object was presented to a Tibetan patriarch as part of a collection of Tantric Buddhist art crafted in the imperial workshop of the Ming emperor Yongle, who ruled from 1403 to 1425. The half vajra is commonly part of the decorative element of a flaying knife as well as the golden Makara biting down on the base of the blade. Makara is an ancient mythological sea creature from India, said to have the trunk of an elephant, the jaw of a crocodile, and the scales of a fish. The stunning execution of this flaying knife points to the highest echelon of Ming craftmanship. Physical implements were often offered to great gurus by wealthy patrons. Conceptually, the flaying knife can be used in the tantric ceremonies of Vajrayana Buddhism to cut through ignorance.

ca. 1407–1410 • Tibet • Iron alloy with gold and silver inlay
H. 17.4 cm

GANDHARAN SCULPTURE

Head of a Bodhisattva

Gandharan art is believed to integrate the indigenous Buddhist aesthetic with Hellenistic Greek idealism, and this sculpture of a virtuous-looking bodhisattva is the perfect example of this. The way the spiral curls of the bodhisattva have been chiselled along with the shape of the eyes, eyebrows, and cheekbones point to the customary style of Greek and Roman sculpture at the time. When Alexander the Great expanded his kingdom in the fourth century BCE, he brought Hellenistic civilization to Gandhara; Greek influence peaked during the Kushan period (30–375 CE).

301 CE–600 CE, Gandhara • Afghanistan or Pakistan • Stucco with traces of pigment

H. 44.8 × W. 22.2 × D. 25.4 cm

Head of Emaciated Siddhartha

The emaciated Buddha sculptures were created to portray the lofty spiritual state of a bodhisattva on the edge of death, contemplating the meaning of life. This is an iconic image and arguably the most graphic picture of Siddhartha's physical hardship and mental dedication on his path to enlightenment. The Buddha's Middle Path refers to staying away from the extremes of indulgence or self-deprivation. Prior to achieving enlightenment, Siddhartha followed a stringent austerity and a fasting regime that was common among the sramana faiths of the time. According to early Buddhist texts, Siddhartha became so emaciated with five other ascetics that he could hardly stand. The sculptor has reflected with great skill the physiological changes that occur during starvation – veins can be seen protruding through the Buddha's paper-thin skin, and his gaunt and chiselled face is a stark contrast from the usual depictions of the wholesome soft face we are accustomed to.

101 CE–300 CE • Gandhara, Pakistan • Gray schist

H. 15.7 × W. 9 × D. 7.8 cm

Torso of a Bodhisattva

This magnificent and intricately detailed torso was taken from a colossal figure that was 10-feet tall and found at the Sahri-Bahlol monastery in the ancient territory of Gandhara. Deeply inspired by the Greco-Buddhist sculptural heritage, the large scale of this sculpture is incredibly rare as unblemished blocks of schist were hard to find. Local artisans of Gandhara emphasized the ideas of figural naturalism, especially the perfected herculean form which was lofty and abstract but still human enough to inspire the viewer. The representation of the Indian dhoti gave an opportunity to reproduce with awe-inspiring technical skill, meticulous folds of drapery as seen on Greek sculptures showcasing the adept and sophisticated expertise of Gandharan artisans.

Probably Sahri-Bahlol Workshop • ca. 5th century • Pakistan (ancient region of Gandhara, modern Peshawar region) • Schist

H. 163.8 cm

Bust of a Bodhisattva Sakyamuni

A youthful Siddhartha Gautama, also known as Sakyamuni Buddha ('Sage of the Sakyas'), is depicted in this stately and beautifully crafted bust. His features are stylized and rhythmic with a wave-like moustache and a nearly perfect symmetrical face. The Gandharan artisans favoured a refined and honed image and paid a scrupulous attention to detail – the consideration for perfection is apparent here with each jewel of his necklace accounted for.

―――

3rd–4th century • Pakistan (ancient region of Gandhara) • Schist

H. 46.4 × W. 33 × D. 16.5 cm

Monumental Bodhisattva Head

The artisans of Gandhara took a novel Hellenic approach to representing the Buddha and bodhisattvas in Western dress and settings, combining them with narratives of Buddha's teachings. This large-scale head was part of a sculpture believed to be 12-feet tall. Monumental statues of the Buddha were generally commissioned by monasteries, and this could have been one of his attendants. The art of Gandhara has a distinct aesthetic that favours the classic form; this sculpture stands out because of an unusually intimate quality – the defined and striking features look as though they may have been modelled from life or memory rather than traditional Buddhist iconography.

———

5th century • Pakistan (ancient region of Gandhara) • Stucco

H. 50.2 × W. 25.4 × D. 25.4 cm

Adoring Attendant from a Buddhist Shrine

The attendant in this artwork looks upon the Buddha with a charming face filled with character; he is bejewelled and wears a royal robe and ornate diadem. His eyes and hands signal in the direction where the Buddha would have been placed in the original shrine. The hands which are now missing may have been gesturing the *anjali* mudra of greeting and respect. The stucco figure would have originally been painted with rich pigments. Stucco, a concrete-like material consisting of lime and sand, was a popular medium of sculpture in Gandhara.

ca. AD 300s–400s, Kushan period (1st century–320) • Afghanistan, Gandhara • Stucco

H. 54.6 cm

Seated Bodhisattva Maitreya (Buddha of the Future)

Maitreya, who is known as the future Buddha and resides in the Tushita Heaven, is the subject of this extraordinary panel. He has a loop knot in his hair and holds a water flask said to be filled with the nectar of immortality – both being Maitreya's traditional attributes.

This exquisitely carved frieze articulates Maitreya's well-modelled physique and shows some stylistic considerations on the artist's behalf with the clear and graphic carved lines. He is dressed in a dhoti secured at the waist, a finely-pleated silk scarf draped over the upper body and is lavishly adorned with an elaborate suite of jewellery, consisting of a headpiece, torque necklace, armbands, and bracelets. He is princely in appearance, which is customary for bodhisattvas; the rich robes and jewels can be seen to represent his spiritual sovereignty.

———

7th–8th century • Afghanistan (found near Kabul) • Schist

H. 77.8 cm

Head of Buddha

Most probably from the early stucco production from Gandharan sites at Taxila, this head of Buddha exhibits the Greco-Buddhist features of rippling hair, a youthful oval face, a narrow-bridged nose, and large almond eyes framed by a defined brow bone. This region reached its creative heights between the first and fifth centuries and is also known as the 'city of artisans' due to the period's masterful sculpture. The masterpieces found at this location made it one of the most critical archaeological sites in Asia.

———

ca. 4th century • Pakistan (ancient region of Gandhara) • Stucco with traces of paint

H. 18.4 × W. 10.8 × D. 12.1 cm

Crowned Bodhisattva

Mathura, a venerated location of historical pilgrimage, is situated southwest of Delhi and northwest of Agra. The location has spiritual ties with Hinduism, Jainism and Buddhism and is mentioned in a number of Buddhist texts. The sculptural artwork in the Mathura style during the Kushan period is distinguished by the use of speckled red sandstone, a medium used for centuries. A hub for skilled artisans, this region had long been known as a centre of creativity. Archaeological finds show that sculpture and artwork from this region were exported to long distances further securing Mathura's reputation for artistic accomplishment. The smooth chest, jewels, and long cascading hair, as seen in this magnificent bust, is typical iconography of a bodhisattva, unlike the Buddha who is usually rendered with hair tied back and wearing a monk's robe.

———

3rd–early 4th century, Late Kushan dynasty • North India
(Uttar Pradesh, Mathura) • Sandstone

H. 42.5 × W. 33 × D. 16.5 cm

Head of Buddha

Between the third and fifth centuries, there was a boom in the financial support given to Buddhist holy sites and monastic institutions; as a result, the majority of Gandharan architecture was built during this time with an outpouring of accompanied sculpture. Stucco proved to be the material of choice for sculptures after the fourth century in Gandhara. The density of stucco was perfect for sculpting due to its workable nature. Over time, it came to be preferred to schist, possibly because stone was harder to find, and it was particularly scarce in Afghanistan where this sculpture originates. The well-preserved surface and paint traces are indicative of how this head appeared when it was used for worship. The head shows stylistic traits found in Gupta iconography from North India.

———

5th–6th century • Afghanistan (probably Hadda) • Stucco with traces of paint

H. 19.1 × W. 12.1 × D. 11.4 cm

Bust of a Bodhisattva

In the fourth and fifth centuries, Gandhara produced increasingly complex Buddhist sculptures. The size of the head and torso of this fragment means the sculpture, when complete, would have originally stood about six-and-a-half-feet tall. These imposing and stunning sculptures began to flourish in what is now modern-day Pakistan and Afghanistan, which was a hub of commercial trade. Something that differentiates Gandhara sculpture from other Buddhist sculptures of varying styles and periods is the detailed expression of the face. The Gandharan sculptors masterfully communicated the meditative and poised countenance of the Buddha and bodhisattvas expressing a spiritual quality through their defined and serene features. The aesthetic nature of the eyebrows and eyes reflect complete ease and calm with the eyelids so relaxed they are barely open. The bow mouth is tilted in a slight smile, and the hair flows outward in pulsating ripples. These defined and expressive features reflect the reason Gandharan sculpture is instantly so recognizable.

———

ca. 4th–5th century • Pakistan (ancient region of Gandhara) • Schist

H. 34.9 × W. 24.4 × D. 26.7 cm

Head of a Bodhisattva

The emperors of the Kushan period were responsible for commissioning hundreds of monumental sculptures in their realm and this head most likely belonged to an oversized standing or seated bodhisattva figure. Though this sculpture includes a fusion of foreign influences, it remains sternly Indian in its iconography. The bodhisattva's oval face, almond-shaped eyes, bow-shaped mouth, and rippling hair characterize the typical blend of Hellenistic and Indian traditions found in Gandharan sculpture. The specific double-loop hairstyle worn by this bodhisattva is usually an indicator for Maitreya and could be compared with the classical Greco-Roman statue of Apollo Belvedere ca. 120–140 AD at the Vatican Museum.

———

Mid-2nd to early 3rd century, Kushan dynasty • Pakistan • Phyllite

H. 34.9 × W. 24.4 × D. 26.7 cm

Standing Bodhisattva, probably Maitreya (Buddha of the Future)

This sculpture depicts Bodhisattva Maitreya, as evidenced by the elegant robes and jewellery that mark his status as a resident of Nirvana. Maitreya's iconography can be similar and confused with Bodhisattva Sakyamuni, however, the latter is usually depicted as wearing a turban. The right arm of this sculpture, which is broken, would have likely held Maitreya's flask of immortality. An alms bowl can be seen at the base, which points to this sculpture being made during the third century CE as the alms bowl was not shown in later renderings. The relatively small size of this sculpture also reflects the style of this period. Maitreya is the earliest bodhisattva to form a following and venerated by the Theravada school of Buddhism.

ca. 3rd century • Pakistan (ancient region of Gandhara) • Schist
H. 59.1 × W. 23.5 × D. 12.4 cm

Head of Bodhisattva Avalokiteshvara

This angelic head can be identified as the bodhisattva of compassion by the incorporation of a small lotus that would have sat in the centre of the jewelled headpiece. Bodhisattvas are enlightened beings who selflessly stay in the cycle of samsara in order to teach others how to reach buddhahood. Mahayana Buddhists believe everyone has the nature of buddha inside of them and can reach enlightenment by committing to the Dharma. In order to become a bodhisattva, Mahayana Buddhists believe, you must embody the 'Six Perfections' which are generosity, morality, patience, energy, meditation, and wisdom.

AD 300s–400s, Gandhara, late Kushan period •
Afghanistan or Pakistan • Stucco with traces of paint

H. 45.7 × W. 35.5 cm

FACING PAGE

Standing Buddha

Artefacts of Gandharan bronze are a rarity, but this image of Sakyamuni Buddha was the prototype most frequently used in metal. He holds his hand in the reassuring *abhya* mudra, to dispel fear, and the auspicious symbol of a Dharma wheel is inscribed in the centre of his upheld palm. The wheel is an omnipresent symbol used across a number of Indian religions including Jainism and Hinduism. The Dharma wheel, which commemorates the Buddha's first sermon in the forest at Sarnath, where he established Dharma, is the most significant symbol of Buddhism. Unusually, another auspicious symbol is located on his chest and peeks through the robe. Symbols on the chest are more common among Jain and Hindu sculptures than Buddhist. He wears the robes of a monk, and his hairstyle of symmetric circular bands was a fashion common in late Gandharan sculpture.

———

Late 6th century • Pakistan (ancient region of Gandhara) or Afghanistan • Brass

H. 33 × W. 13.3 × D. 5.4 cm

FOLLOWING PAGE LEFT

Garuda Vanquishing the Naga Clan

Garuda is a divine entity and his iconography is always that of a giant bird. Garuda is the majestic hawk-like bird with open wings in the centre of this sculpture. His more traditional form is anthropomorphic, and Garuda often has the chest, arms, and legs of a man. In Buddhist teachings, Garuda, also known as Garula, is golden-winged and nagas are mythical human-like creatures that are half serpent; both are mortal enemies to each other. They are known as two of the Aagatya, the eight kinds of inhuman beings, according to the Buddhist idea of samsara. The subject matter of this sculpture was not a particularly fashionable theme as the Garuda and nagas are often background motifs in Buddhist art. However, the mythical nagas were said to live in Gandhara, and therefore this sculpture is not necessarily unanticipated.

———

ca. 2nd–3rd century • Pakistan (ancient region of Gandhara) • Schist

H. 33.3 × W. 25.1 cm

FOLLOWING PAGE RIGHT

Siddhartha at the Bodhi Tree

This skilfully crafted relief with magnificent depth and detail is one of the finest examples of its kind. The Buddha under a bodhi tree was a particularly popular theme in the second century AD and was often included in friezes of the Buddha. The revered bodhi tree can be identified by its heart-shaped leaves in Buddhist art.

After seven weeks of meditation under a bodhi tree, the Buddha achieved enlightenment, and so the doctrine of Buddhism began. The appearance of this relief integrates aesthetics from the Mediterranean, whereby the Buddha is displayed with a nimbus and wearing a simple robe with no jewellery or embellishments. The Buddha is decidedly larger than the other figures in this type of sculpture to emphasize spiritual hierarchy. This sizeable frieze would have most likely flanked the entrance to a stupa.

———

AD 100s–200s • Pakistan, Gandhara • Schist

H. 73.7 × W. 57.2 cm

Standing Buddha

This beautifully sculpted figure of the Buddha Sakyamuni (the historical Buddha) was sensitively chiselled in schist, a stone typical of Gandharan sculpture. This style of artefact was found in large numbers around what would have been consecrated regions within Gandhara and so may have been intended for monastic worship. The topknot of the Buddha served as a reminder that the Buddha was born into the warrior caste. His hair is styled in a way that looks soft and wavy, and he wears a monk's robe that could reflect a toga, elements that were customary for Gandharan sculpture. The nimbus surrounding the Buddha's head is akin to halos found in ancient art traversing many religions. The nimbus was absorbed into Buddhist iconography by the third century and believed to have been brought to the East from the Greeks.

AD 150–200, Kushan period • Pakistan, Gandhara • Schist

H. 119.7 cm

Standing Bodhisattva Maitreya (Buddha of the Future)

The earliest known anthropomorphic portrayals of the Buddha were found in Mathura and the Gandhara region. The medium used for these sculptures were stucco, clay, terracotta, and the most popular schist as seen here. The majority of Gandharan Buddhist sculpture was produced from the third to the fifth centuries as this was a period of abundant economic growth. The influx of wealth to the area led to the expansion of devotional Buddhist sites. This figure of Bodhisattva Maitreya wears a suit of jewels, regal attire, and jewelled sandals; the materialistic and luxuriant nature of his costume can be seen to reflect his high rebirth.

ca. 3rd century • Pakistan (ancient region of Gandhara) • Schist

H. 80.7 × W. 29.2 × D. 15.2 cm

Head of Buddha Sakyamuni

Despite the majority of Buddhist sculpture being found in Gandhara, more so than the rest of ancient South Asia, our knowledge of the territory's art is still confined by the amateur early excavations. The sculpture we can analyse today was mostly taken by archaeologists in the nineteenth century during the period of British rule. Gandharan sculpture can be dated through a number of considerations, namely the material used and the stages of representation, from the first narrative works to later independent portraits of Buddhas and bodhisattvas. With strong classical features, this bust showcases a distinct Roman nose. Some of the first artefacts from Gandhara attesting to an interaction with Mediterranean culture date to the first century BC.

1-200 CE • Gandharan • Gray schist
H. 28.9 × W. 17.5 × D. 17.8 cm

Head of a Bodhisattva

This masterfully sculpted head of a bodhisattva has a nobel appearance, features of this bust with relaxed almond eyes, an abundance of curls looped in a bun, and *ushnisha* above an aquiline nose follow the prototype of Maitreya in style and iconography. The lavishly jewelled headband shows signs of a worn symbol of the *triratna* in its centre, which makes this bust a rarer representation. The *triratna* visually represents the three jewels of Buddhism: the Buddha, the Dharma, and the Sangha.

3rd–4th century • Pakistan (ancient region of Gandhara) • Schist

H. 27.2 × W. 21.6 × D. 16.5 cm

GANDHARAN SCULPTURE

FACING PAGE

Garland Holder with a Winged Celestial

Stupas were frequently decorated with garland holders such as these. These volutes were used to hold a festoon of flowers that were often strung across the drums of miniature stupas. These figures are among the earliest known examples of Buddhist sculpture found in the first century. Gandharan sculpture tends to be limited in medium and can be categorized generally by the use of either schist or stucco. Schist sculptures can usually date the object as being earlier and it was widely used until the third century CE, after which stucco started to take over as a medium.

———

Mid-1st century • Pakistan (ancient region of Gandhara) • Schist

H. 24.9 cm

FOLLOWING PAGE LEFT

Head of the Fasting Siddhartha

In Gandharan sculpture, we find many depictions of the Buddha, Siddhartha, and Maitreya. The emaciated Buddha image is a rare and particularly moving subject. The physical suffering illustrated by the emaciated body affirms the power of the human will to overcome hardship and affliction. This delicately carved sculpture represents the head of a fasting Siddhartha and can be interpreted to represent the strict asceticism imposed at the time by Brahmanic gurus before the Buddha renounced the practices. Other scholars interpret the image as a portrayal of the Buddha after his enlightenment – fasting – as he was engrossed in seven weeks of uninterrupted meditation. Informed by Greco-Roman aesthetics, the sculptor's desire for realism is conveyed by the gaunt and chiselled face. The treatment of Buddha's hair in this image is distinctive, with loose, rippling hair emerging from the centre of his hairline to above the high-domed *ushnisha*.

———

ca. 3rd–5th century • Pakistan (ancient region of Gandhara) • Schist

H. 13.3 × W. 8.6 × D. 8.3 cm

FOLLOWING PAGE RIGHT

Fasting Buddha Sakyamuni

This sculpture is particularly harrowing as it reveals the brawny tendons and veins stretched over the Buddha's skeletal figure while he sits in meditation on the verge of death. The pedestal on which he is seated features the Buddha's first sermon at Sarnath. The scriptures of Theravada Buddhism, known as the 'Pali Canon', describe how Buddha addressed five ascetics who had been his companions in his first sermon. After hearing the Four Noble Truths, which summarize his core teachings, the ascetics converted to Buddhism.

———

3rd–5th century, Kushan period • Pakistan (ancient region of Gandhara) • Schist

H. 27.8 cm

130 BUDDHISM: A JOURNEY THROUGH ART

FACING PAGE

Head of an Adorant

One of the most spectacular and effective examples of cross-cultural artistic innovation in history is Graeco-Buddhism. The hybrid of East and West influenced art and architecture, dominating the creative expression of Buddhist art, where we find parallels of characters from Greek mythology and the conventional Greek fashions with Buddhist sculpture. The present head of an adorant serves as an example of this. With rapturous curls in a knot upon the head, lightly curved brows, and slightly pursed lips, the serene demeanour is enhanced by the remarkable realism of the physical features.

———

201 CE–500 CE • Afghanistan or Pakistan (Ancient region of Gandhara) • Stucco

H. 24.1 × W. 16.8 × D. 18.2 cm

Head of a Buddha

The beautifully idealized features of this sculpture were crafted by a mould with the hair modelled by hand. Many such moulds were unearthed around Gandharan sacred sites leading scholars to believe that the sculptures were created on the temple grounds that employed them.

———

4th century, Kidarite dynasty, 320–467 AD • Gandharan • Stucco with traces of pigment

H. 45.7 × W. 29.2 × D. 26.7 cm; WT: 39 lbs. 6 oz. (17.9 kg)

The Dream of Queen Maya (the Buddha's Conception)

A beautiful scene of Maya, the historical Buddha's mother, at the point of the Buddha's conception. She sleeps on a bed swathed in embroidered textiles, surrounded by attendants wearing fine robes and jewellery, marking the queen's noble lineage. To her left, a female guard (yavanī) holds a sword protectively by her bedside. The disk above Maya depicted an elephant motif signalling to her prophetic dream in which a sacred six-tusked elephant entered her womb through her right side. This dream was interpreted to mean that she had conceived a child who would become either a worldly ruler or a buddha.

Decorative tablets which are sculpted on one side are called friezes. These narrative scenes were employed to embellish monastic buildings, stupas, or ornamentation. The elaborately carved tales illustrated pivotal moments of the historical Buddha's life which were largely transmitted orally or visually to the mostly illiterate population of the time.

———

ca. 2nd century, Kushan period • Pakistan (ancient region of Gandhara) • Schist

H. 16.5 x W. 19.4 x D. 4.8 cm

Rondel with Goddess Hariti

Hariti is one of the twenty-four protective deities of Mahayana Buddhism. This is one of the oldest known artefacts featuring her iconography which has affinities with foreign goddesses known in Gandhara as well as the Hellenistic goddess, Tyche. Hariti is a protector of children and can be depicted with up to five children in art; sometimes, she is also depicted with her consort Panchika. There are a few stories of the origin of Hariti; historically the word 'Hari' meant to 'steal' or 'remove' in Hindu and Vedic mythology. One story is that Hariti was a kidnapper of children causing much distress in her wake. However, she was transformed into a righteous protector by the Buddha himself and became a much-worshipped and revered goddess. As Buddhism spread, Hariti and her companion Panchika gained widespread veneration across the whole of Asia.

ca. 1st century • Pakistan (ancient region of Gandhara) • Silver with gold foil

D. 8.9 cm

Buddha with Radiate Halo and Mandorla

Sculptures like these were commonly created for personal veneration and inexpensive to produce and accessible to all. However, this example made in brass would have most likely belonged to a senior monk. The way the nimbus is formed with its distinct pattern of solar rays is comparable with sixth-century Gupta-period Buddhas of North India. The halo, when depicted as rays of light, is understood to have pagan origins and was believed to possibly have been inspired by the ancient Greek sun god, Helios.

———

6th century • Pakistan (ancient region of Gandhara) • Brass

H. 29.2 × W. 14 cm

Seated Buddha

This rare and stunning bronze sculpture from Gandhara is believed to be one of the first iconic depictions of Sakyamuni and leans towards Greco-Roman classicism more than any other early surviving Buddha artefact. The hair, which is parted from the centre of the forehead, reflects the Roman style of portraits as well as the meticulous drapery of the robe in the form of a traditional Roman toga. This sculpture would have been produced using the lost-wax method which was prevalent for the time. The figure is seated in a meditative position with his right hand in *abhaya* mudra. The circular lotus flower in the centre of the hands and feet represents the three jewels (*triratna*), which symbolize the Buddha, the Dharma, and the Sangha. This bronze would have been painted and gilded as evidenced by traces of gold in the robe and halo.

1st to mid-2nd century • Pakistan (ancient region of Gandhara) • Bronze with traces of gold leaf

H. 16.8 × W. 11.4 × D. 10.2 cm

DEPICTIONS
OF BUDDHA

Birth of the Buddha

The woodblock print has long played an iconic role in the history of Japanese art. This print of the birth of Buddha was created during the Edo period, arguably the greatest era for woodblock printing. The central figure here is an infant Buddha who stands upon a lotus flower, his mother (Maha Maya) is seen reaching up to grasp a tree branch. According to Buddhist legend, Maha Maya travelled to the Lumbini grove outside of Kapilavastu where the newborn Buddha miraculously emerged from beneath her right arm as she stood upright and grasped the branch of a sal tree. A dream Maha Maya had before conception expressed this good omen, in which a white elephant with six tusks passed through her right side – this was believed to imply a prophecy that she would give birth to either a global ruler or a spiritual leader. Seven days after his birth, Maha Maya died and was reborn in the Tavatimsa Heaven.

1705–1715, Hanegawa Chincho • Japan • Hand-coloured woodblock print; vertical o-oban, tan-e

H. 50.8 × W. 27.1 cm

Drum Panel with Great Departure and Temptation of the Buddha Scenes

Cylindrical drums were often embellished with narrative panels of the Buddha's life as the practitioner would have to walk clockwise to follow and contemplate the carved narration and this act in turn served as a meditative ritual. The drum panel in this image features two important Buddhist scenes. Atop is the trial of Buddha fighting Mara and his demon army. Mara is infamous for his role in trying to destroy the Buddha's resolve during his journey to enlightenment. In this relief, Mara's army is riding an elephant and storming upon the Buddha who remains in a meditative posture. Below, marks the story of Siddhartha fleeing from his father's palace and renouncing royal life in order to pursue his destiny as a spiritual leader. The Buddha sits upon a horse whose hooves are being guided by mythological beings called *yakshas*, who ensure the guards won't hear them flee.

First half of the 3rd century, Ikshvaku period • India (Andhra Pradesh, Nagarjunakonda) • Limestone

H. 144.2 × W. 92.1 × D. 15.2 cm; WT. 854.3 lbs (387.5 kg)

Head of a Buddha

The fine features of this bust remain impressive despite damage. The plump and youthful face of this stunning sculpture is masterfully carved in a style typical of the pre-Angkor period. Angkor Borei was an essential centre of Buddhism and served as an important archaeological site in Cambodia, although many artefacts were lost. Thankfully, the good array of sculptures that survived give us an indication of the techniques and mastery of the sculptors of this period.

———

7th century, pre-Angkor period • Southern Cambodia • Sandstone

H. 61 × W. 33 × D. 32.4

Buddha Offering Protection

This sculpture of the Buddha was created during the Gupta period, known as the golden age of art in North India. This is when Indian medieval art started to shift to a more refined and graceful style. At this time, the production of Buddha figures expanded and were often rendered in large scale. The webbed hands of this expertly cast metal Buddha – thought to be one of the auspscious markings of the Buddha – instantly draw the eye and are an indicative feature of sculpture from the period. Some Buddhist scholars, such as Bhikkhu Anālayo, have noted that the webbed hands are remarkably advantageous to sculptors since the fingers are the most susceptible to damage, therefore perhaps this auspicious marking was, in fact, initiated and spread by the artists themselves. The casting of this sculpture is exceptional and according to museum records, the figure had been cast horizontally with the assistance of ingenious internal gates which channelled the molten copper alloy from the back to the front. Interestingly, some gateways specifically led to the draperies in the robe which would have been particularly difficult to cast.

———

Late 6th–early 7th century, Gupta period • India (probably Bihar) • Copper alloy

H. 47 × W. 15.6 × D. 14.3 cm

Head of a Buddha

The aesthetic of this bust is a classic example of sculpture created in northeast China, around the sixth century. Northern Qi is an indirect version of the Indian Gupta style, which was transferred to China via Central Asian trading routes. The Buddha, here, is in a state of meditation with his eyes characteristically relaxed and almost closed; he has a short and rounded nose with dramatic bow-shaped lips.

———

Mid-6th century, Northern Qi dynasty (550–577) • China • Limestone with traces of pigment and gilding

H. 24.1 × W. 15.9 × D. 16.5 cm

Seated Shaka

This elegant yet robust sculpture of the Buddha was carved during the Heian period when wood was the favoured medium for sculpture in Japan. This artwork is an excellent example of the customary method of carving a single piece of tree trunk. The later Kamakura period saw sculptors use a technique using several pieces of wood, which in turn allowed for more elaborate forms and details.

———

ca. 10th century • Japan • Wood with lacquer and traces of colour

H. 57.2 × W. 38.1 cm

Crowned Buddha

This is an exceptional sculpture of the Buddha. He stands on a double lotus pedestal and is surrounded by an aureole with flaming finials. He is in the posture of *tribangha* and clothed in a plain robe whilst wearing a suite of lavish jewellery which perhaps evoke his time as a prince on Earth or the majesty of the Buddha in Heaven. The tasselled cape reflects Central Asian influence on Kashmiri Buddhist art of this period. His right hand is raised in the mudra of reassurance and he holds the folds of his *sanghati*, the outer robe, in his left. The towering crown and floral flourishes are familiar Kashmir iconography.

9th century • India, Ancient kingdom of Kashmir • Brass

H. 51.8 × W. 22.9 × D. 7.6 cm

Standing Buddha

The energy conveyed in the Buddha's form as well as the countenance of the face makes this piece unequivocally a masterpiece of Buddhist art. This rare ninth-century sculpture from Kashmir is unusually large for metal work. The robe of the Buddha is at one with his body and the pleats ripple like liquid across his torso creating an ethereal appearance. The hem of the robe is bordered with well-expressed folds distinctive of the eastern Indian Pala style. The Buddha stands upon a lotus, the auspicious symbol of purity, whilst gazing towards the viewer and gesturing the *abhaya* mudra for protection. The Tibetan inscription on the pedestal identifies the owner of this sculpture as Nagaraja (ca. 988–1026), a royal monk from western Tibet, who was instrumental in the revival of Buddhism in this region.

ca. 10th century • India, Ancient kingdom of Kashmir • Brass with silver and copper inlay

H. 98.1 cm; BASE: 28.2 cm

Right Hand of Buddha

This hand represents one of the earliest mudras found depicted on a number of Hindu, Buddhist, Jain, and Sikh images – the *abhaya* mudra. *Abhaya* in Sanskrit means fearlessness, and thus this is the gesture of reassurance and safety. Made with the right hand raised, the palm of the hand facing outward, and the fingers upright and joined.

Mudras, literally translating to 'seal' or 'sign' in Sanskrit, play an important role in Buddhist faith and iconography. There is a huge variation of mudras within Buddhism to assist the physical, emotional, or spiritual well-being of the practitioner. The *abhaya* mudra seen in this example is arguably the most popular within Buddhist art.

ca. 550–560, Northern Qi dynasty (550–577) • China (Northern Xiangtangshan, North Cave) • Limestone with pigment and gilding

H. 52.1 × W. 38.1 × D. 50.8 cm

DEPICTIONS OF BUDDHA 149

Hand of Buddha

Many Buddhist-inspired arts flourished throughout the Nara period (Tempyo period), an era when Buddhism, in the form of the ritsuryo official religion, had a political and cultural influence in Japan. This beautifully crafted hand of Buddha is gesturing the *shuni* mudra, also known as the seal of patience. In Sanskrit, *shuni* means Saturn, the planet known for governing discipline. While the middle finger symbolizes responsibility, the thumb represents divine fire, and when joined, they manifest patience and compassion within the practitioner.

Late 8th century, Nara period • Japan • Wood

H. 40 cm

Buddha Sakyamuni

This beautiful limestone relic is from a region in Andhra Pradesh, a major Buddhist pilgrimage site and academic centre in Southern India, confirmed by the numerous ruins of monasteries and artefacts found there. Although limestone is a durable medium for sculpture, it can be highly reactive when exposed to the elements, particularly rain water. The weathering of this third-century sculpture has created an obscure abstraction of the Buddha. This organic degradation has pointedly captured the Buddha's divine nature and ability to persist through the ravages of time.

———

Late 3rd century • India, Andhra Pradesh • Limestone

H. 60.96 × W. 16.51 × D. 8.89 cm

DEPICTIONS OF BUDDHA 151

Buddha

Several princes and queens contributed to the construction of Buddhist shrines in the Kingdom of Ikshvaku, where Buddhism flourished. Here, the Buddha is portrayed in his usual stance as 'universal ruler' made from limestone, which was very usual for sculpture in Southern India at this time. His idealized body represents his stature as a stately spiritual leader. The drapery of his robe, despite having no other context, instantly brings to mind a figure of divinity. The robe depicted in this way, which probably originated with Greek sculpture, has become the symbol of a religious leader or god throughout history.

———

3rd century A.D, Ikshvaku period (ca. 225–320) • South India (ancient Andhradesa, probably Nagarjunakonda) • Limestone

H. 76.2 × W. 27.9 × D. 11.4 cm; WT. 111.3 lbs (50.5 kg)

Standing Buddha

The Mon-Dvaravati period had a rather standard style of depicting the Buddha. The robe, for example, is without pleats and has a unique and almost abstract way of flaring outwards as a seamless extension of the body. The face has an expression of gentle introspection and the hands are elevated in the *vitarka* mudra (a teaching gesture), which was frequent in the Mon Buddhist Dvaravati kingdom. The Dvaravati culture had an early economic and artistic association with India and were motivated and inspired to incorporate and spread the design of the Indian art styles.

8th–9th century, Mon-Dvaravati period • Thailand (Nakhon Pathom Province) • Bronze with traces of gilt

H. 68.6 × W. 26 × D. 13.7 cm

Buddha, Probably Amitabha

In the early Tang period, the dry lacquer technique was much in vogue but despite its popularity, very few sculptures of this medium exist today. This example of the Amitabha Buddha is an important and rare one. The craft was believed to have been developed to give strength to the sculpture. Asian resin is produced from tree sap and very durable although, when added to cloth, has a suitable modelling ability. However, this method was expensive and time-consuming. First, a wooden core was covered in clay, then layers of cloth immersed in lacquer were applied, slowly over time, to form the sculpture.

Having amassed supreme merit as a bodhisattva named Dharmakara through countless previous births, Dharmakara became the Buddha Amitabha residing in the Western Paradise. Amitabha is an important and venerated Buddha in the Mahayana school, particularly in the Pure Land sect. Practitioners believe rebirth in Amitabha's paradise is possible through devotion and reciting his name.

Early 7th century, Tang dynasty (618–907) • China • Dry lacquer with polychrome pigment and gilding
H. 96.5 × W. 68.6 × D. 57.1 cm

Seated Buddha

Seated in the lotus position, with both hands in a *dhyana* mudra, is the Sakyamuni Buddha. His robes drape elegantly whilst a dhoti is secured at the waist. Carved from the highly prized jade, he is illuminated with a beautiful green polish. One of the most precious stones in ancient China, it was considered to personify admirable qualities. The term for jade, pronounced 'yu' is frequently used in Chinese idioms and proverbs to refer to beautiful things or people. Between the late seventeenth and early eighteenth centuries, China exercised direct sovereignty over the jade-producing regions of Central Asia, including Hotan and Yarkand. As a result, an abundance of beautiful nephrite was sent to Beijing for carving during this period. Jadeite from Myanmar (earlier Burma) began to make its way into the city around the middle of the eighteenth century.

―――

18th century, Qing dynasty (1644–1911) • China • Jade (nephrite)

H. 13.5 × W. 9.5 × D. 7 cm

Naga-enthroned Buddha

This sculpture depicts a popular image of the Buddha being sheltered by Muchalinda, the king of the nagas who assumes the form of a serpent. A torrential downpour occurred for seven days whilst Siddhartha Gautama meditated under the bodhi tree before his enlightenment. Muchalinda shielded the Buddha from the elements by curling his snake tail into a chair and sheltering the Buddha with a protective cobra-like hood flare. Once the storm passed, Muchalinda transformed into a human form and bowed to the Buddha.

This tale was often illustrated in sculpture under the reign of King Jayavarman VII who made Buddhism the official state religion over Hinduism. There is some speculation as to why the king chose to adopt and propagate this image of the Buddha above others. The snake can be seen to symbolize water, on which the kingdom depended, snakes can also represent healing – and building hospitals was one of Jayavarman's many legacies.

12th century • Cambodia (Angkor, Angkor Wat) • Bronze

H. 58.4 × W. 28 cm

Standing Buddha Offering Protection

Gupta-style carving has several identifying attributes, especially for representations of the Buddha. This spectacular red sandstone sculpture is an excellent example of Gupta craftsmanship. A radiating Buddha, stands with a now missing right arm and hand which would have gestured the *abhaya* mudra of protection. The body, which is soft and graceful, can be seen under the fine drapery strings of his sheer robe – a prominent characteristic of Buddha sculptures of the era. Other features include the exquisite nimbus, which frames the Buddha's head and is patterned with ornamentation and floral motives. His plump, oval face with purposeful expression, long stretched earlobes that represent his former princely status, full lips, and lined neck, are also prevalent iconography of the Buddha.

———

Late 5th century, Gupta period (4th–6th century) • India (Uttar Pradesh, Mathura) • Red sandstone

H. 85.5 × W. 42.5 × D. 16.5 cm

DEPICTIONS OF BUDDHA 157

Meditating Buddha with Alms Bowl Enthroned in a Foliated Niche

This stone panel is likely a depiction of one of the medicine or healing Buddhas, Bhaisajyaguru, believed to be able to cure ailments by the mere touch of his image. The Buddha meditates inside walls that are guarded by the monstrous-looking Kirtimukha on the very top of this frieze. In Tibetan art, the Kirtimukha is commonly represented as a beastly face without a lower jaw with a string of jewels descending from the upper jaw. A guardian of the doorway, Kirtimukha can be found on the panels of temple walls or pillars. This relief served as a false window antefix from a Pala-period Buddhist monument.

———

ca. late 10th–early 11th century, Pala period • India (Bihar) • Stone

H. 43 cm

Head of Buddha

This fine cast-iron sculpture from the Ming dynasty pays testament to the exceptional metal craftsmanship of the time. The period is distinguished by the Buddha's straight hairline, large heavily-lidded eyes, and soft full face. The *ushnisha*, or cranial extension, is one of the Buddha's thirty-two physical attributes and a symbol of his limitless wisdom. These attributes also include his plump cheeks and the dot on his forehead (*urna*). The artist has shown considerable attention to the ears which protrude outwards to frame the face. The Buddha's large ears are a reminder of the renunciation of his past as a prince when his ears were once weighed down by fine jewellery. The size of his ears can also be seen to reflect on his infinite ability to listen with compassion.

ca. 16th century, Ming dynasty (1368–1644) • China • Cast iron

H. 74.9 × W. 114.3 × D. 69.9 cm

Head of a Buddha

The head of this Buddha is made from porous volcanic rock, skilfully carved into characteristically poised Javanese features. The design of this sculpture parallels the Buddha models found at the Borobudur temple in Central Java, which were endorsed by the Sailendra dynasty in the early ninth century. By Indonesian academic standards, this example was seen as the optimal portrayal of the Buddha. Sculptures from this period can be seen to have a uniform style. However, variations such as the broadness of the face, curls of the hair, and *urna* or lack thereof, can show subtle diversity.

9th century, Central Javanese period • Indonesia (Java) • Andesite

H. 34 × W. 25 cm

Head of Buddha

The northern Qi dynasty was a time of complete artistic innovation. Some scholars believe this was one of the most critical cultural periods of Chinese history. Buddhism was still an enduring inspiration on the arts, and this remarkable head of the Buddha displays the skill of the age and the swift progression of sculptural style from the northern Wei. The Buddha here has a pronounced *urna* between his eyebrows representing the third eye and tight spiral curls that reflect the time he cut off his hair as a young prince.

———

ca. 570, Northern Qi dynasty • China, Hebei province, northern Xiangtangshan caves, South cave • Limestone

H. 62.2 × W. 54.6 cm

Hoofd van Boeddha

Reijer Stolk was born in Java, and his parents migrated to the Netherlands when he was very young. Not a very commercially minded artist, Stolk didn't exhibit often and usually only printed limited runs of his work and so was somewhat obscure during his time. Despite this, exhibits in the Rijksmuseum in Amsterdam and the RKD in The Hague have secured his legacy as an artist. This print of the Buddha proves today to be one of the most popular and commercially graphic images from Stolk's archives.

———

By Reijer Stolk • 1943 • Netherlands • Paper

H. 32.1 cm × W. 24.5 cm

Head of a Buddha

This superbly sculptured head of Buddha was from the Southern Xiangtangshan Buddhist cave temples, which were funded by the imperial court and aristocracy of Northern Qi. These caves were cut into the mountains of northern China and were the greatest artistic achievement of the Northern Qi dynasty of the sixth century, once home to a spectacular collection of sculptures, including enormous Buddha figures. The limestone caves were badly damaged in the first part of the twentieth century, when the contents were raided and sold widely in the global art market.

ca. 565–75, Northern Qi dynasty (550–577) • China (Southern Xiangtangshan) • Limestone with pigment

H. 39.4 × W. 25.4 × D. 30.5 cm

Buddha

This magnificent and youthful Buddha is a remarkable example of Buddhist sculpture from the Mon-Dvaravati school. Influenced by Indian antecedents in features which are blended with typically Mon characteristics of a broad face and notably intertwined, arching eyebrows, the Dvaravati's artisans and patrons based the features of the Buddha on the local population. By tightly clinging to the body, the monastic robes highlight the purity and flow of form influenced by the Sarnath tradition.

———

7th century • Thailand • Sandstone
H. 132.7 cm; without tang: H. 114.2 cm

Buddha Sakyamuni Seated in Meditation (*Dhyana* mudra)

This spectacular large-scale Indian sculpture holds pride of place in the Art Institute of Chicago's Alsdorf Galleries. The largest Buddha in the mainland United States and a highlight from the museum's entire collection, this sculpture was chiselled from granite, which is the hardest natural stone – justifying the skill of the artisan and rarity of the sculpture. Madhuvanti Ghose, the Alsdorf Associate Curator of Indian Art, makes the interesting observation of the Buddha's auspicious long ears. Although it is popularly believed the Buddha's large ears and elongated earlobes represent the heavy jewellery he wore as a prince before Buddhahood, Ghose notes that they could also be seen to represent the white elephant his mother saw in a dream before his birth.

ca. 12th century, Chola period (ca. 855–1279) • India, Tamil Nadu (near Nagapattinam) • Granite

H. 160 × W. 120.2 × D. 56.3 cm

Seated Amitayus Buddha

This monumental marble statue of the Buddha Amitayus is one of the most stunning and rare examples of Northern Qi dynasty sculpture. During the renovation work, the Cleveland Museum of Art noted modifications made prior to the museum's acquisition. The eyes of the Buddha had been carved to look bigger than the original, and new painted irises had been added. Although aesthetic restoration can prove to be a disaster for most artefacts, the eyes of this work, despite adaptation, are incredibly poignant and beautiful. The double lotus pedestal the Buddha Amitayus sits upon is sculpted in the ornate design, characteristic of early Tang sculpture.

ca. 570s • China, Northern Qi dynasty (550–577) • Marble

H. 110 × W. 66.1 cm

Head of Buddha

The features of this head of Buddha points to this artefact originating from China. Buddha's appearance at this time period was quite similar to that of his Indian Gupta ancestors. He had meditative eyes that were barely open, cupid bow lips, and dramatically arched brows. As with Gupta prototypes, snail-shell curls cover the head and the *ushnisha* became an extension of the skull, rather than a protuberance. Stone as a medium of sculpture was widely employed in Chinese art.

500–600 CE • China • Stone

H. 40.6 × W. 25.4 × D. 32.7 cm

Head of Buddha Sakyamuni

This Buddhist sculpture has a very distinct style and is instantly recognizable as being from Thailand due to the limited artistic perimeters the artisans worked within. The monarchy of Thailand being the main patrons of Buddhist art maintained that the sculpture of the Buddha should be in the manner of the earliest archetypes, believing these depictions to be the purest. Features attesting to this style are shown in this head of the Buddha which dates from the early Ayutthaya period. This head would have originally been a part of a sitting or standing large-scale sculpture. Exquisitely cast with an oval face and tranquil appearance, the lips are gently upturned in a smile. Heavy lidded eyes sit under the curved brow which moves directly into the single line of his nose. The long ears are slender and pointed at both ends and his hair is tightly curled around a heart-shaped hairline.

15th–16th century • Thailand • Bronze with traces of gilt

H. 39.4 × W. 25.4 × D. 22.9 cm

Head of a Bodhisattva

Incredibly, this fragment of a mural on mud plaster has remained preserved just enough for us to see the beautifully painted face of a bodhisattva. Some pigments have endured the degradation giving us a glimpse into how it may have looked in the sixth century. The facial features of the bodhisattva can still be seen in detail – the arching brows, meditative eyes, and long nose leading to rosebud lips and a small plump chin are archetypal attributes of the figures painted in the Kizil Kingdom cave dwellings.

———

ca. 6th–7th century, Kizil kingdom • China (Xinjiang Uyghur Autonomous Region) • Pigments on mud plaster

H. 13 × W. 13.3 cm

Seated Buddha

The Buddha has many forms depending on the date and culture of the work, but this beautiful cast iron sculpture is the quintessential image. This is the form that would be found in a tourist shop of souvenirs, as even if a person had not the slightest notion of Buddhism, they would not fail to recognize this iconic representation. Perhaps the most prevailing features of the Buddha in a generalized sense would be his unusual ball-shaped tapered hair, large elongated ears, plump wide face, meditative eyes, and an *urna* between his eyebrows. This sculpture was made during the reign of the Goryeo dynasty, a time of profound Buddhist devotion. Goryeo was a Buddhist state with large Buddhist temples and monasteries. A large amount of its resources went toward practising Buddhism and making ritual tools and works of art.

918–1392, Goryeo dynasty • Korea • Cast iron

H. 64.14 × W. 50.8 × D. 38.1 cm

Buddha

This sculpture is a prime example of Buddha imagery from the Kandyan period. The representation of Buddha figures wearing robes with pleats went through something of a renaissance in the late eighteenth and early nineteenth centuries. During this time period, the pleats were drawn in a more rhythmic zigzag pattern. Beginning in the seventh century and continuing beyond, the majority of metal figurines were made with a flame finial, known as a *sirispata*, affixed to the *ushnisha*.

18th century, Kandyan period • Sri Lanka, Kandy district • Copper alloy with gilding

H. 59.4 × W. 22 cm

DEPICTIONS OF BUDDHA 171

Plaque with the Image of Amitabha Triad

A new cultural age referred to as the United Silla period began after the Paekche in 660 and the Koguryo kingdoms in 668 were conquered by the Silla-Tang alliance. Buddhism flourished in this period, and the United Silla era was regarded as the golden age of Korean art. The artists of United Silla were exceptional metalworkers as exemplified by this exquisite copper alloy panel featuring Amitabha Buddha with two attendants.

Eastern craftsmen knew that copper alloy was durable and easy to work with for engraving and used a technique of gently hammering the metal from behind to create a relief. Bronze too was a popular metal in this period but copper, which is comparably flexible and malleable, was often used for ornamentation.

———

676–935, Unified Silla • Korea • Embossed copper plate covered with gold leaf

H. 11.5 × W. 11 cm

Veneration of the Buddha as a Fiery Pillar

One of the anicons of Buddha was a blazing pillar adorned with symbols such as the lotus and the *trishula*. The burning pillars of Buddhism are a remnant of the Vedic notion, in which *agni* or 'fire' is portrayed as the cosmos' axis and as a pillar extending between Earth and Heaven.

The blazing pillar represents the Buddha's presence, which is hailed by celestial beings as they dance around it. At the top of the pillar (here, the bottom of this fragment), we see the combining of a lotus flower and a *trishula*-shaped symbol, which is often used to indicate the presence of Buddha. In early India, the *trishula* symbol, which can be seen to represent the three jewels of Buddhism, was found on the sole of artistic renditions of the footprints that were the very first aniconic representation of the Buddha.

AD late 100s–200s • Satavahana Southern India, Andhra Pradesh, Amaravati • Limestone

H. 59 cm

DEPICTIONS OF BUDDHA 173

Head of a Buddha

The Buddha's idealized features contrast with a humanistic softness and the snail-shell curls of the hair are more naive and abstract than is often seen in other cultures; this spiral rendering of the hair was typical of Gupta style. Gupta art at this time focused on the portrayal of the individual Buddha and bodhisattvas as marks of reverence, whereas previously, it was more traditional to sculpt narrative panels of the Buddha's life. The standout feature of this particular figure would be the beautiful red stone which had been used as the medium for carving. This particular type of mottled red sandstone can identify the sculpture as being from the Mathura school.

Late 5th–early 6th century, Late Gupta period • India (Uttar Pradesh, Mathura) • Red sandstone

H. 25.4 × W. 14.3 × D. 16.5 cm

Amitabha Buddha's Assembly in the Western Paradise

The Joseon dynasty cultivated a unique Korean artistic style and leaned mostly on their own sense of culture for their creative craftsmanship albeit having some imported Chinese art for inspiration. Buddhist art remained a continuing component despite the rigid rule of the Neo-Confucian philosophy at the time. The monarchy still sponsored Buddhist art privately and via the court and in later years were able to successfully lift the sanctioned ban on Buddhist worship. In this image, we see Amitabha, also known as the Buddha of Infinite Light. Worship of Amitabha is believed to lead to reincarnation in his Western Pure Land which we see illustrated here in this preliminary ink sketch which would have been pasted behind a semi-transparent silk ready for painting. Underdrawings such as this are exceedingly rare and preserve an important insight into Joseon Buddhist painting techniques.

―――――

Late 18th–early 19th century, Joseon dynasty (1392–1910) • Korea • Ink and traces of colour on paper

H. 151.1 × W. 151.1 cm

Enthroned Buddha Granting Boons

This seated Buddha sculpture is from the Gilgit kingdom around the fifth century when Buddhism was flourishing in the region. This example is of the highest quality of craftsmanship as it was commissioned by royalty. The inscription on the pedestal confirms it was commissioned by Queen Mangalahamsika, the senior queen of King Vajradityanandi (reigned ca. 600). Making this sculpture rarer still is the fact that it is one of three of the oldest datable sculptures related to the monarchy of Gilgit. The Buddha wearing a robe that spans over both shoulders was common to Buddhist sculpture in Gilgit as was the throne of lions the Buddha sits upon. Both lions have a characteristically parted mane.

Dated by inscription to ca. 600, Patola Shahi period • Pakistan (Gilgit Kingdom) • Gilt brass with silver and copper inlay

H. 24.4 × W. 15.2 × D. 8.9 cm

DEPICTIONS OF BUDDHA 177

FACING PAGE

Niche with the Seated Bodhisattva Sakyamuni Flanked by Devotees and an Elephant

This architectural frieze portrays a meditative Sakyamuni with crossed hands and legs within a curved arch which is distinctly Indian in design. This narrative style relief shows an affinity with classical Roman sculpture with the figures exhibiting quintessential realism. As classical sculpture had been part of the region's history since Alexander the Great's movement in the fourth century BC, it is somewhat unusual to see such a close interpretation at this time.

The leading figure in the centre can be identified as Sakyamuni, judging from his jewelled turban and princely appearance. He is in a state of meditative bliss whilst flanked by devotees who bask in his enlightenment. The revered elephant kneels to his side – this could possibly be a nod to the tamed wild elephant, most probably a metaphor for the undisciplined mind which can be balanced with meditation.

———

ca. 4th–5th century • Afghanistan (Hadda) • Stucco

SHEET: H. 42 × W. 46.4 cm × D. 25.4 cm

FOLLOWING PAGE LEFT

Intelligence was Mine! I Became the Buddha, Plate 12 of 2

Odilon Redon (1840–1916) was a French painter, draughtsman, pastelist, and printer. Early in his career, both before and after his participation in the Franco-Prussian War, he nearly exclusively used charcoal and lithography to create noirs. His illustrations initially received widespread recognition in 1884, when they were cited in Joris-Karl Huysmans' novel *Against Nature* (Rebours), which was released the same year. His work demonstrates his profound fascination with the Buddhist and Hindu religious and cultural traditions.

———

By Odilon Redon • 1896 • France • Lithograph in black-on-light grey China paper laid down on ivory-wove paper

SHEET: H. 31.5 × W. 21.5 cm

FOLLOWING PAGE RIGHT

The Buddha

Odilon Redon produced close to 30 etchings and 200 lithographs during his lifetime, nearly exclusively in black and white. His reputation developed in part because his prints were readily available. This image of the Buddha perfectly demonstrates why Redon was considered a forefather of surrealism. The Buddha sits in darkness with light waves refracting from his figure mirroring the corneal and pupil of the eye – perhaps evoking the mind's eye. His deep-rooted fascination with philosophy and Japanese art inspired a number of 'dream-like' lithographs.

———

By Odilon Redon • 1895 • France • Lithograph in black-on-cream China paper laid down on ivory-wove paper

SHEET: H. 31.5 × W. 21.5 cm

l'Intelligence fut à moi! Je devins le Buddha

Head of Buddha

The Goryeo artists were famed for their Buddhist metalwork, and Buddhist art flourished under substantial patronage from the aristocracy. Goryeo being an affluent trading point as well as Buddhism being the state religion led to what is known as 'the golden age of Buddhism', where Buddhism enjoyed a cultural peak. The gold lacquer has remarkably still remained mostly intact on this exceptional Buddha head, and the expression and smile is of particular sweetness and compassion. Sculptures of the Buddha are often gilded expressing the theory that the Buddha himself had brilliant golden skin.

———

10th century, Goryeo period • Korea • Gilt bronze

H. 8.6 cm

Buddha Maitreya (Mile) Altarpiece

This elaborate sculpture features Maitreya who is gesturing the mudra of boon-granting in the centre. An intricately patterned nimbus surrounds his head, and the ornate detailing expands into a fiery aureole which is encircled by celestial musicians. The gilt bronze gives a luminous and divine quality to the sculpture. He looks to be descending, which corresponds with Maitreya, the Buddha of the future, descending to Earth to preach the Dharma at a time when it has completely ceased. He is surrounded by many other smaller figures here that can be identified as bodhisattvas, donors, and guardians in the form of thunderbolt bearers.

Dated 524 (5th year of Zhengguang reign), Northern Wei dynasty (386–534) • China • Gilt bronze

H. 76.8 × W. 40.6 × D. 24.8 cm

Lotus Sutra, Chapters 12 and 14

The Lotus Sutra is an important and revered scripture for the Mahayana tradition, Tendai, and Nichiren sects. In Japan and China, the chanting of the Lotus Sutra is believed to bring liberation to the practitioner. Copying the sutra is also considered a form of merit-making and was particularly prominent during the Nara period (710–794). This handscroll from the Edo period shows how the royal court had revived this tradition. The scroll is extravagantly illustrated and written on indigo-dyed paper with gold and silver ink.

ca. 1667, Edo period (1615–1868) • Japan • Two handscrolls; gold, silver on indigo-dyed paper

H. 28 × W. 454.5 cm

DEPICTIONS OF BUDDHA 183

184 BUDDHISM: A JOURNEY THROUGH ART

FACING PAGE

The Diamond Sutra

The Diamond Sutra being one of the most popular Buddhist scriptures was oftentimes exposed to a commercial aesthetic that was comprehensible and familiar to the wider populace of China. By the late Ming dynasty, most Buddhist scriptures were printed rather than written by hand, but this example is hand-painted with an 'in demand' marketplace in mind. The fantastical colours and engaging pattern of clouds and halos create an overall attractiveness. This is just one illustration of many within the hand-painted sutra, each page has an endearing and captivating quality, the cultural style of the work transcends boundaries of more sophisticated art to appeal to a wide range of audience.

———

Ming dynasty (1368–1644), Wanli period (1573–1620) • China

H. 31.8 × W. 14 cm

FOLLOWING PAGE LEFT

Scene Inspired by the Scrolls of Frolicking Animals and Humans

This charming illustration by renowned artist Tomioka Tessai (1836–1924) is a modified version of the Choju-jinbutsu-giga scrolls which are attributed to the monk Toba Sojo (1053–1140), the head priest of the Tendai sect of Buddhism. The acclaimed set of four scrolls could be considered to be the first form of manga with the use of animals to humorously depict humans and curiously no accompanying text. The function of the scrolls is up for debate but can be interpreted as satire or entertainment. Here, we have a scene from the set's first scroll, a frog, who impersonates the Buddha, sits in meditative poise on a leafy throne. He is flanked by monkeys, rabbits, and foxes in the guise of adoring monks and laypeople.

———

By Tomioka Tessai • 1890s, Meiji period (1868–1912) • Japan • Hanging scroll; ink and colour on satin

H. 67.6 × W. 59 cm

FOLLOWING PAGE RIGHT

Sakyamuni Conquering the Demons (Shaka Gōma-zu)

Kawanabe Kyōsai (1831–89) painted with much wit, vigour, and personality – he is known as one of Japan's most influential artists with particular significance to manga. Somewhat overshadowed by his predecessor Hokusai, who is immensely iconic, the work of Kyōsai is nevertheless important, and he is considered one of the greatest caricaturists in the artworld. This finely executed painting of ink and pigments illustrates the Buddha's journey to enlightenment under the bodhi tree. The fire-breathing dragon represents Mara, who embodies the forces that oppose enlightenment. An extremely proficient draughtsman, Kyōsai contrasts his skill with traditional materials, humour, and frivolity, perfectly encapsulating the absurd yet beautiful nature of art and culture.

———

By Kawanabe Kyōsai • ca. 1888, Meiji period (1868–1912) • Japan • Album leaf mounted as a hanging scroll; ink and colour on silk

H. 36.8 × W. 27.9 cm

常寂光圀土
衆生所遊樂
做るうれ候る本尊
団坐徐今畫
鐵鉢學人

DEPICTIONS OF BUDDHA 189

FACING PAGE

Death of the Buddha

This woodblock print has an element of spontaneity which is often lost with this method. The configuration of the print as well as finer details, such as random insects or animals commanding attention in a somewhat irregular composition, give the overall impression of an offhand painting. It appears that the colour was added post print and by hand since some elements such as the trees seem to show the pigment laying over the black ink. Nishimura Shigenaga (1697–1756) was an ukiyo-e artist from Japan. His earlier work was mostly yakusha-e portraits of kabuki actors in the style of the Torii school. His later work was a more personal style that showed affinities with artists Okumura Masanobu and Nishikawa Sukenobu.

———

By Nishimura Shigenaga • 1720s • Japan • Woodblock print

H. 40.32 × W. 24.77 cm

FOLLOWING PAGES

Nehan: Death of the Buddha

The Buddha lays on his right side with his head facing North whilst surrounded by grieving disciples, monks, and celestial beings. Their sadness and anguish is contrasted by a peaceful-looking Buddha. Resplendent with luminous gold skin under a golden robe, the Buddha appears giant in stature signifying his status as a spiritual leader. The Death of the Buddha is a poignant and significant theme in Buddhist art, also known as *parinirvana*, symbolizing the end of the karmic cycle of rebirth and samsara.

———

Late 17th/early 18th century • Japan • Hanging scroll; ink, colours, and gold on silk

H. 229 × W. 331.5 cm

Otsu-e Nirvana of the Buddha

This painting offers a satirical take on the conventional depiction of the death of Buddha and is one of the most fascinating Buddhist illustrations to exist, painted with both humour and remarkable skill. Despite being an antiquity – the freedom of expression and approach to the subject has a timeless and modern characteristic. Without the historic context, you would be forgiven for thinking this was a current illustration by a clever cartoonist. Hakuin Ekaku was an important monk, artist, and calligrapher credited with reviving Rinzai Zen Buddhism in Japan. He was exposed to Buddhism from an early age by his devout Buddhist mother and at the age of fifteen was ordained at his local Zen temple. For Hakuin, painting was part of his Zen practice. His quirky, fun, and captivating style of illustration was admired by all.

―――

By Hakuin Ekaku • 19th century, Meiji period (1868–1912) • Japan • Hanging scroll; ink and colour on paper

H. 201.9 × W. 78.7 cm

The Buddha Descending from Trayastrimsa Heaven at Sankissa

This beautifully painted silk depicts the Buddha descending from the second level of Buddhist Heaven called Trayastrimsa, translated as 'of the 33 gods', an expression rooted in Vedic mythology, referring to 'the pantheon of gods'. In the upper register of this painting, we see the Trayastrimsa Heaven which is surrounded by lavish palace walls; inside are deities in a state of worship whilst others peek through celestial windows at the Buddha's descent. The Buddha floats down a jewelled stairway, a popular artistic theme and Buddhist concept. He is surrounded by musicians and divine deities whilst at the bottom of the stairs, humans venerate him. The Trayastrimsa is the highest heaven with a physical connection to the rest of the world.

19th century • Thailand • Colour on silk

H. 142.2 × W. 74.3 cm

Crowned Buddha

The Buddha sits in *dhyanasana* with his hands gesturing the *dhyana* mudra whilst perched on a double lotus pedestal. His richly patterned robe falls from one shoulder, and his plump oval face is exquisitely cast with a smiling countenance. His hair of tight spiral curls expands up to the *ushnisha* which sits above a lavish crown.

The crowned Buddha during the Ming dynasty can be somewhat ambiguous, and more often than not, this representation would be Sakyamuni. In Buddhist iconography, this form is also very similar to the Bodhisattva Guanyin. This is likely to be Amoghasiddhi, who is one of the five cosmic Buddhas. The additional adornments such as the bracelets, arm bands, earrings, and the bodhisattva style of dress indicate one of the five cosmic buddhas whereas Sakyamuni's robe is usually more monastic in appearance.

15th century • Ming dynasty (1368–1644) • China • Bronze with traces of gilt decoration

H. 38 × W. 26 × D. 20 cm

Seated Buddha

Buddha Sakyamuni is characteristically cross-legged with the feet atop in meditation. His hands gesture the *bhumisparsha* mudra where his right hand points towards the ground and his left is in his lap with the palm facing upwards. This mudra symbolizes when the Buddha called the earth to witness his time of awakening. He wears a robe over his left shoulder and has a soft and poised expression on his face; his eyebrows are gently arched leading to a narrow nose, above smiling lips. Flanked by long ears, his hair is characteristically tightly curled leading up to a pointed *ushnisha*. This sculpture's iconography is important and serves as a reminder of the treacherous events that led to the Buddha's enlightenment when he had to battle and overcome powerful and evil illusions cast upon him by Mara. The art of Burma refined as Buddhism grew during the pagan era of the eleventh to the thirteenth century. The beautiful way in which this sculpture has aged shows the black lacquered surface of the wood under the deteriorated golden gilt lacquer, making it one of the finest surviving examples of this type of sculpture.

12th century • Burma (Myanmar) •
Gilt lacquer on solid wood

H. 100 × W. 62 × D. 30 cm

Seated Buddha

This fragment of a cross-legged Buddha is a rare surviving Khotan frieze from sixth-century China, rarer still since terracotta seldom survived. The lined drapery of the robe was derived from Gandhara and blended with the local aesthetic, which is portrayed in the features of the face and hair. Khotan was an affluent and important area positioned on a branch of the Silk Road that went along the southern edge of the Taklamakan Desert and is credited with aiding the migration of Buddhism from India to China. Buddhist archaeological relics, mostly in the form of fragments, reveal that Buddhist art flourished in the Kingdom of Khotan with strong political and social support.

———

6th–7th century, Khotan kingdom • China (Xinjiang Autonomous Region) • Terracotta

H. 12.7 × W. 7 cm

DEPICTIONS OF BUDDHA 197

Welcoming Descent of Amida Buddha and Twenty-five Bodhisattvas

This hanging scroll depicts the Amida Buddha and his bodhisattva's descent from heaven to take the faithful, upon death, to the Western Paradise. Painted scrolls depicting this scene could be hung near someone on their deathbed with significance to the practitioner's faith that salvation could be attained through the belief of Amida Buddha. As a ritual, such a painting may be placed to meet the dying person's gaze in an important visual aid to assist their journey to the Pure Land. Known as raigo paintings, these were very popular in Japan. According to the Metropolitan Museum of Art, this painting was commissioned in 1668 by Oikawa Zen'emon, a resident of Easten Edo, to honour the loss of his wife. Her cremated remains reside in the metal roller knobs from the scroll.

1668, Edo period (1615–1868) • Japan • Hanging scroll; ink, colour, and gold on silk

H. 129.9 × W. 61.6 cm

Buddha, Bodhisattvas and Taoist Scholars

This image combines Buddhist and Daoist art from late Joseon. Chilseong Buddha, the deified North Star in the painting, was known for his ability to demolish misfortunes. Seven Buddhas, representing the Great Dipper's Seven Stars, surround the central Buddha, who is flanked by Chandraprabha (Moonlight) and Suryaprabha (Sunlight). Below are the Daoist equivalents to the Seven Buddhas.

In Korean Shamanic culture, the Big Dipper, also known as Ursa Major, is revered and despite being regarded as a unique deity, the subject is most usually represented as a seated Buddha supported by other Buddhist deities and followers. In Taoism, Chilseong, an altered form of Buddha Yaksayeorae, is revered in Buddhist monasteries and considered to keep an eye on people's fortune. The worship of Chilseong developed across the country, mixing folk religion with Buddhism and Taoism.

20th century • Korea •
Ink and pigments on linen

H. 83.1 × W. 127.8 cm

200 BUDDHISM: A JOURNEY THROUGH ART

DEPICTIONS OF BUDDHA 201

FACING PAGE

Preaching Sakyamuni

Tsakli are miniature paintings that look like small cards. These important portable paintings usually portray various deities and are used by Buddhist monks for meditation, rituals, or training purposes. Tsakli are rare artefacts due to their perishable nature – usually made from paper or cloth. This is still rarer since the majority of Tibetan art was destroyed from 1949, experiencing persecution from the Chinese. Tholing Monastery, located where this rare tsakli originated, was built in 997 AD making it one of the oldest monasteries in the Ngari Prefecture of western Tibet.

———

11th century • Western Tibet, Tholing Monastery • Miniature votive painting (Tsakli); ink, colour, and gold on paper

H. 11.6 × W. 10.7 cm

FOLLOWING PAGE LEFT

Taima Mandala

The initial painting of the Taima Mandala was made around 763 AD after which many reproductions were made. The Taima Mandala represents the Western Pure Land and the imagery of the painting is largely based on the Sutra of Contemplation. The border of this painting portrays parables from the sutra. In the centre of this extremely ornate and detailed scroll, we see a large palace surrounded by a gilded pond, and within the palace walls, Amitabha Buddha sits among enlightened worshippers.

———

1750, Edo period (1615–1868) • Japan • Hanging scroll; ink, colour, and gold on silk

H. 106.2 × W. 96 cm

FOLLOWING PAGE RIGHT

Buddha Sakyamuni and Scenes of His Previous Lives (Jataka Tales)

This beautiful painting personifies the Buddha's ability to recall his past lives in order to explain karma, rebirth, and morality. The Buddha Sakyamuni is surrounded by his various incarnations in the form of small painted stories that seamlessly go from one to the next. These smaller pictures narrate numerous Jataka tales which are texts relaying the previous incarnations of the Buddha. In one portion clockwise to the Buddha, we see a tale of compassion from his past life as a bodhisattva who sacrificed himself to feed a starving lioness. In another section, we see the Buddha reborn as a hare, who was rewarded for selfless virtue.

———

1573–1619 • Tibet • Distemper on cloth

H. 69.5 × W. 47 cm

BODHISATTVAS

Bodhisattva Avalokiteshvara

This bronze and its style are typical of Prakhon Chai, a district in northeast Thailand. The artistic culture of this region thrived from the seventh to ninth centuries and the statues of the Buddha and bodhisattvas created during this time and region had a very distinctive aesthetic. Rather than depicting bodhisattvas like royalty in lavish robes and jewellery, the Prakhon Chai interpretation was far simpler like this example of a four-armed figure of the Bodhisattva Avalokiteshvara. The unadorned bodhisattva emulates an ascetic, wearing a plain dhoti with no jewellery or any embellishments. The body is slim and narrow. The only extravagant feature of Prakhon Chai figures is the elaborate hairstyle of meticulous curls, and in this instance, a small figure of the Buddha Amitabha resides in the headdress identifying this figure as the Bodhisattva Avalokiteshvara.

Second quarter of the 8th century • Northeastern Thailand • Copper alloy inlaid with silver and glass or obsidian

H. 142.2 × W. 57.2 × D. 38.7 cm; WT. (approx.) 2001 lbs. (907.6 kg)

The Bodhisattva Avalokiteshvara Seated in Royal Ease

This depiction of the Bodhisattva Avalokiteshvara is quite unusual due to its anthropomorphic qualities. At first glance, this sculpture looks like it could simply be a royal portrait. The seated posture, although relatively usual for the Bodhisattva Avalokiteshvara is unnaturally human in its representation – this was because during those times, it was usual for sculptors to use the likeness of their royal patrons to embody buddhas or bodhisattvas. Metal work from the Angkor period is seldom in such good condition, and this is one of the best-preserved sculptures of its kind.

Late 10th–early 11th century, Angkor period • Thailand or Cambodia • Copper alloy, silver inlay

H. 57.8 × W. 45.7 × D. 30.5 cm

Head of Lokeshvara

It was during the reign of the king Jayavarman VII that the Bodhisattva Lokeshvara attained significant popularity. Lokeshvara is the name used for Avalokiteshvara in Cambodia and Thailand. During this period, the facial features of Buddhist sculpture had a likeness to king Jayavarman VII himself, as does this soft and graceful sculpture. One of the most popularly depicted bodhisattvas across Asia, this elegant example has an undeniable poise in expression that instantly brings the viewer to a feeling of peace, perfectly encapsulating Lokeshvara's compassion.

Late 12th–early 13th century • Cambodia, reign of Jayavarman VII • Sandstone

H. 35.3 cm

Head of Avalokiteshvara, the Bodhisattva of Infinite Compassion

Bronze sculpture during the Angkor period of Cambodia was made using the lost-wax casting method, and it was during this period that the technique reached the apex of its production and skill. The lost-wax casting method was achieved by putting a wax model over a clay or plaster core in a fireproof mould. When the wax melted during baking, molten bronze filled the void.

This bronze bust from the tenth century is an amazing illustration of the level of expertise accomplished by Khmer metal workers. Bronze figures commissioned at this time have a strong Khmer style as exemplified here. The single line of the eyebrows frame almond-shaped eyes, and the hairline is distinctively Cambodian, as is the shape of the lips and the gently arched moustache.

ca. Third quarter of the 10th century, Angkor period • Cambodia • Bronze

H. 15.9 × W. 14 cm

Head of a Bodhisattva

Nearly a thousand years old, this bust is a splendid example of Buddhist sculpture from the Song dynasty, when wood superseded stone as the most preferred media. Not only does the sculpture display exceptional artistic and technical skill, it shows that the artist had a sophisticated eye for detail and beauty. Undoubtedly, this is one of the most elegant and captivating sculptures of a bodhisattva to exist today. Despite the weathering over time, the competence of the features has not been lost. The rhythmic hair which flows in unison to a crescendo of ornate flourishes from a diadem gives the bust an otherworldly element whilst the sweet face has a more personal quality. The facial expression down to the pursed lips with lightly-dimpled plump cheeks and a round chin strikes the perfect balance of both natural and supernatural. The Northern Song is famous for a revival in Buddhism with a particular emphasis on creating the finest art and literature with the emperor himself being a keen artist and connoisseur of the arts.

960–1127, Northern Song to Jin dynasty • China (Henan province) • Wood

H. 86.4 × W. 40.6 × D. 38.1 cm

Guanyin

The bodhisattva of infinite compassion and mercy in Chinese Buddhism, Guanyin, exquisitely sculpted with a tender expression and elegant poise sits in the *rajalalitasana* position, where the right knee is raised and the left leg is crossed. This particular pose embodies the 'Water-Moon' manifestation, also known as Shuiyue Guanyin. This representation is understood to illustrate Guanyin in his Pure Land, meditating on a rock whilst enjoying the Moon's reflection in the water. This stunning wooden sculpture, with Guanyin's eyes looking downward towards the reflection, perfectly encapsulates the feeling of tranquillity that is interpreted by his relaxed and informal posture and facial expression of perfect contentment and calm.

———

ca. 12th century, Liao dynasty (907–1125) / Jin dynasty (1115–1234) • Shanxi, China • Willow and paulownia wood with painting and gilding

H. 117.0 × W. 111.0 × D. 74.0 cm

Avalokitesvara Padmapani: Bodhisattva of Mercy Bearing a Lotus

Avalokiteshvara Padmapani is the most popular form of this bodhisattva. Padmapani translates to 'lotus bearer', and can be recognized by the lotus (*padma*) and the small Buddha in the headdress. This sculpture is typically Nepalese in style identified by the floral flourishes, inlaid semiprecious stones, and gilding which has now worn away to expose the bronze beneath. The early sculpture from Nepal showed affinities with Indian styles before developing their own unmistakable aesthetic as exemplified here.

11th century • Nepal • Bronze with gilding, pigment, and semiprecious stones

H. 62 cm

Avalokiteshvara, the Bodhisattva of Infinite Compassion

A regal and dignified Avalokiteshvara extends one hand in *varadan* mudra, the boon-granting mudra, whilst standing with a gentle tilt. His body is lithe and elegant which was adapted from the Indian Pala style. The face is contented with a peaceful expression, the gilding partially degraded to reveal the raw copper alloy underneath.

10th century, Thakuri period • Nepal (Kathmandu Valley) • Gilt-copper alloy

H. 30.5 × W. 12.1 × D. 11.7 cm; WT. 5 lbs (2.3 kg)

Head of a Bodhisattva

The elegance and beauty of this sculpture is testament to artistry at a time when Buddhism was thriving, and the highest quality of Buddhist art prospered. This head of a bodhisattva represents the pinnacle of beauty for the Tang dynasty. The graceful plump face, meditative eyes, and harmonious features, flanked by elongated earlobes, personify the distinctly Chinese representation of a bodhisattva. The unique hairstyle with a stately topknot behind a jewelled diadem is consistent with the early sculpture of the period.

ca. 710, Tang dynasty (618–907) • China • Sandstone with pigment

H. 40 × W. 20.3 × D. 19.1 cm

Head of a Bodhisattva

The artist of this cast-iron bust remained sternly within the constraints of the divine iconography of a bodhisattva from the fifteenth century in China. This can be identified by a few definite features that were prevalent during the period. The lips are small, well defined, and rendered with an exaggerated bow-shaped aesthetic. The almond-shaped eyes are abnormally large, heavily lidded, and framed by graceful eyebrows. The parted and curled hairline which channels into the *ushnisha* would have originally had an added ornamentation of the decorated crown. Traces of pigment are still visible on the sculpture's lips, which with some imagination gives an idea of how this figure would have looked when it stood and was revered within a Buddhist nunnery.

14th–15th century • China • Cast iron with traces of pigment

H. 37 cm

Eleven-headed Avalokiteshvara, the Bodhisattva of Infinite Compassion

Avalokiteshvara has many manifestations, and this example from Thailand depicts the eleven-headed and multi-armed esoteric version. The slender hands and arms of this sculpture gently fan outwards in graceful authority. Amitabha Buddha is believed to have bestowed Avalokiteshvara with the extra limbs, so that as the bodhisattva of infinite compassion, he could reach out and help as many people as possible.

10th century • Thailand • Bronze
H. 55.8 cm

Attendant Bearing a Fly-whisk

We know that this fragment of a torso would have been part of a pair that would have flanked an important figure, however, there is some conjecture about whether this is an attendant of the Buddha or the attendant of a king/member of aristocracy. The informal stance and casual posture identify this figure as an attendant, and the fly-whisk he holds in his right hand was a marker of royalty. Fly-whisks were adopted in ancient imperial India by courtiers, used to fan royalty as well as shield them from insects. The fly-whisk was also a symbol of the way Buddha used to deter insects in a compassionate way so as not to incur karma. Early Buddhist sculpture adopted the fly-whisk as part of the attendant's iconography to speak for the spiritual sovereignty of the Buddha.

AD 100–150, Kushan period • Northern India, Uttar Pradesh, Mathura • Red sandstone

H. 55.8 cm

The Bodhisattva Avalokiteshvara in the Form of Padmapani, the Lotus Bearer

This bronze figure depicts the Bodhisattva Avalokiteshvara in the form of Padmapani. The figure's elaborate suit of jewellery stands out from other renditions as there is a unique flare to the pieces giving the impression that the sculptor may have enjoyed adding their distinct mark to an otherwise fixed iconography. This sculpture from Tibet has the recognizable Kashmir style descending from when the artists from Kashmir settled in the ancient kingdom of Guge in western Tibet.

12th century • Tibet • Bronze with later turquoise inlay

H. 54 × W. 20.3 × D. 10.2 cm

White Jambhala on a Dragon

A pot-bellied White Jambhala sits upon his dragon steed. Since the White Jambhala is best known for removing poverty, it is only fitting that he should be bedecked in expensive and lavish jewels. The two emblems of this god of fortune are a wealth banner and a gold sword; and he is often depicted seated upon a mythical creature, with the dragon being most popular. White Jambhala who was born from the right eye of Bodhisattva Avolokiteshvara is one of the five incarnations of Jambhala, with his counterparts being red, green, yellow, and black.

18th–19th century • Mongolia • Brass with pigment, inlaid with copper and silver; lost-wax cast

H. 13.3 cm

Manjuvajra Mandala

This sculpture depicts the esoteric form of the Bodhisattva Manjushri. Black stone sculpture intricately carved into an oblong relief is the archetypal style of the Pala period, which is noted as a unique and particularly skilled period for Indian art. This esoteric form of Manjushri with three heads and six arms first appeared in the Nama-samgiti tantra. Two arms across his chest would have held vajras, the other four brandish a sword, a lotus flower, and a bow and arrow (now missing). He sits upon a lotus throne surrounded by mystical animals and divine beings. Above him is an alcove of stupas surrounded by fiery flourishes. Each stupa has a different incarnation of Manjushri residing within.

———

11th century, Pala period • Bangladesh or India (Bengal) • Black stone

H. 116.8 × W. 61 × D. 19.1 cm

FOLLOWING PAGE LEFT

Guanyin, the Bringer of Sons

Guanyin is depicted here in her incarnation as 'Bringer of sons', an unusual subject in painting and more frequently expressed through sculpture. In this form, Guanyin assumes the role of a mother, and meditating on her image would assist the practitioner in conception. She cradles a new-born son on her knees whilst sitting upon a majestic lion. In Chinese culture, having a son was the only way to carry the family lineage and secure legacy and reputation. And so, this form of Guanyin as the bringer of sons was especially revered in the region.

———

Late 16th century, Ming dynasty (1368–1644) • China • Hanging scroll; ink, colour, and gold on silk

H. 120.7 × W. 60.3 cm

FOLLOWING PAGE RIGHT

Sadaksari-Lokeshvara Surrounded by Manifestations and Monks

There is a uniform science within Tibetan Buddhist art as to how divine iconography should be portrayed, and this mostly depends on numerology and proportions within the painting. Auspicious symbols and particular attributes were also important markers of each deity and manifestation. This was perhaps important so that the educational and spiritual message of each piece is easy to decipher, with nothing ambiguous for future generations to interpret. In this sense, although Tibetan art is famous for its rich and exciting visuals, it prized the Buddhist principles above the artist's identity.

This ink drawing wonderfully communicates the very specific and meticulous way in which Buddhist deities and buddhas were represented in Tibet. Sadaksari-Lokeshvara is a four-armed emanation of the Bodhisattva Avalokiteshvara. His primary hands are held to his chest in the *anjali* mudra of veneration, whilst others hold rosary beads and a lotus flower. Sadaksari-Lokeshvara is believed to be the embodiment of the healing Sanskrit mantra *'om mani padme hum'*, which translates to 'the jewel is in the lotus'.

———

Late 15th century • Tibet • Distemper, gold and ink on cloth

H. 102.6 × W. 79.4 cm

The Bodhisattva Manjushri as a Ferocious Destroyer of Ignorance

The Bodhisattva Manjushri usually has a calm and sweet countenance but is depicted here with a downturned mouth and furrowed brows which indicate a tantric manifestation. Buddhist tantric emanations are often semi-wrathful in appearance as their function is to destroy the obstacles to attain peace and enlightenment. This metal-cast figure of Manjushri can be identified as Nepalese by its considered proportions – the arms are exceptionally long and the hands are unusually large. The face also fits this prototype with a distinct curvature of the brows, broad face, and a small chin.

10th century, Thakuri period • Nepal, Kathmandu Valley • Gilt-copper alloy with colour and gold paint

H. 31.8 × W. 15.9 × D. 8.3 cm; WT. 12 lbs (5.4 kg)

Head of Bodhisattva Avalokiteshvara

Cambodian sculpture has a rich history that spans various kingdoms and dynasties. The particular characteristic of friendly charm that is emphasized in the proportions of the facial features are seen here. The short nose and broad face with plump cheeks have a youthful quality whose pleasantness is a far cry from the sterner and more imposing depictions from other cultures. The attractiveness of sculpture from Cambodia of this period is possibly why some of the most revered artefacts in Buddhism have originated from here.

———

9th century, Angkor period • Cambodia • Stone

H. 20.6 × W. 11.4 × D. 10.8 cm

Head of Bodhisattva Avalokiteshvara

Sometimes a work of art has the intangible quality of sacredness and it is difficult to pinpoint exactly why the piece feels pious or religious in nature. This can be put down to subconscious markers that have been subtly reflected in expression by conscientious artists who have studied the divine nature of proportions. The use of volcanic rock, which is evident by the porous look of the surface, was a typical sculpting medium in Java. As the rock was hard to carve, the features would often appear less refined but despite this the unmistakable appearance of a bodhisattva remains. The downcast eyes, youthful plump cheeks, slightly upturned lips, and narrow chin are features that can be found across the board of religious sculpture and immediately bring to mind a sense of devotion.

———

9th century • Central Java • Andesite

H. 51.5 × W. 19 × D. 21.6 cm

Attendant Bodhisattva

This beautifully carved sculpture has many elements that stand out, especially the incredible lifelike features of the face. The lips and nose are exceptionally realistic whilst the eyes and eyebrows have a slightly more stylized quality. The hair and torso were deliberately simplified by the sculptor so that the eye is drawn immediately and intentionally to the figure's face. The brows are furrowed in deep contemplation and contrasted by an amicable countenance of soft facial features. This sculpture of a bodhisattva attendant was most likely part of a massive triptych that featured a Buddha in the centre.

10th–11th century, Five Dynasties (907–60) or Liao dynasty (907–1125) • China • Wood (willow) with gesso and pigment; single woodblock construction

H. 149.9 cm

Sun Bodhisattva (Nikko Bosatsu)

The Heian period was a masterful time for wooden sculpture in Japan where a single block of wood was skilfully used for the entire sculpture, creating a continuity and fluidity of the grain. This was not an easy technique, but as this figure exemplifies, the results are outstanding. This sun bodhisattva (Nikko Bosatsu) would have had a moon bodhisattva counterpart (Gakko Bosatsu) and both would have flanked the Buddha in a triad.

ca. 9th century, Heian period • Japan • Japanese nutmeg-yew wood with traces of colour and gold

H. 46.7 cm

Head of a Bodhisattva

This undeniably beautiful bust of a bodhisattva showcases the sensational talent of the sculptor through the incredible lifelike features of the mouth, nose, and eyes. Beyond this point, there has been a deliberate decision to be more abstract, and this juxtaposition of technique was natural within Chinese Buddhist sculpture of this period. Ordinarily, the bodhisattva within the constraints of Buddhist iconography is portrayed as being less austere or introspective than the Buddha. They have renounced their own salvation and immediate entrance into nirvana in order to devote all of their strength and energy to saving suffering beings on earth. As a compassionate deity, the bodhisattva is typically depicted with precious jewellery, elegant clothing, and graceful poses.

1368–1644 • China • Linden with traces of painted and gilt decoration

H. 43.6 × W. 15.4 cm

Bodhisattva Manjushri (Wenshu)

Manjushri sits in a relaxed pose whilst holding a scroll in his right hand which commemorates his iconography. However, at first glance, this sculpture is also very close to the Bodhisattva Avalokiteshvara in the Water Moon form. Manjushri's body is healthy and soft with a little over belly forming over his dhoti. His expression is one of contemplation, and his stance and features classically encapsulate the Buddha's supreme wisdom. Due to Manjushri's attribute of absolute knowledge, this sculpture looks particularly reflective. Scholars consider Manjushri the earliest and most important Mahayana bodhisattva. Manjushri is initially referenced in early Mahayana sutras like the Prajnaparamita, and he came to represent *prajna* very early in the tradition (transcendent wisdom).

Late 10th–early 12th century, Northern Song dynasty (960–1127) • China • Wood (foxglove) with traces of pigment; single woodblock construction

H. 109.2 × W. 58.4 cm

FACING PAGE

Mandala of the Bodhisattva Hannya (Prajnaparamita)

The bodhisattva Hannya who represents the embodiment of perfect wisdom resides in the centre of this mandala with two attendants and sixteen guardian deities surrounding her. Hannya is not a common subject in Buddhist art making this mandala particularly unusual. Meditating upon devotional mandalas was believed to evoke the deity depicted and also a popular tool for monks and practitioners.

———

14th century, Nanbokuchō period (1336–92) • Japan • Hanging scroll; ink, colour, gold, and gold foil on silk

H. 163.8 × W. 123.5 cm;
Overall with painted mounting: H. 211.5 × W. 146.7 cm

FOLLOWING PAGES

'Universal Gateway' Chapter 25 of the Lotus Sutra

An exceptionally rare artefact and believed to be the earliest known painted version, this is a section of a huge scroll of illustration and calligraphy recounting the twenty-fifth chapter of the Lotus Sutra. Famous for the graphic, imaginative, and animated style of painting, the narrative scrolls during this period were used to commemorate historical events and religious texts.

———

Calligraphy by Sugawara Mitsushige • 1257, Kamakura period (1185–1333) • Japan • Handscroll; ink, colour, and gold on paper

With mounting: H. 24.6 × W. 934.9 cm

ABOVE

Seated Bodhisattva (left attendant of a triad)

This golden cherubic bodhisattva from the Joseon dynasty most likely would have been part of a pair flanking the Buddha in a triad. The sweet countenance of the face with petite and charming features was a marking of this period in Korea. The bodhisattva wears a gorgeous crown similar in style to a thirteenth-century sculpture of the Water Moon Avalokiteshvara.

———

ca. Mid-17th century, Joseon dynasty (1392–1910) • Korea • Gilt wood

H. 51.4 × W. 51.4 × D. 36.2 cm

Ema (Votive Painting) of Chinese Lion Led by Utenō

This wonderful ink painting is unmistakably from the Edo period, a time when illustrations reached a peak of playfulness and whimsy. The bodhisattva, known as Monju Bosatsu in Japanese, is a Buddhist deity who epitomizes wisdom. This Ema depicts the mythical lion steed of Bodhisattva Monju and its handler, the god Uteno. The artistic rendition of the lion started to take on the features of a dog during the Edo period. Lions have long been a symbol of sovereignty and guardianship in Buddhism, with dogs being loyal protectors, and the hybrid of the two is known as Komainu. The lion in this appearance takes on special meaning, believed to protect the patron's heart and mind from evil forces.

―――

1627, Edo period (1615–1868) • Japan • Ink and colour on wood
H. 27.3 × W. 36.5 cm

FOLLOWING PAGE LEFT

Memyo Bosatsu (Ashvaghosha Bodhisattva) Mounted on a Horse

The Bodhisattva Memyo wears rich and vibrant silks woven with gold brocade in regal dress. He is sumptuously adorned with gold jewellery and gemstones and wears an ornamented diadem behind a thick chignon hairstyle. Known for providing devotees with much-needed clothing is reflected in his highly fashionable aesthetic. Even his steed, a mythical white horse, is magnificently embellished with silks, gold, and fur. In one hand, he holds a red disc and in the other are balancing scales.

───

15th–16th century, Muromachi period (1392–1573) • Japan • Hanging scroll; ink, colour and gold on paper

H. 50.2 × W. 29.8 cm

FOLLOWING PAGE RIGHT

Eleven-headed Bodhisattva Guanyin

This Qing dynasty image of the Bodhisattva Guanyin is an embroidery which is so masterful that at first glance you could be forgiven for thinking this was a painting. Guanyin in her eleven-headed and thousand arms manifestation holds a number of auspicious symbols including a golden wheel, her emblem the lotus flower, a vase of pure water, a bow, and an arrow. The bodhisattva wears royal silk fashioned into a dhoti and a luxurious suit of jewellery representing her earthly connections. There are certain restrictions within embroidery which make it a particularly difficult method for elaborate artworks. China had long prized embroidery as an important form of artistic culture, and so artisans continuously pushed to become even more sophisticated and competent. This drive from the artisans made embroidery one of China's most revered forms of artwork which is still unrivalled throughout the world.

───

1778, Qing dynasty (1644–1911), Qianlong period (1736–95) • China • Silk and metal thread embroidery

H. 142.2 × W. 85.1 cm

Bodhisattva Skanda

This wooden sculpture from the Ming dynasty is portraying the Buddhist protector deity called Skanda. Perhaps, what makes this rendition stand out from others is the detail executed in his handsome armour, which has been meticulously carved in gruelling detail. As a staunch protector of the Dharma, it was important for the artist to make his armour as impressive as possible in order to exalt his divine warrior status.

———

16th–17th century, Ming dynasty (1368–1644) • China • Lacquered and gilded wood

H. 29.2 × W. 12.7 × D. 10.2 cm

Bodhisattva Avalokiteshvara of the Lion's Roar, or Simhanada Avalokiteshvara (Shi Hou Guanyin)

Bodhisattva Avalokiteshvara sits in relaxed posture upon a lion steed. The mythical lion represents sovereignty and due to their nature of guardianships of the Dharma in Buddhism, they would often be depicted with bodhisattvas in a protective role. The muscular creature looks less like a lion and more like a horse. In theory, this could be because over time, the aesthetic of the lion had changed with artistic taste, with the sculptors looking to other artistic renderings for inspiration rather than knowing what a real lion actually looked like. This is an incredible example of Ming dynasty sculpture in excellent condition albeit missing a diadem with the figure of the Buddha which would have sat on his head to identify him as the Bodhisattva Avalokiteshvara.

———

Late 15th–early 17th century, Ming dynasty (1368–1644) • China • Wood (poplar) with pigment; single-woodblock construction

H. 107 × W. 73.7 × D. 33 cm

Head of an Attendant Bodhisattva

This limestone bust from China may arguably be one of the most graceful renditions of a bodhisattva from the Northern Qi dynasty. The articulated nose, philtrum, plump lips, and slight double chin give a realistic consideration to this otherwise divine-looking figure. This head is from the complex of Xiangtangshan, which consists of seven minor shrines located nine kilometres from the Northern Xiangtangshan's three gigantic cave temples. Both the Eastern Wei (535–50) and Northern Qi dynasties reigned from Ye in Hebei province's south, and both financed the construction of new cave temples.

———

ca. 565–75, Northern Qi dynasty (550–577) • China • Limestone with pigment

H. 38.1 × W. 28.6 × D. 21 cm

Head of a Bodhisattva

This head is remarkable given its huge size and even more so for it was part of a complete figure that guarded the entrance to Xiangtangshan's central cave. The articulated features and sense of facial proportions point to the Northern Qi dynasty. An expressed bridge for the nose and gently curved eyebrows were the customary style with the addition of a gentle philtrum between the nose and mouth. The hairline is flat and the face is well defined with plump cheeks and elongated earlobes.

ca. 565–75, Northern Qi dynasty (550–577) • China • Limestone with pigment

H. 81.3 × W. 44.5 × D. 30.5 cm

Bodhisattva Avalokiteshvara (Guanyin)

The slender and fluid form of this gilt bronze figure reflects the artistic style of the Sui dynasty. The Bodhisattva Avalokiteshvara can be identified by a water vessel in the right hand containing the bodhisattva's main attribute – the nectar of life. In the left hand is the sacred emblem of a willow branch which the Bodhisattva Avalokiteshvara is said to use as a utensil to sprinkle divine water upon devotees. This act of dashing water on the faithful was a type of baptism in order to garner blessings.

Late 6th century, Sui dynasty (581–618) • China • Gilt bronze

H. 43.8 × W. 12.7 × D. 12.4 cm

Bodhisattva Manjushri: Lord of Wisdom

This impeccable bronze of Manjushri, from India, is an ideal representation of his divine iconography. He sits upon a lion mount, which reflects his power to tame the mind. Two lotus spring from his shoulders, the left holding a palm-leaf manuscript of the Prajnaparamita Sutra and the right (now missing) his flaming sword of wisdom used to cut down ignorance. A stupa tops his enlightenment throne under which are the flames of purification. He sits in the posture of royal ease bedecked in jewellery and a crown. The features of his face are well articulated and display a feeling of contemplation with the overall appearance of transcendental wisdom and sanctity.

11th–12th century • India • Bronze with gilding and inlay of semiprecious stones

H. 31.2 cm

Stele with the Bodhisattvas Avalokiteshvara (Guanyin) and Mahasthamaprapta (Dashizi)

Two bodhisattvas stand side by side in a relaxed posture with a flourishing nimbus emanating from both heads signalling their transcendent divinity. Despite the degradation of this ancient artefact, the beautifully detailed sculpture can still be interpreted and consecrated for its adept and skilful craftsmanship. The bodhisattvas are bedecked in jewels which drape down to their kneecaps, and they are wearing grand robes fit for royalty as is prevalent in depictions of bodhisattvas. The museum that houses the artwork notes, 'The symbols on the headdresses of the two bodhisattvas visible here can be used to identify them: the figure on the right is Avalokiteshvara (as suggested by the presence of a little Buddha), and the one on the left, wearing the vase sign, is Mahasthamaprapta.'

Mid- to late 7th century, Tang dynasty (618–907) • China (Henan province) • Limestone with traces of pigment

H. 163.8 × W. 90.8 × D. 32.4 cm

Guanyin

As a child, you may remember getting a blank piece of paper, some charcoal and making 'rubbings' against trees and all sorts of things to create a pattern. Looking at this image, it's astonishing to realize this was created using a similar method albeit refined to the point of creating masterful pieces of artwork. For centuries, carved relief ink rubbings were employed to preserve or make copies of important art in China. The intricate linework in this image shows how sophisticated this method had become by the twentieth century. Each strand of Guanyin's hair is visible in rhythmic and painstaking detail and the fluidity and movement of the contours of Guanyin's robe have the quality of an ink drawing. Today, we may use a medium such as rubber for relief printing which is very malleable and easy to carve, but this image was created using a stone relief, exemplifying the incredibly technical skill of the sculptors.

20th century, Zhou Xun (Chinese, 1649–1729) • China • Rubbing of a Qing dynasty (1644–1911) • Stone carving; ink on paper

H. 190.5 × W. 106.7 cm

A Bodhisattva

In China, during the eighth century, Buddhist sculptors embraced new standards of secular beauty for spiritual forms. Bodhisattvas, the benevolent deities who lead an individual to salvation, typically have more humanistic characteristics than representations of the Buddha. This is in large part because the bodhisattva still has ties to the material realm.

———

618–906, Tang dynasty • Tianlongshan, China • Sandstone

H. 95 × W. 45 × D. 17 cm

The Bodhisattva Maitreya

Limestone was seen as a fantastic medium for sculpture in early China due to its ability to retain fine details whilst also being strong enough to last for a long period of time. Antiquities made from limestone, however, are often lost due to the stone's corrosive nature when exposed to the elements and in particular, water, over long periods. Although this sculpture displays natural deterioration over time, the distinct markings of the original sculpture remain. This early sculpture from China depicts the bodhisattva Maitreya in a seated pose, cross-legged and making the gesture of *abhaya* mudra (fearlessness). His crown, which is now weathered, would have most likely had a small stupa emblem at its centre. In typical iconography for Maitreya, he is accompanied here by two guardian lions at his feet.

500–525 • China • Limestone

H. 46 × W. 37.5 × D. 8 cm

Guanyin and the Sixteen Luohans

This stunning example of Ming dynasty silk painting was originally a round fan which has later been framed and mounted within an album. The magnificent artistry suggests this fan would have been within the ownership of a very wealthy patron or a member of aristocracy. Whilst the fan has a practicality of keeping the heat and insects at bay, in the Ming dynasty, it also served as a fashionable reflection of class and status. Such importance was placed on the fan that they were often hand painted in scrupulous detail – the more impressive the artwork, the greater prestige of the patron. In this splendid artwork, the Bodhisattva Guanyin sits in a cave atop the mountain. Sixteen *luohans*, or wizened guardians of the Buddhist law, pay her respect. A young pilgrim boy is prostrating before Guanyin seeking spiritual guidance.

16th–17th century, Ming dynasty (1368–1644) • China • Round fan mounted as an album leaf; ink, colour, and gold on silk

SHEET: H. 30.5 × W. 31.1 cm;
D. 21.3 cm

Banner with Bodhisattva, possibly Mahamayuri

Mahamayuri is a bodhisattva and queen within the wisdom king patheon in Vajrayana Buddhism. This depiction of the bodhisattva is not completely unusual for the Tang dynasty; however, certain considerations within the painting point to an artist who let his own imagination play a part in the formal execution. The features of the bodhisattva have been exaggerated to emphasize and exalt an unnatural deity – the nose is incredibly slight, the eyes are unnaturally large, and auspicious attributes, such as elongated ears and a three-ringed neck are present. The bodhisattva has a benevolent expression and holds a peacock feather in her right hand alluding to her Chinese name which translates to 'peacock wisdom'. She is fashionably dressed in richly coloured and embellished silks and wears a suit of impressive jewellery.

9th–10th century, Tang dynasty (618–907) or Five Dynasties period (907–960) • China (Dunhuang area, Gansu Province) • Ink and pigment on silk

H. 57 × W. 28 cm

Bodhisattva Guanyin

This splendid figure of the Bodhisattva Guanyin almost looks childlike in appearance due to the round face and petite proportions. The Ming dynasty favoured a large face and narrow body in sculpture, but due to the bodhisattva's robes, we are unable to see the slender waist which would have given the bodhisattva a more mature appearance. Guanyin sits with his legs crossed in a meditative posture and holds a small vessel filled with pure water that is said to have divine healing properties. He is adorned in royal attire, lavish jewellery, and a large opulent crown in which a tiny figure of the Amitabha Buddha resides.

15th–16th century, Ming dynasty (1368–1644) • China • Leaded brass

H. 38.4 × W. 27.9 × D. 17.8 cm

Seated Bodhisattva

This wooden sculpture of a bodhisattva has remained in remarkably good condition as the wood was well protected by the lacquer which has now eroded away. Some traces of the gilding have endured, giving the sculpture a mottled look and allowing us insight into how this sculpture was created and how it would have looked in its original state. Exceptionally sculpted, the calm and stately bodhisattva is seated in a frontal, meditative pose. Details worth considering when judging the adeptness of a sculptor are to look at the hands. The hands in this instance are incredibly graceful and lifelike. The bodhisattva is adorned with beautiful jewellery and silks. The features of the face are wonderfully carved to give a perfect impression of transcendental stillness. The hair is in typically Japanese style with a parted thick ponytail that cascades into a convoluted chignon behind a refined diadem. The precise execution with each strand of hair and each jewel accounted for point to a master craftsman.

770 CE–780 CE • Japan • Wood core, dry lacquer, traces of gold leaf

H. 61 × W. 43.2 × D. 32.3 cm

MONKS, LAMAS, AND ARHATS

The Activities of the Twelve Months

Nichōsai observed and caricatured the activities of monks and illustrated their daily lives over a period of twelve months. This is the tenth image in the scroll and illustrates monks and nuns at a Buddhist sermon. Buddhist practitioners pray in order to evoke the compassion and wisdom of buddhas and bodhisattvas, garnering inner peace for the self and wider world. The monk conducting the sermon

wears a *rakusu* around his neck, a traditional Japanese garment worn by Zen Buddhists who have taken the precepts. Japanese Buddhism which still holds elements of early Shintoism is a combination of faith in Amida as well as Zen principles. The style of Nichōsai's illustration is unmistakable with an endearing and playful quality.

By Nichōsai (Matsuya Heizaburō) • 1794 • Japan • Ink and colour on paper; mounted as a handscroll

H. 18.4 × W. 914.4 cm

FACING PAGE

Portrait of Sonam Lhundrup, Buddhist Abbot of the Kingdom of Lo

This is an exceptional example of a portrait of Sonam Lhundrup, the Great Abbot of the Kingdom of Lo. The identifying features include a rotund pot belly, distinct hairline, round face, and his robe supported by a belt that rests high on the chest with a patterned undercloth. The sculpture has been cast masterfully and details such as the hands and face are stunningly realistic. A sword and Prajnaparamita Sutra text resting upon a lotus reside behind him, and he holds a flaming *triratna* in his left hand. The graceful poise of the abbot, with fine ornamental flourishes adorning his robe, define this sculpture as one of the most impressive portrayals of Sonam Lhundrup.

———

By Namkha Drag • 16th century • Tibet • Copper alloy with silver and copper inlay, pigment, and cold gold

H. 28.6 × W. 21.3 × D. 16.5 cm

FOLLOWING PAGE LEFT

Pictorial Biography of Tsongkhapa (One from a series of biographical paintings)

The Tibetan style of painting has been so ingrained within the wider popular Buddhist culture that it is unmistakable in its composition. Tibetan art can be identified by its busy and complex scenes, use of vibrant colours, symbology, and geometric precision. The artform of the thangka follows strict guidelines that must be adhered to due to the sacred nature of the subject; and therefore, paintings from Tibet have a uniform appearance and to distinguish one artist from another would be achieved with some difficulty. Here, we have the central figure of the prominent monk Tsongkhapa, the founder of the Gelug school of Tibetan Buddhism, identified by his tall yellow hat. He is surrounded by tales of his life, examples of his influence, and manifestations of deities.

———

ca. 19th century • Tibet • Colours on cloth; cloth mounting

H. 66 × W. 44.5 cm

FOLLOWING PAGE RIGHT

Panchen Chos Rgyan (blo bzang chos kyi rgyal mtshan) with Ksharpana Avalokiteshvara and White Six-armed Mahakala

This stunning painting depicts an esteemed lama surrounded by auspicious symbols in a ritual where he has summoned the Bodhisattva Khasarpani Avalokiteshvara and Mahakala. The giant size of the lama compared to the other monks reflects his spiritual hierarchy having achieved the highest level of awareness. The lush green foliage and water surrounding him signify purity and harmony of the mind. He sits on a lavish throne and is surrounded by refinement and comfort in paradise.

———

9th century • Tibet • Colours on cloth

H. 74.9 × W. 49.2 cm

258 BUDDHISM: A JOURNEY THROUGH ART

MONKS, LAMAS AND ARHATS 259

Hotei Admiring the Moon

Budai sits upon his famous cloth sack and gives gratitude to the Moon in this Zen illustration. Budai, a semi-historical Buddhist figure, is a popular subject of Chinese and Japanese art (known as Hotei in Japan). This rendition is a bit more unusual due to the composition; we see Budai from behind in a posture of reverence. The more ordinary depiction of Budai is front on, in a relaxed cross-legged posture with his belly exposed, and laughing broadly in a cheerful and amusing display. He doesn't look as rotund as is customary to his iconography in this illustration. Over time, the image of Budai became more exaggerated, possibly due to market demand. An unmistakable identifier of Budai is his cloth sack in which he was believed to carry all of his possessions as a wandering monk.

Formerly attributed to Ikei Shūtoku (Japanese, active first half of the 16th century) • Probably 19th century, Edo (1615–1868)–Meiji (1868–1912) period • Japan • Hanging scroll; ink on paper

H. 92.7 × W. 45.1 cm

MONKS, LAMAS AND ARHATS 261

Portrait of Bodhidharma

Artist Hakuin Ekaku (1686–1769), an accomplished and devout Japanese monk, showed his satirical side through his paintings. His humour would often be contrasted by poignant Zen inscriptions, and this method of encouraging the public to engage with Zen teachings through entertainment was nothing short of genius. His unique style of ink illustration showed confidence and competence as an artist. He had an unmistakable style where one can tell he was enjoying the process – having fun – with his paintings whilst the flow of the lines are undoubtedly Zen. Hakuin created several portraits of the monk Bodhidharma, who was most likely a source of reverence and inspiration. Bodhidharma is a legendary monk who was credited with transmitting Zen to China in the sixth century. Most of these portraits were painted in the same spontaneous fashion as this example. The calligraphy reads: 'No matter how one looks at it . . . '.

———

By Hakuin Ekaku • Mid-18th century, Edo period (1615–1868) • Japan • Hanging scroll; ink on paper

H. 117.5 × W. 54 cm

LEFT

Standing Monk

The lacquer that would have initially covered this beautiful figure of a monk has managed to protect the integrity of the sculpture over time, with wood being a medium susceptible to natural degradation. In its current state, we can appreciate the sculptor's mastery with the grain of the wood rolling in sync throughout. Unfortunately, the arms and hands which would have been attached separately are now missing. Despite the wear of this artefact, of most probably one of ten high-ranking disciples of the Buddha Sakyamuni, the features of the face have remained remarkably pronounced – the soft smile, rounded face, meditative eyes, and elongated ears still have vitality and an attractive character to them.

———

ca. 1275–1350 • Japan • Wood with traces of lacquer and linen

H. 106.5 × W. 30 × D. 23 cm

FACING PAGE

Poet Strolling by a Marshy Bank

This is possibly the most atmospheric and beautiful Zen painting to have survived the Song dynasty. The artist of this piece, Liang Kai, is well known for creating spiritual depth through his art and popularizing the 'Xie Yi' style of painting, in which the goal is to conjure a mood with the least amount of detail. Liang Kai has perfectly depicted inner stillness with this meditative painting. A solitary figure looks up at huge mountains covered by clouds; the work in itself perfectly portrays the imposing magnitude of nature whilst also demonstrating the impermanence of the self. The small figure reflecting upon the scene ahead of him has been overwhelmed and enveloped within his natural surroundings, giving the viewer a sense of physical and metaphorical perspective.

———

By Liang Kai • Early 13th century, Southern Song dynasty (1127–1279) • China • Fan mounted as an album leaf; ink on silk

H. 22.9 × W. 24.3 cm

Lineage Portrait of Buddhist Monks

This painting of twenty-four Buddhist priests is wonderful as the orderly formation of the monks with coordinated ceremonial attire is rhythmically pleasing to the eye whilst on closer inspection, the acute differences of the individual features draw the viewer into intriguing details. Often, we see the archetypal monk within Buddhist art but the fascinating aspect of this painting is that this is clearly a portrait of people who have lived and have been immortalized by the artist. The painting is so masterful that each figure can be studied in detail, and the age, looks, and personality of each is documented meticulously.

17th century • China • Hanging scroll mounted on a panel; ink, colour, and gold on papers

H. 171.5 × W. 99.7 cm

Daruma

A Zen Buddhist monk looks towards the viewer earnestly. With a groomed beard and a slight smile, this figure is believed to be the Buddhist monk Daruma (A.D. ca. 470–543), credited with being the founder of Zen. The ornate hooded robe he wears was reserved only for monks who had reached the highest skill within meditation and also pays homage to Daruma's Indian heritage. The rich red silk and golden embroidery of his robe further reflects his exalted status. Zen portraiture favoured the concept of negative space within an artistic composition, and this became a popular feature of Japanese art in general. The blank background of this portrait reflects the importance of its subject, Daruma.

1545–1555 • Japan • Hanging scroll; ink, colours, and gold on silk

H. 109.2 × W. 54 cm

The Illustrated Life of Shinran (Shinran shonin eden)

The tales of Buddhist monks were a popular subject for hanging scrolls. These graphic images depict the life of the Japanese Buddhist monk Shinran. The paintings are highly detail-oriented with an analytical quality to them that has a pragmatic and mathematical precision. Each scene is fascinating and gives an insight into how revered and respected Shinran was. The narrative of his story progresses chronologically from right to left, bottom to top. With scenes divided by horizontal bands of clouds, this would have been the first

MONKS, LAMAS AND ARHATS 267

attempt at a storyboard. These scrolls were an ideal way to commemorate and educate future generations of great and influential Buddhist monks.

17th–18th century, Edo period (1615–1868) • Japan • Set of four hanging scrolls; ink, colour, and gold on silk

SCROLL A: H. 194.3 × W. 87.9 cm • SCROLL B: H. 193.7 × W. 87.9 cm • SCROLL C: H. 193.7 × W. 87.9 cm • SCROLL D: H. 193 × W. 87.9 cm

MONKS, LAMAS AND ARHATS 269

FACING PAGE

Luohan, after a set attributed to Guanxiu

Guanxiu's paintings have long been thought of as masterpieces within Chinese culture, and these exceptional examples of a set of luohans exemplifies why. The Qianlong emperor believed he found an original pair of Guanxiu's paintings in a Hangzhou monastery in 1757. The emperor commissioned copies and had them carved in stone so that rubbings such as these could be made to preserve their original appearance. These copies are important examples of Guanxiu's style because the originals are lost. Since 1500 BC, ink rubbings have preserved China's art, culture, and history. These beautiful creations are made by inking small sheets of wet paper into stone or other hard materials to imitate the original. A characteristic black ink field surrounds the white impressions where the paper was pressed into the carving. Rubbings were the most important means to reproduce and share historical art in China.

———

Unidentified artist, possibly Ding Guanpeng (active 1726–71) • Stone carved in 1757; rubbing 18th or 19th century; Qing dynasty (1644–1911) • China • Ink on paper

With mounting: H. 138.7 × W. 70.5 cm

FOLLOWING PAGE LEFT

The Fury of Monk Raigo

Kobayashi Kiyochika (1847–1915) was an accomplished artist famous for his graphic depictions. His realistic perspective blended with his animated and energetic style led to a truly unique artist who undoubtedly was one of the best in his field. This painting depicts the legendary tale of monk Raigo (1002–1084) who was said to have assisted emperor Shirakawa in conceiving a son through prayer. The emperor promised to grant monk Raigo whatever he wanted as a sign of his gratitude but later redacted his word leading the monk to fly into a rage, as depicted here. Monk Raigo can be seen ripping apart the emperor's sacred scrolls with his teeth in an act of spite whilst a fire ravages the temple.

———

By Kobayashi Kiyochika • ca. 1900, Meiji period (1868–1912) • Japan • Hanging scroll; ink, colour, and gold paint on silk

H. 108 × W. 78.7 cm

FOLLOWING PAGE RIGHT

Thangka of Portrait of Sakya Pandita

Tibetan paintings are acclaimed for their exciting imaginative visuals and use of vibrant colours. This image of Buddhist scholar and spiritual leader Sakya Pandita (1182–1251) is no exception. Although Tibetan art has a spiritual intention and is not created for aesthetic purposes, paintings from Tibet are some of the most beautiful masterpieces in the world admired in museums and galleries alike. Many features of this work make it intriguing – the clashing of textures and patterns establish a highly decorative overall visual whilst the eye is drawn to the main subject of Sakya Pandita. In the background, we clearly see his beautiful residence which reflects a luxury that our carnal human nature can appreciate and interpret as bliss and contentment. Sakya Pandita was so knowledgeable and respected as a monk and leader that he is considered an emanation of Manjushri, the embodiment of all wisdom.

———

ca. 1800 • Tibet • Pigment on cloth

H. 65 × W. 50 cm

270 BUDDHISM: A JOURNEY THROUGH ART

MONKS, LAMAS AND ARHATS

Kana Letter on Stamped Images of Buddha

The juxtaposition of written calligraphy with the image of the Buddha stamped repeatedly behind creates an interesting and inadvertent piece of art. Monk Jogyo, who despite his family's military background chose the path of the Buddha, was the draughtsman of this calligraphy. Stamped repetition of the Buddha or Buddhist deities were seen as an act of devotion, and so this would explain the writing's unique background of Buddha stamps that have seeped through from the opposite side of the paper. The importance of monk Jogyo within the Buddhist faith would have warranted the preservation of his calligraphic scrolls in any case; however, the added Buddha stamps would suggest this scroll was used within a reliquary to honour his death. Using a woodblock print and ink to repeatedly stamp the image of Amida Buddha was an act of merit-making – a traditional Buddhist practice that would have been employed to assist monk Jogyo in his next life.

By Monk Jogyo • Early 13th century, Kamakura period (1185–1333) • Japan • Hanging scroll; brush written letter, ink on paper (front); stamped images, ink on paper (reverse)

H. 27 × W. 41.9 cm

MONKS, LAMAS AND ARHATS 273

Portrait of Hotto Enmyo Kokushi

Shinchi Kakushin (1203–1298) was a renowned Japanese Zen master who was given the posthumous title of Hotto Enmyo Kokushi by the emperor Go-Daigo. The stand-out feature of this sculpture of the Buddhist monk Kokushi is the remarkably expressive and realistic face. He almost looks as if he may catch you staring. Despite the realism of this work, the artist could not resist showing his finesse for design with conscious stylistic considerations, such as the minor exaggerations of the ears and cheekbones. The artist was careful to simplify the robe and body in a tasteful way so that the sculpture's face drew the eye first and commanded attention. The shoes which lay below his robe where he is sitting cross-legged in meditation, are a considered detail used in Japanese art of revered Buddhist figures. The Kamakura period is famed in Japanese art history as a time that reached the apex of realism in sculpture.

ca. 1295–1315, Kamakura period (1185–1333) • Japan • Hinoki cypress wood with lacquer, metal staples, and fittings

H. 91.4 cm

RIGHT

Buddhist Monk Budai

Budai, a significant monk in the tenth century, is often mistaken for the Buddha in Western ideology. The average person may describe Budai when thinking of the Buddha due to his popularity in art and his presence in commercial souvenirs and brands. This small figure is unmistakably Chinese due to the use of historic white porcelain. This is a particularly fine example due to the acute detail of his features – we can even see the full set of his teeth and the inside of his mouth. His eyes have irises and pupils and are surrounded by expression lines which have been executed with extraordinary skill.

17th–18th century, Qing dynasty (1644–1911) • China • Porcelain with ivory glaze (Dehua ware)

H. 617.1 × W. 18.4 × D. 14 cm

LEFT

The Buddhist Disciple Phra Sankachai

This is a popular image of the famous Buddhist disciple known as Phra Sankachai in Thai Buddhism. Southeast Asian Buddhism adopted him from the Chinese monk Budai. This is an unusual and incredible sculpture from seventeenth-century Thailand; the figure is squat and dumpy unlike the usual Thai Buddhist figures of this era, which are slender and defined, the characteristics are unmistakably Phra Sankachai and his legendary appearance makes for an interesting and beautiful form. One of the finest portrayals of Phra Sankachai, this bronze sculpture is exceptional with his fine features and perfectly cast repetitive circular hair. Holding his belly with a gentle and contented countenance, he is a joy to behold.

ca. Late 17th century • Thailand • Bronze with traces of gilt; eyes inlaid with shell and garnet

H. 36.8 × W. 39.4 cm × D. 28.6 cm

Three Poems from the Later Collection of Japanese Poems (Gosen wakashū), or 'Shirakawa Fragment' (Shirakawa-gire)

Calligraphy has long been considered a meditative practice, and the proficiency in which an artist can elegantly and effortlessly write in cursive can be seen to be a direct reflection of their state of spiritual awareness. The nature of taking the written word and turning this into a visual art is something that Buddhism has always excelled in. This example in which the original artist is unknown displays a confident and adept style in which the lines flow in beautiful harmony and grace.

Traditionally attributed to Monk Saigyo (1118–1190) • Late 12th century, Heian period (794–1185) • Japan • Folio from a booklet, mounted as hanging scroll; ink on paper

H. 17.4 × W. 14.5 cm

Virtue

A large and graphic 'Virtue' dominates this cursive text by the famed artist and Zen Buddhist monk, Hakuin Ekaku (1686–1769). Believed to be originally composed by Chinese historian and Confucian scholar Sima Guang, the inscription reads:

If you pile up money for your children and grandchildren, they won't be able to hold onto it.
If you pile up books for your children and grandchildren, they won't read any of them.
No, the best thing to do is to quietly accumulate virtue, in the spiritual realm.
Such a gift will benefit your descendants for a long, long time.

Trans. adapted from Jonathan Chaves

———

By Hakuin Ekaku • Mid-18th century, Edo period (1615–1868) • Japan • Hanging scroll; ink on paper

Ascetic Holding a Skull

Ascetics are sometimes portrayed as starving figures due to their history of going through gruelling physical trials in the quest for enlightenment. This gilt bronze figure has an angular form to portray the ascetic's visible jutting bones, his ribcage is pronounced over a belly swollen from hunger. There is something very spellbinding about the stylistic elements employed by the artist. Interesting considerations in approach to this sculpture appear primitive and simplistic. The overall impression is that this form is ritualistic or esoteric in nature. The face and hair have a particularly abstract quality; each mark from the carver's tool can be seen in a contemplated rustic and intimate way. This figure is special because of an intangible quality of artistry that is difficult to describe. This relatively small piece is not a subject of academic analysis but undoubtedly a true masterpiece of sculpture.

———

ca. 6th century • China, Northern Wei dynasty • Gilt bronze

H. 19.4 cm

MONKS, LAMAS AND ARHATS 279

RIGHT

Arhat Nagasena

An arhat sits in contemplation in a relaxed pose of royal ease. He is adorned in fine silks and a generous robe exalting his status as an important enlightened being. This captivating sculpture encapsulates the divine but human balance of the arhat with a serene but dignified expression, his face flanked by elongated ears and his neck featuring three rings, both auspicious symbols of Buddhahood.

———

ca. 18th century • Tibet • Gilded copper alloy

H. 19.1 × W. 12.7 × D. 11.4 cm

LEFT

Buddhist Monk Bodhidharma (Chinese: Damo)

The detail of this figure's expression and the dramatic execution of the drapery is more impressive when we consider the small size of this sculpture. This portrait is of Bodhidharma, the monk credited with founding the Chan (Zen) sect of Buddhism. He is wearing full monastic robes and seated cross-legged in meditation with his eyes closed. His posture is unsurprising since Bodhidharma's legend has been in large part immortalized by a story that he spent nine years meditating in a cave.

———

17th century, Late Ming (1368–1644)–early Qing (1644–1911) dynasty • China • Rhinoceros horn

H. 10.8 × W. 8.3 × D. 7 cm

Monk Nichiren in Exile on Sado Island, From the Series 'Illustration of Famous Monks'

A lone monk struggles up a snowy mountain and is caught in a snowstorm. He is clearly ill equipped for the journey and is struggling uphill which reflects the trials he is yet to face. Behind him and at the bottom of the mountain, a village, symbolic of the civilization he leaves behind can be seen. This noteworthy ink print was by the highly esteemed artist Utagawa Kuniyoshi (1797–1861), well known for his woodblock prints. The print depicts the life of the monk Nichiren (1222–1282), the founder of the Nichiren Buddhist sect, who lived in exile on Sado Island from 1271 to 1274.

By Utagawa Kuniyoshi • 1835–36, Edo period (1615–1868) • Japan • Woodblock print; ink and colour on paper

H. 24.8 × w. 37.5 cm

MONKS, LAMAS AND ARHATS 281

高祖御一代略圖

佐州塚原雪中

Fudo Myoo Threatening a Novice

This image is a testament as to why Tsukioka Yoshitoshi (1839–1892) is considered a master of woodblock printing. The black ink background adds to the overall drama and gravitas of the scene, and due to his brightly coloured and patterned garb, our eyes are instantly drawn to the Buddhist deity, Fudo Myoo. The artist draws our eyes to him through the contrast of a bright nimbus that frames his face. An artistic consideration to make Fudo Myoo's skin grey was to illuminate his bright sword that points to the novice monk and emphasize the deities' original state of stone. This painting depicts the legend of Abbot Yūten (1637–1718) of Zojoji Temple, who prayed for Fudo Myoo's aid to become a wise monk. He then had a dream that the statue of Fudo leaped down from its pedestal and made him swallow one of his swords; upon waking, he became an excellent cleric.

By Tsukioka Yoshitoshi • 1885, Meiji period (1868–1912) • Japan • Triptych of woodblock prints; ink and colour on paper

Overall (a): H. 37.5 × W. 25.4 cm • Overall (b): H. 37.1 × W. 25.4 cm • Overall (c): H. 37.9 × W. 25.6 cm

MONKS, LAMAS AND ARHATS 283

FOLLOWING PAGE LEFT

Portrait of the Indian Monk Atisha

The artist of this portrait has cleverly used contrasting colours and space so that the eye is drawn immediately to the monk's golden skin, which is an illuminating and sacred colour in Buddhism. His spiritual enlightenment is further emphasized by the auspicious symbol of the Buddha's golden wheel on his palm, signalling divine wisdom. His nimbus is dark in order to accentuate his yellow hat which identifies him as Atisha, who was the abbot of Vikramashila monastery in northern India, one of the *mahaviharas* (great monasteries) that granted the learned degree of pandita.

———

Early to mid-12th century • Tibet • Distemper and gold on cloth

H. 49.5 × w. 35.4 cm

FOLLOWING PAGE RIGHT

Portrait of a Buddhist Monk

This is a particularly impressive lineage painting of a Buddhist monk. The posture of sitting in meditation is a bit more unusual as lineage portraits usually have the same prototype adopted from China whereby the subject is seated on a chair with a footstool. The practice of portraiture was intended for remembrance, historical context, and providing authenticity to the appointed abbots.

———

Late 18th/early 19th century • Korea • Ink and colour on silk

H. 99.7 × w. 78.1 cm

FACING PAGE

Portrait of the Great Master Seosan

Hyujeong is a revered Korean leader of Seon (Zen) Buddhism who in his youth rebelled against the dominant social climate of Neo-Confucian. In his later years, after becoming a great Seon Master, he was called upon to defend the capital of Korea against Japanese invaders (1593) with an army formed of monks. He played a critical role in the expulsion of the Japanese invaders. This portrait has taken great consideration to dignify Hyujeong who would become known as 'the Great Master Seosan'. He sits cross-legged in a magnificent robe featuring the traditional Korean royal colours. He holds in his hand a fly-whisk made from a white yak tail and embellished with jewels, a sign of spiritual sovereignty. He has long nails that signify his nobel status, being exempt from manual labour – as only the highest echelons of society had the privilege of long nails.

———

Late 17th–18th century, Joseon dynasty (1392–1910) • Korea • Hanging scroll; ink and colour on silk

H. 152.1 × w. 77.8 cm

286 BUDDHISM: A JOURNEY THROUGH ART

MONKS, LAMAS AND ARHATS 287

288 BUDDHISM: A JOURNEY THROUGH ART

A Nenbutsu Gathering at Ichiya, Kyoto, from the *Illustrated Biography of the Monk Ippen and His Disciple Ta'a (Yugyo Shonin engi-e)*

The artist has entirely captured the mood and atmosphere of an excited crowd. People are talking amongst themselves, some are bored and others cheerful, whilst children play.

This illustration depicts the people who have come from far and wide to watch Ippen, a monk who was a prominent figure at the time. They are waiting in anticipation and huddled together to see their illustrious leader and watch a chanting and dancing procession. It was said that he could invoke the Amida Buddha through prayer. Ippen believed in the Pure Land doctrine and that salvation could be accomplished by reciting the Amida Buddha's name.

Late 14th century, Nanbokuchō period (1336–92) • Japan • Section of a handscroll mounted as a hanging scroll; ink and colour on paper

H. 32.4 × W. 45.1 cm

Biographies of Lian Po and Lin Xiangru

This handscroll features calligraphy from Zen Buddhist adept, Huang Tingjian (1045–1105), and is an account of a rivalry between two officials – Lian Pao, a general; and Lin Xiangru, a master strategist. The spontaneity is evident by the continuing lines which show no break in the ink. The flow of the text infers swiftness and balance whereby the artist was allowing his hand to move intuitively without much thought to the paper. Writing in this way was a mental exercise that assisted the cultivation of mindfulness.

———

Calligraphy by Huang Tingjian • ca. 1095, Northern Song dynasty (960–1127) • China • Handscroll; ink on paper

H. 33.7 × W. 1840.2 cm

A Gatha (Contemplative Verse) by Fu Daishi (497–569)

This is an exquisite example of confident and skilled calligraphy by Japanese Zen master Bankei Yotaku (1622–93). He was an interesting character, who from a young age questioned everything he was taught including Confucianism; he also had a deep interest in philosophy and social science. He lived sporadically as a hermit throughout his life in order to obtain answers to his questions about the meaning of existence. He eventually landed on his own philosophy that blended Zen and the Dao.

This calligraphy reads:

*Existing even prior
to heaven and earth
without form, silent,
alone by itself,
Its boundless power
controls all creation;
It remains unchanged
as the seasons unfold.*

(Trans. John T. Carpenter, Courtesy, The Metropolitan Museum of Art)

———

By Bankei Yōtaku (Eitaku) • Late 17th century, Edo period (1615–1868) • Japan • Hanging scroll; ink on paper

H. 126 × w. 51.8 cm

Buddhist Maxim on the Saving Power of Amida

This wonderful calligraphy by Zen Buddhist monk Gukyoku Reisai (1336–92) reiterates the belief of the Pure Land sect of Buddhism that reciting Amida Buddha's name can lead to salvation. Noted by the Metropolitan Museum of Art: 'This couplet, written in Chinese cursive script, reads, from right column to left:

For an utterly evil person, there is no other expedient means. Simply recite the name of [A]Mida to achieve birth in Paradise.

(Trans. John T. Carpenter)

By Gukyoku Reisai • 15th century, Nanbokuchō period (1336–92) • Japan • Pair of hanging scrolls; ink on paper

H. 93.4 × W. 22.3 cm each scroll

Portrait of Daruma

This portrait is quite different from the other renditions we have in this book of the famous Buddhist monk Daruma, also known as Bodhidharma. His expression is quite serious, looking downwards in contemplative meditation. He is in profile and is rendered with only a few carefully established lines of ink, his hair which is brushed on last contrasts against his skin and the background. The empty space surrounding him can be seen to represent the notion that one must first be empty in order to be fulfilled. Unkoku Togan (1547–1618) was a Kano atelier-trained artist, the successor to Toyo Sesshu's (1420–1506) lineage of Chinese ink painting.

By Unkoku Tōgan • Early 17th century, Momoyama (1573–1615) • Japan • Hanging scroll; ink on paper

H. 100.3 × W. 35.9 cm

Portrait of Shun'oku Myōha

The composition of this portrait with the subject sitting on a chair opposite a footstool, together with his incredibly fine and expensive robes would suggest that this is an important Zen priest with an authoritative position in society. His shoes sitting upon the pedestal is a symbol of hierarchy common in Zen portraiture. He sits cross-legged whilst holding a bamboo staff, his face is pensive and calm and the fabric of his robes have overlapped into his seating area. According to the title, this is the Zen monk Shun'oku Myōha (1311–1388) and as noted by the Metropolitan Museum of Art, Shun'oku inscribed his portrait with a poem:

There are no eyes atop the head.
There are eyebrows below
the chin.
This is everything; this is nothing.
I also could not become
a phoenix.

Inscribed by Myōha of Tenryū[ji] for [illegible] at Muryōju'in
— Translation by Anne Nishimura Morse and Samuel Morse

Nanbokuchō period (1336–92) • Japan • Hanging scroll; ink, colour, and gold on silk

H. 115.9 × w. 52.1 cm

Portrait of Dengyo Daishi (Saicho)

Saicho was a notable Buddhist monk credited with establishing Tendai Buddhism in Japan. Despite this, he is not a hugely popular subject in Buddhist art and this is probably the finest portrait of Saicho that exists. He can be identified by his distinctive head covering which, in this case, is beautifully embroidered with silk in a lavish display. It was not unusual for Buddhist masters to wear ceremonial robes and be seated in a chair in this type of portrait. However, this rendition is interesting due to the silk painting behind him – perhaps alluding to the master's departure from the earthly realm. The reverence for Saicho's memory is evident by the technical skill and high level of detail in this painting, which is meticulous in its representation down to the textures of the fabrics and upholstery, to the silk painting Saicho sits in front of.

Early 18th century, Edo period (1615–1868) • Japan • Hanging scroll; ink, colour, and gold on silk

H. 117.2 × W. 58.1 cm

FACING PAGE

Portraits of Two Lineage Masters of the Kagyu Order: Phagmo Drupa (1110–1170) and Tashipel (1142–1210)

Two monks, side by side mirror each other's gaze, sitting cross-legged in a posture of meditation on a lotus pedestal, symbolic of their divine nature. Surrounded by auspicious symbols, mythical animals, and powerful deities, both have a radiating nimbus emanating from the head and are sheltered by temple enclaves. They wear vibrantly-coloured robes that are richly patterned and embroidered with silk ornamentation – robes such as this reflect the wearer's high spiritual rank whilst being connected to the material realm. On the right, sits the founder of the Taklung Monastery in Lhasa, the capital of Tibet next to his predecessor on the left. Tibetan thangkas are often colourful and visually stimulating in order to reinvigorate the practitioner with divine energy and leave an imprint on the introspective mind.

———

ca. 1236–1310 • Tibet • Gum tempera on sized cotton

H. 51.4 × W. 39.4 cm

FOLLOWING PAGE LEFT

Lineage Portrait of an Abbot

The Buddhist tradition of lineage portraits is an important one. Great masters imparted their wisdom to their students and this practice ensured that sacred knowledge remained throughout the generations. The heritage of the great masters who transmitted their wisdom is documented in portraits such as this in a form of remembrance but also important historical context for the temple. Tibetan Buddhists also immortalized important monks and lamas in lineage portraits as a source of reverence and devotion; they believe the lamas were an emanation of the Buddha who had chosen a life on earth to help humanity move closer to enlightenment.

———

ca. 1350 • Central Tibet • Distemper on cloth

H. 77.2 × W. 59.7 cm

FOLLOWING PAGE RIGHT

Portrait of a Lama, Possibly Dromton

A lama sits with his legs crossed whilst his hands hold prayer beads. He wears an embroidered red-and-gold silk robe signalling his high spiritual rank. His expression is one of peace and contentment. He sits upon a throne guarded by various auspicious symbols and animals whilst two bodhisattvas look at him from above. According to the Metropolitan Museum of Art, 'In all likelihood it depicts Dromton (1005–1064), of whom Chengawa Tsultrim Bar was a leading disciple. Dromton was the founder of the Reting monastery, seat of the Kadampa school and the foremost disciple of the Indian monk Atisha, who revitalized Tibetan Buddhism in the first half of the eleventh century.'

———

Last quarter of the 11th century • Tibet • Distemper on cloth

H. 46.4 × W. 36.2 cm

MONKS, LAMAS AND ARHATS 301

FACING PAGE

A Group of Luohans

During the Ming dynasty (1368–1644), Ding Yunpeng was a Chinese painter who specialized in human figures and landscapes. His characterizing style was confident and bold. He favoured detail, and his work is often witty and amusing. This ink drawing of a group of luohans (Buddhist arhats who have achieved salvation) is typical of his style of illustration. Ding was born in the Anhui province of China, in the city of Xiuning. His sobriquet was 'Shenghua jushi,' and his style name was 'Nanyu'. Ding's paintings resembled artwork from the Song dynasty and were inspired by Qiu Ying's approach.

———

By Ding Yunpeng • 1613, Ming dynasty • China • Ink on paper

H. 137.3 × W. 84.9 cm

FOLLOWING PAGE LEFT

Thangka of Vajriputra, One of the Sixteen Great Arhats

This is a painted thangka of Vajriputra, one of the legendary sixteen arhats. He is depicted in his usual iconography of having a fine groomed moustache and grey trimmed hair, which identifies him as being of mature age. He raises his right hand in the *karana* mudra, which is believed to eliminate barriers and guide the practitioner to enlightenment. He looks upon a pheonix which reflects his peaceful countenance and wisdom. An exquisite red fly-whisk topped with a tuft of white yak-tail hair is held in the hand of his left arm which is a sign of spiritual sovereignty. An orange areola surrounds his head, and a celestial figure stands to the right. Ushnishavijaya, the Goddess of Long Life, dwells above him.

———

Late 17th/early 18th century • Tibet • Pigment and gold on silk and cotton

H. 102 × W. 61.5 cm

FOLLOWING PAGE RIGHT

Arhats

This is one of the most fabulous portrayals of Buddhist arhats from Korea in the nineteenth century. The expressive personalities of the figures and their vivid, vibrant attire make for a beautiful and interesting painting. The monk on the right is more esoteric in nature, clutching a wish-granting jewel and a dragon. The dragon was believed to be able to control the weather and depending on what was necessary could help dispel or bring rainfall. The monk on the right is more meditative in his stance and expression. Their robes suggest they are at the highest levels of spiritual reverence; they are green, red, and blue reflecting the region and time of their sect. The two arhats, one older and most likely with his disciple, together are a formidable and powerful force. It is worth noting the use of clashing textures throughout the painting; texture and pattern were used as a way to illustrate the abstract essence of reality.

———

Late 19th century, Joseon dynasty (1392–1910) • Korea • Panel; ink and colour on cotton

H. 82.23 × W. 63.18 cm

Monk Renshō Riding his Horse Backwards

During the Heian period of Japanese history, Kumagai was a famous soldier who served the Genji (Minamoto) clan. Later in life, as a disciple of Honen, he became a Jodo-shu Buddhist priest. He changed his name to Renshō and vowed never to abandon Amida, the Buddha of the Western Paradise. Kumagai is frequently depicted in artistic renditions riding his horse backwards. Though more myth than historical fact, he is said to have been determined, as part of his penance and devotion, to always face the Western Paradise of Amida, even when riding to the east. Ink wash paintings in Japan were influenced by and the result of Zen calligraphic concepts. These illustrations have no room for error due to their simplicity with brush lines being the main focus, and this is one of the most beautiful examples.

———

By Matsumura Goshun (1752–1811) • ca. 1784, Edo period (1615–1868) • Japan • Hanging scroll; ink on paper

H. 38.3 × w. 55.1 cm

Courtesan of Eguchi

On a white elephant sits a woman dressed in a lavishly designed kimono. The subject of this painting is based on a fifteenth-century Noh play about a courtesan who is believed to be a manifestation of Fugen Bosatsu (usually depicted riding an elephant, his sacred vehicle), a Buddhist deity who is said to accompany the Historical Buddha Sakyamuni according to the Lotus Sutra. On his approach to the temple in Osaka one rainy night, itinerant monk-poet Saigyo stopped at a brothel for shelter. The prostitute initially refused him to enter because he was a monk, but Saigyo objected, saying that a person who has not forsaken the world should not dare to deny lodging to a monk. The courtesan finally gave in and allowed him to stay. The artist conveys the Buddhist teaching that appearances are false. The combination of the sacred and profane appealed to Edo's popular cultural sensibilities, and the topic gained substantial popularity.

By Katsukawa Shunshō (1726–1792) • Calligraphy by Butsumo Keisen (1771–1854); Painting: 1770–80; Inscription: 1820s–1830s, Edo period (1615–1868) • Japan • Hanging scroll; ink and colour on paper

H. 37.8 × W. 51.9 cm

A Luohan

One of the eighteen followers of the Buddha, the luohan Ajita is depicted attentively listening to the reading of a sutra. He is finely carved from wood with an extremely realistic face due to the finer details such as the small folds of skin under the eye and the curvature of his cheeks. It can be assumed by the realism of this portrayal that this sculpture was created with the assistance of a seated life model. The irises and pupils have been inlaid with glass and glint in the light. Although mostly lost, some lacquer and pigment is still present on the surface giving an insight into how magnificent this sculpture would have been.

ca. 13th–15th century • China • Wood, traces of polychrome decoration, lacquer and glass

H. 109 × W. 59.5 × D. 44.5 cm

Luohan Laundering

This fascinating painting was part of a huge commission of 100 temple paintings which paid homage to a Chinese legend, called the five-hundred luohans. In this scroll, we see the luohans doing their laundry in the river and hanging the clothes out to dry. This is an intimate portrayal as luohans are often usually depicted as transcendent and mythological beings. Each luohan has different identifying features which distinguishes one from the other. The luohan with long eyebrows is Asita who is known for this characteristic. The painting shows a well-educated and considered approach to the execution, the ripples and waves of the river for example, show the traditional decorative way of painting that had been long established in China.

By Lin Tinggui • 1178, Southern Song dynasty • China • Ink and colour on silk

H. 112.3 × W. 53.5 cm

The Sixteen Luohans

This painting was one of a set depicting the sixteen luohans. The grouping of sixteen luohans was seen as an auspicious number with this formation originating in India before spreading to the rest of Asia. In this scroll, they have been softly caricatured in fine and beautifully stylized brush strokes. One luohan sits meditatively inside the bark of a tree, unnaturally at one with the balance of nature, the tree growing around him to form a throne. The perfectly groomed formation of the background foliage surrounding the pair represents the supernatural qualities the luohans were believed to possess, they have escaped the karmic cycle of reincarnation and reached a state of perfection.

By Wu Bin (active ca. 1583–1626) • 1591, Ming dynasty (1368–1644) • China • Handscroll; ink and colour on paper

H. 32.1 × W. 415.4 cm

MONKS, LAMAS AND ARHATS 309

TEMPLES
AND ARTEFACTS

Vajra with Angry Heads and Makara Prongs

The vajra is a ritual tool often used in conjunction with a bell. These two combined are most commonly used in Tibetan Buddhist ceremonies. The vajra reflects the feminine, the bell the masculine, and together they symbolize the enlightened mind. The vajra, like the diamond, destroys yet cannot be destroyed and has two meanings in Sanskrit: 'thunderbolt' and 'diamond'. The thunderbolt was originally the symbol of the Hindu deity Indra and was later assimilated into Tantric Buddhism.

―――

Tang dynasty (618–907) • China • Gilt bronze

H. 3.2 × W. 4.4 × D. 21.6 cm

Blade and Mounting for a Double-Edged Dagger (Ken)

The ritual sword is something that is more prevalent in Buddhist paintings, particularly with respect to the iconography of a guardian deity. In Tantric Buddhism, a much smaller physical ritual dagger is used ceremonially; however, a sword is rare. We know this sword is ritualistic in nature due to the hilt of a triple-pronged vajra. The vajra represents skill and method and is considered to be able to cut through the physiological barriers of ignorance and fear.

―――

Blade, late 12th–early 13th century; mounting, 14th century • Japan • Steel, wood, copper, gold

L. of blade 30.6 cm;
L. of cutting edge 20.8 cm;
L. of hilt 9.7 cm

TEMPLES AND ARTEFACTS **313**

Wheel of the Buddhist Law (Rinpo)

The Dharma Wheel, commonly known as the Dharmachakra, is a venerated symbol in Buddhism and possibly the oldest and most well known. It represents Buddha's first sermon near Sarnath. The Dharmachakra's eight spokes signify the Eightfold Path and the wheel represents the completeness of the dharma. The wheel can also be seen to signify the cyclical nature of existence, reincarnation, and karma.

―――

Late 13th century, Kamakura period (1185–1333) • Japan • Gilt bronze

DIAM. 12.7 cm; TH. 11 cm; WT. approx. 1.2 lbs (530 g.)

Top of a Bell in the Form of a Demon King or Guardian

This beautifully formed but grotesque figure has bulging eyes, sharp fangs, and an expression of grimace. He wears armour and is stout with a pot belly. He carries a flaying knife in one hand and a helpless adversary who also wears armour in the other. This threatening figure was the centre point of decoration for a temple bell and was a character from early Buddhism, called Rakshasa. This deity originated from Hindu mythology and was assimilated into the Buddhist pantheon of mythical creatures as a once malevolent supernatural being turned into a wrathful protector of Buddhist scripture.

ca. Second half of 12th–early 13th century, Eastern Javanese period • Indonesia (Java) • Bronze

H. 12.5 cm

Buddhist Ritual Object in Form of a Canopy on Lotus Base

This beautiful object would have been part of a set of eight. Each decorative and sacred piece represents the eight Buddhist treasures. These include the parasol, the golden fishes, the treasure vase, the lotus, the turning conch shell, the endless knot, the victory banner, and the wheel. This would have been first displayed in the set of these sacred objects and represents the parasol. In early Buddhist depictions when the Buddha was not anthropomorphic, the parasol would often represent his presence.

1736–1795, Qianlong period • Indonesia (Java) • Cloisonne enamel on copper alloy

H. 38.1 × W. 12.1 cm

TEMPLES AND ARTEFACTS 317

LEFT

Chōmeiji Temple Pilgrimage Mandala

The pilgrimage mandala came into fashion in sixteenth-century Japan. The painting would serve as an attractive informational and travel endorsement for the temple in order to raise much-needed funds for repairs and upkeep of the sites. This is a stunning example of the bird's eye view of the Chōmeiji Temple. The painting serves its purpose to garner interest and excitement with incredible detailing as well as the beautiful natural surroundings and impressive architecture. The mandala strikes the perfect balance of technicality and imagination.

———

Second quarter of 16th century, Muromachi period (1392–1573) • Japan • Hanging scroll remounted as a two-panel folding screen; ink, colour, gofun (ground shell pigment), and gold on paper

H. 148.3 × W. 161 cm

FOLLOWING PAGES

Scenes in and around the Capital

These stunning ink and gold-leaf silk screens are a true marvel from the Edo period featuring major landmarks in Kyoto. The detail of the village on close inspection is truly incredible and so fascinating, one could look at this work for hours and find something different. Each individual is wearing unique clothing, has different features, and plays a different role within the village. The buildings and the perspective in which they were painted shows the incredible technical skill of the artist. Japan is prized for the artistry of silk screens which have become part of the fabric of Japanese art and culture. Many examples of silk screens, which are used as room dividers, can be found in Buddhist monasteries. The fact that this screen is so beautifully gilded and the design is so elaborate, it is fair to assume it was commissioned by a wealthy patron.

———

17th century, Edo period (1615–1868) • Japan • Pair of six-panel folding screens; ink, colour, gold, and gold leaf on paper

Image (each): H. 156.1 × W. 352.2 cm

Overall (each): H. 170 × W. 366.2 cm

TEMPLES AND ARTEFACTS 319

320 BUDDHISM: A JOURNEY THROUGH ART

TEMPLES AND ARTEFACTS 321

FACING PAGE

Kinryūsan Temple at Asakusa, from the series 'One Hundred Famous Views of Edo'

This striking print showcases the style and refinement of woodblock printing from the Edo period. This intimate scene was created from the vantage point of the viewer; we are looking through a temple doorway at a beautiful snowy scene of Asakusa. The colour red is prominent in Japanese architecture, particularly at Shinto shrine gates. Akani, this specific red colour, is believed to protect against evil or disaster. It also strengthens the spiritual bond between living beings and the gods, known as kami worshipped at Shinto shrines. Considered one of the most revered temples, Kinryusan Sensoji was dedicated to the Bodhisattva Kannon.

———

By Utagawa Hiroshige • 1856, Edo period (1615–1868) • Japan • Woodblock print; ink and colour on paper

H. 35.7 × W. 24.1 cm

ABOVE

Funerary Pagoda with Four Buddhas

This architectural model of a pagoda is beautiful and curious. Exactly why this incredible work of art was created is up for debate. The ornate detailing and extraordinary technical skill of the sculptor means this piece would be for a very important purpose. It may have housed the remains of an influential monk, which would be a natural use for this type of object. It could also have been commissioned by a wealthy patron to hold the relics of his family.

———

ca. 560–75, Northern Qi dynasty (550–577) • China (probably Shandong province) • Limestone with traces of pigment

H. 241.3 × W. 171.5 cm

Ritual Crown with the Five Transcendent Buddhas

This headpiece would have been worn by a Buddhist monk during certain rituals or ceremonial practices within Esoteric Buddhism. Each Tathagata Buddha is represented in one of the five registers with the colour denoting the Buddha's form (from left to right) we find: Ratnasambhava (yellow), Amitabha (red), Vairochana (white), Amoghasiddhi (green), and Akshobhya (blue).

———

Late 14th–early 15th century • Tibet •
Opaque watercolour and gold on board

Each panel: H. 19 × W. 11.2 cm

Finial in the Shape of a Dragon's Head and Wind Chime

The dragon is revered in Korean art and culture as it is regarded as a defender of mankind as well as a deterrent to evil spirits. For this reason the dragon is traditionally hung from the rafter corners of Korean Buddhist temples as an emblem of guardianship and protection. This sculpture, which served as a wind chime, is a testament to how skilled Goryeo metalworkers were. A metal-plated clapper was originally within the bell, which served as a *punggyeong*. Auspicious symbols usually adorn such bells, in this case, the swastika, an ancient Buddhist symbol of universal harmony, prosperity and good fortune, is embossed on the front. A hook would have been used to suspend the bell from the dragon's mouth loop. This dragon has a furrowed brow and full set of teeth on display to demonstrate its fierceness in the face of an adversary. On the other hand, the large eyes, short nose, and upturned mouth give the sense of an affable and domesticated creature ready to defend the devout. In the Korean tradition, the dragon was a benevolent creature and associated with good luck.

Dragons appear in the lore of many ancient civilizations. The early Buddhist dragon can first be traced back to India in the form of *nagas*, mythological beings associated with water. After being assimilated into the other Buddhist traditions and regions of Asia, the dragon changed form and function depending on the region in which it had taken root. In Korea it became one of the most important Buddhist divinities.

10th century, Early Goryeo dynasty (918–1392) • Korea • Gilt bronze

Finial: H. 129.8 × W. 22.9 × D. 39.4 cm;
Chime: H. 38.7 × W. 18.4 cm

Spring Sunrise at Horai

This calm and scenic illustration of Horai, a mythological Japanese paradise, is in the style of Buddhist Zen painting. These paintings often focus on the grandeur of nature whilst mirroring the simplicity and immaterial nature of life. In this case, this is reflected with small figures of people dotted within the picture doing their daily tasks. Small plots of architecture are overwhelmed with mountains, foliage, and trees which reflect a more transcendental view of reality.

———

By Tanomura Chokunyū (Japanese, 1814–1907) • 1881, Meiji period (1868–1912) • Japan • Hanging scroll; ink and colour on satin

H. 149.5 × W. 65.8 cm

Guardian Lion

This is one of the most stunning examples of a Buddhist temple lion to exist. The features and muscle definition suggest a master sculptor of the traditional white marble from China. The lion, who is a protector of Buddhist temples and the dharma, takes on a mythical appearance, and this example looks more like a traditional lion than most. Some don't look like lions at all – they can take on an anthropomorphic quality usually in the mouth and sometimes resemble dogs; while some look fierce, others look more cheerful. These changes in appearance can stem from the region or time period.

———

ca. 7th century, Tang dynasty • China • White marble

H. 78.8 cm; WT: 435 lbs (197.3 kg)

Bronze Ritual Bell

The bell has long been a symbol of time and also used ceremonially by a number of religions. The design of this bell is identical to a typical Buddhist temple bell called *bonsho*. The *bonsho* is a huge bell that would sit within a temple tower so that the sound could reverberate for a long distance for the whole town or village to hear. This version, being a miniature version, would have been used for individual rituals inside a temple.

―――

13th century, Goryeo period • Korea • Cast bronze with incised inscription

H. 22.6 cm

Zao Gongen

This wonderful figure, made all the more beautiful due to the bright green patina formed with age, is a deity called Zao Gongen. This is an unusual figure for the Buddhist pantheon as the origins are solely Japanese rather than stemming from India where Buddhism was first derived. Zao is a guardian deity with a distinct look – he has hair that flows from a diadem with a flame-like quality, he usually stands in an intimidating stance with one foot raised ready to trample upon enemies. The raised vajra that he holds is a weapon often seen on the wrathful deities of Tantric Buddhism.

———

11th century, Heian period (794–1185) • Japan • Gilt bronze with incised decoration

H. 34.6 × W. 18.1 × D. 9 cm

328 BUDDHISM: A JOURNEY THROUGH ART

FACING PAGE

Peafowl and Phoenixes

Peafowl and phoenixes are two auspicious and sacred birds in Buddhism. The phoenix is a symbol of peace and abundance and is believed to rise from the ashes of the illusionary world, representing wisdom. Peafowls are often included within Buddhist art of deities, in particular bodhisattvas, who may hold a peacock feather or have a peacock present. The peacock is revered within Buddhism due to its ability to eat plants that are poisonous without getting ill; in the same way, Buddhism teaches its practitioners to not avoid perceived hardships but to become nourished by them. Both birds, in particular, the peacock, are associated with the Amida Buddha's Pure Land and as such became popular emblems for Buddhist textiles and silk screens.

———

By Tosa Mitsuyoshi • Late 16th century • Japan • Pair of six-panel screens; ink, colour, and gold on gilded paper

H. 175.9 × W. 377.2 cm

ABOVE

Willows and Bridge

The Uji Bridge, built over River Uji is one of Japan's oldest bridges, and legend says it was built by a monk from Nara. The ancient bridge was a popular subject of art and folding screens. This screen features the bridge, atop flowing water surrounded by willow trees and a waterwheel. An important metaphor within Taoist and Buddhist beliefs, the willow has an uncanny ability to survive difficult weather conditions. In the same way, Buddhism teaches practitioners to cultivate a mind that can experience and survive difficult realities without resistance. The lustrous gilding with an almost abstract quality to the ink renderings of the scene are typical of Japanese design at this time.

———

Early 17th century, Momoyama period (1573–1615) • Japan • Pair of six-panel folding screens; ink, colour, copper, gold, and gold leaf on paper

H. 171.8 × W. 352 cm

Dril-Bu and Dorje

Tibetan Buddhist ceremonial recitation requires the bell (*dril-bu*) and vajra (*dorje*). They're coordinated and used as one with the bell held in the left hand, and the vajra held in the right. Method and wisdom are the two components of Buddhist practice and these two instruments when used together reflect the perfection of both as an important ritualistic Buddhist practice. As seen here, the vajra is double-sided with prongs that form a pointed sphere at each end. The vajra is believed to originate from the Hindu deity Indra, who used it as a weapon. In Buddhist ritual the vajra is used to destroy any adversaries to enlightenment and peace.

───

19th century • Tibet • Bronze

Dril-Bu: H. 77.7 × w. ±9 cm; Dorje: H. 12.7 × w. 4.5 cm

Footed Bowl with Scenes from the Gauttila Jataka

The delicate and intricate design of this vessel as well as the raised and almost vase-shaped bowl would suggest ceremonial use and may have been used as a ritual vessel for offerings. It would possibly be part of a set and is an incredibly rare and early artefact from India. Making a vessel with a design as elaborate as this would have been a technical and highly skilled process. This was a big commission for an artisan, and we can surmise that the patron was incredibly wealthy. The scenes around the bowl most probably depict the Gauttila Jataka, a story from one of the Buddha's previous births in which a king in Varanasi organizes a musical competition after an ambitious pupil challenges his master for the position of court musician.

ca. 5th–6th century • Southern India, probably Andhra Pradesh • Copper alloy
H. 21 × D. 22.2 cm; WT. 6 lbs (2.7 kg)

TEMPLES AND ARTEFACTS 333

Illustrated Legends of the Kitano Tenjin Shrine (Kitano Tenjin engi emaki)

Tenjin worship includes Shinto and Buddhist principles and according to legend, the revered Kitano Tenjin Shrine was built to appease an angry nature spirit depicted here as a wild eight-headed lion. This spirit once belonged to a pious statesman called Sugawara no Michizane, who rose so quickly through the ranks at court that jealous adversaries conspired against him leading to his unjust exile. Believing his angry spirit was haunting and creating bad karma for the region, the Kitano Tenjin Shrine was established in 947 to pacify and honour the spirit. This thirteenth-century ink illustration shows a distinct element of impromptu sketching. The image was created in large part from the artist's imagination and interpretation of the story; this freedom of expression gives the finished composition a fascinatingly reverent and mystical quality.

Late 13th century, Kamakura period (1185–1333) • Japan • Set of five handscrolls; ink, colour, and cut gold on paper

H. 28.8 × W. 689.4 cm

Illustrated Legends of the Origins of the Kumano Shrines

This handscroll is from a set of three that portrays the folklore and legend surrounding the shrines at Kumano, where it was believed that divine spirits (*kami*) descended from heaven. The shrines were later built where the three *kami* were believed to have resided. This holy site is one of the most important in Japan for the Kumano faith, which is a blend of Shinto and Buddhist beliefs and is even today a popular pilgrimage site. Traditionally, these divine spirits are believed to be intertwined with nature and can express their supernatural power through the elements.

Late 16th–early 17th century, Momoyama period (1573–1615) • Japan • Set of three handscrolls; ink and colour on paper

H. 24.1 × W. 615.5 cm

TEMPLES AND ARTEFACTS

Female Torso

Buddhism has long celebrated female energy believing that enlightenment cannot be achieved without the feminine. In Tantric Buddhism, male deities will often have a female counterpart, they embrace in the yab-yum position and become one as enlightenment can only be achieved by perfectly balancing both energies. Tara, the female Buddha is also testament to the authority of the divine feminine – one of many revered godesses in the Buddhist pantheon. In Vajrayana Buddhist art we find the dancing dankinis who are a celebration of the enlightened feminine form. The narrow waist, round breasts and cascading jewellery was common iconography for Indian goddesses during the Pala dynasty, and this beautiful sculpture was believed to have once guarded a temple doorway.

11th century, Pala dynasty • India • Black Chlorite

H. 89 × W. 44 × D. 19 cm
WT: 217 lbs. (98.4 kg)

Emperor Xiaowen and his Entourage Worshipping the Buddha

The incredible preservation of this historic sculptural frieze can be put down to the fact that it was largely shielded from the elements in the Central Binyang Cave, which is part of the Longmen complex, near Luoyang in Henan province. This relief depicts emperor Xiaowen and his entourage and there was a coordinated section depicting his empress with her attendees. The carvings are believed to have been commissioned by their son, Xuanwu. The commission could be seen as paying tribute to the Buddha which would garner merit for the deceased as well as immortalizing their memory for future generations.

ca. 522–23, Northern Wei dynasty (386–534) • China • Limestone with traces of pigment

H. 208.3 × W. 393.7 cm

Helmet (Zukinnari Kabuto)

This unusual iron hat is akin to what samurai soldiers would have worn as armour and is in the shape of the Kabuto helmet. The decorative flame which emanates from the middle of the helmet has a small figure of Fudo Myoo in its centre. The flames represent purification of karma and in this three-pronged formation references the flaming jewel in Buddhism. Fudo Myoo, the immovable or unshakable one, was an important deity to the samurai, who prayed to him as a protective figure or guardian deity.

16th century • Japan • Iron, lacquer

H. 41 cm

TEMPLES AND ARTEFACTS 339

Mountain Spirit (Sanshin)

In Korean folklore, Sanshin are native mountain spirits and the subject of devotional art found in many Buddhist temples in South Korea. The ancient mountain spirit is depicted as an elderly man with a beard dressed in regal Confucian attire, flanked by at least one tiger and a Korean red pine tree. This is a truly magnificent example of painting from the Joseon dynasty in exceptionally good condition. Korean folk art is renowned for its skill in depicting textures in an almost abstract way giving expression and depth to the painting. The tiger is rendered with remarkable skill, the texture of silky fur contrasting with the flat green of an overlapping banana leaf. The juxtaposition of textures and paint lead to a rich and exciting composition.

———

19th century, Joseon dynasty (1392–1910) • Korea •
Ink and colours on silk

H. 86.4 × W. 62.2 cm

Stupa

The original stupas, used as burial mounds, were a form of architecture that pre-dated Buddhism. Over time, the symbol of the stupa became synonymous with the Buddha, and was also the earliest form of Buddhist art. The use of this smaller metal stupa would be to protect Buddhist relics. The ancient image of the stupa, which has many forms but is always unmistakable in its iconography, embodies the transcendental idea of deliverance from the material world.

Mid-15th century • Tibet • Brass

H. 50.8 × W. 18.4 cm; DIAM. 17.5 cm

Vajracharya Priest's Crown

This Vajracharya Priest's Crown is an imposing and magnificent thing to behold. The opulent and extravagant nature of the crown has all the markings of the highest echelons of Nepalese design. Identifying features include the ornate and highly decorated flourishes as well as the use of inlaid precious stones. The pointed and elaborate ritual crown was initially modelled from ancient Buddhist traditions with origins from India. Vajrayana Buddhism involves initiation, ritual, and mantra recitation that tantric masters would undertake whilst wearing a crown to embody the Buddha. The process of wearing such a crown would assist the priest in dissociating from the emotional constraints of the human condition and allow him to enter into a state wherein he could access the essence of Buddhahood.

1717 • Nepal • Gilt copper alloy inlaid with semiprecious stones

H. 30.5 × W. 19.1 × D. 17.1 cm

GLOSSARY

Names of buddhas, deities, monks, practices, scripture and other terms referencing the descriptions, discussions or illustrations within this book.

A

Abhayakaragupta – tantric master and abbot of Vikramasila monastery in modern-day Bihar in India.

Abhaya mudra – a symbol of fearlessness and protection. The left hand is in the meditation (*dhyana*) mudra, while the right hand is upright with the palm facing outwards.

Acala – a wrathful deity and dharmapala (protector of the Dharma), prominent in Vajrayana Buddhism and East Asian Buddhism.

Acalanatha – meaning 'Noble Immovable Lord', another word for the deity Acala.

Adorant – a follower of the Buddha 'one that adores'.

Aizen Myoo – the wisdom king of passion revered in Esoteric Buddhism.

Ajita – meaning 'invincible', another name for Bodhisattva Maitreya.

Akshobhya – one of the Five Wisdom Buddhas located in the east of the Diamond Realm and lord of the Eastern Pure Land.

Amaterasu – the goddess of the sun in Japanese mythology.

Amitabha – a bodhisattva who presides over a Pure Land in the west of the universe.

Amitayus – another name for Amitabha, the primary Buddha of Pure Land Buddhism.

Amoghasiddhi – one of the Five Wisdom Buddhas of the Mahayana and Vajrayana traditions.

Anjali mudra – the practice of meeting the hands together in a 'prayer position'.

Arapacana – one of the various forms of Manjushri.

Arhat – one who has gained insight into the true nature of existence and has achieved nirvana.

Ashtasahasrika – a Mahayana Buddhist sutra in the category of Prajnaparamita sutra literature.

Ashvaghosha – the most famous in a group of Buddhist court writers.

Asita – a hermit ascetic depicted in Buddhist sources as having lived in ancient India.

Atisha – an Indian Buddhist religious leader and master (982–1054 AD) responsible for reintroducing pure Buddhism into Tibet.

Avalokiteshvara – the Bodhisattva Avalokiteshvara, known in Chinese as Guanyin, is the embodiment of the virtue of compassion and became the most important deity in Buddhism around the sixth century.

B

Bankei Yotaku – a Japanese Rinzai Zen master, and the abbot of the Ryomon-ji and Nyoho-ji.

Bhairava – a fierce emanation of bodhisattva Manjushri in Vajrayana Buddhism.

Bhaishajyaguru – commonly referred to as the 'Medicine Buddha' believed to cure suffering using the medicine of his teachings.

Bhumisparsha mudra – formed with all five fingers of the right hand extended to touch the ground/earth, this hand gesture symbolizes the Buddha's enlightenment under the bodhi tree, when he summoned the earth to bear witness.

Bhutadamara – one of the various emanations of Akshobhya.

Bishamonten – guardian King of the North and one of the four fierce protectors of the cardinal directions.

Bodhidharma – a semi-legendary Buddhist monk credited as the transmitter of Chan Buddhism to China.

Bodhisattva – a Buddhist deity who has attained the highest level of enlightenment, but who delays their entry into Paradise in order to help the earthbound.

Brahma – regarded in Buddhism as one of the Twenty Devas or the Twenty-Four Devas, a group of protective dharmapalas.

Budai – a Chinese monk who is often identified with and venerated as Maitreya Buddha in Chan Buddhism.

Buddha nature – Mahayana Buddhists believe

that all humans have the nature of the buddha within them already, which can be cultivated with practice.
Buddha Sakyamuni – founder of the Buddhist religion.
Buddhahood – a state of absolute enlightenment attained by a bodhisattva (awakened one).
Buddhapada – Buddhist icons shaped like an imprint of Gautama Buddha's foot or both feet, usually rendered in stone.

C

Candraprabha – a moonlight bodhisattva often seen with Suryaprabha, the sunlight bodhisattva.
Chaityas – a shrine, sanctuary, temple, or prayer hall.
Chakra – various focal points of the body used in a variety of ancient meditation practices, collectively denominated as tantra.
Chakrasamvara – a powerful deity of Buddhism in Tibet, Mongolia, and Nepal.
Chakravatin king – a being who has accumulated a vast amount of merit, and as a result, has taken rebirth as a king with dominion over all four continents as described in Buddhist cosmology.
Chan – a Chinese Buddhist sect attributed to Bodhidharma that emphasizes attaining Buddhahood which subsequently spread to Japan where it was called Zen.
Chilseong Buddha – 'The Seven Stars', in English this buddha was absorbed into Buddhism from Taoism, and he governs human affairs and fortunes.
Choju-jinbutsu-giga scrolls – a famous set of four picture scrolls belonging to Kozan-ji temple in Kyoto, Japan.
Chunda – a minor female deity in Himalayan and Tibetan Buddhist art. The Chinese Buddhist tradition associates Chunda with Avalokiteshvara.

D

Daiitoku myoo – Daiitoku Myoo (Sanskrit: Yamantaka) is one of the five Great Light Kings of Esoteric Buddhism.
Dainichi – meaning 'great sun', occupies the highest rank in the Japanese Buddhist pantheon and is the chief deity in Shingon Buddhism. In Dainichi Nyorai, the Japanese word Nyorai (thus come) is the translation of the Sanskrit and Pali word Tathagata, the term the historical Buddha used most often to refer to himself.
Dakini – the name of a tantric priestess of ancient India who transported the souls of the dead into the sky. As such, a dakini is sometimes called a 'sky dancer'.
Dechen gyalmo – literally, the Queen of Great Bliss represents, within Vajrayana Buddhism, the deified form of the great female practitioner, Yeshe Tsogyal.
Deity – a tantric enlightened being.
Demon – 'mara' in Sanskrit. Anything that obstructs the attainment of liberation or enlightenment.
Dengyo Daishi – a Japanese Buddhist monk credited with founding the Tendai school of Buddhism.
Devas – a type of celestial being above humans, although the same level of veneration is not paid to them as to buddhas.
Dharma – the nature of reality regarded as a universal truth taught by the Buddha; the teaching of Buddhism.
Dharma wheel – also known as dharmachakra is a symbol widely used to represent the Buddha's Dharma.
Dharmakara – a figurative term, meaning the body of the Buddha's teachings.
Dhyana mudra – a sacred hand gesture or 'seal', used during yoga and meditation practice as a means of channelling the flow of vital life force energy known as *prana*.
Dhyanasana – the seated and cross-legged meditation position in which the Buddha Sakyamuni is usually shown.
Dhyani – any of a group of five 'self-born' celestial buddhas in Mahayana and Vajrayana Buddhism.
Diamond Sutra – one of the most important sutras in Chinese Buddhism. It is called the Diamond Sutra because the diamond symbolically cuts away all delusion, reveals reality, and brings people to enlightenment.

Dromton – the chief disciple of the Buddhist master Atisa, the initiator of the Kadam school of Tibetan Buddhism and the founder of Reting Monastery.

E
Eightfold Noble Path – the Eightfold Path of Buddhism deals with eight moral and philosophical concepts that one needs to practice in order to attain enlightenment.
Eisai – a Japanese Buddhist priest, credited with founding the Rinzai school of Zen Buddhism.
Emanation – form manifested by buddhas or bodhisattvas to benefit others.

F
Flaying knife – used in tantra to skin the hides of demons. Conceptually, its purpose is to cut through illusion and to kill ignorance.
Fly-whisk – one of the traditional symbols of Buddhist monastic hierarchy in China and Japan.
Frieze – a decorative horizontal band running along the top of a wall, stupa, or drum.
Fudo Myoo – 'the immovable one', one of five myo-o, or lords of light, whose wrathful appearance guards the Law of Buddhism.
Fugen Bosatsu – the bodhisattva of universal goodness, virtue, and worthiness.

G
Garuda – enormous predatory birds described as beings with intelligence and social organization.
Gatha – a Sanskrit term for 'song' or 'verse'.
Gelug – the newest and largest school of Tibetan Buddhism.
Green Tara – associated with enlightened activity and compassion, the manifestation from which all her other forms emanate.
Guanyin – the Chinese translation of Avalokiteshvara, the bodhisattva of compassion.
Gukyoku Reisai – a prominent Zen monk from the Pure Land sect.
Guru Dragpo – a fierce emanation of the guru-saint Padmasambhava.

H
Hakuin Ekaku – one of the most influential figures in Japanese Zen Buddhism. He is regarded as the reviver of the Rinzai school.
Hannya – a Japanese phonetic transcription of the Sanskrit word prajna, meaning 'wisdom of the Buddha'.
Hariti – essentially a demoness converted to the Righteous Path by the Buddha.
Hellenistic – the widespread Greek-based artistic culture that developed after the conquests of Alexander the Great.
Hevajra – one of the main *yidams* (enlightened beings) in tantric, or Vajrayana Buddhism.
Honen – the religious reformer and founder of the first independent branch of Japanese Pure Land Buddhism called, Jodo-shu.
Hotei – one of the most beloved characters of Zen Buddhism and believed to be an emanation of Maitreya.
Hotto Enmyo Kokushi – a posthumous title bestowed upon the Zen Buddhist monk Shinchi Kakushin.
Hungry ghosts – beings who are driven by intense emotional needs in an animalistic way.
Hyujeong – also called Seosan Daesa was a Korean Seon master.

I
Ichiji Kinrin – one of the deities worshiped in Esoteric Buddhism associated with the sacred Sanskrit syllable, 'bhruuM', which was uttered by Sakyamuni to verbalize his thought while he was absorbed in profound meditation.
Indra – a deity who reigns over the heaven of the gods in Buddhist, Hindu, and Jain mythology.

J
Jain – an Indian religion teaching a path to spiritual purity and enlightenment through disciplined non-violence to all living creatures.
Jambhala – the five Jambhalas are the manifestations of the compassion of buddhas and bodhisattvas who have the essence of generosity to increase wealth and benefit.
Janguli – also known as Vidyarajni or

'wisdom queen' mentioned in the 6th-century Mañjuśrīmūlakalpa: one of the largest Kriya Tantras devoted to Manjushri.
Jina Buddha – the Five Great Buddhas are emanations of the five qualities of the Adi-Buddha or 'first Buddha'.
Jnanadaka – *jnana* means wisdom, a fierce manifestation of the Buddha Vajrasattva, who presides over the five Tathagatas.
Jnanadakini – the feminine aspect of Jnanadaka.
Jnanasattva Manjushri – 'knowledge being', another form of the wisdom deity Manjushri.
Jogyo – a bodhisattva whose name means 'superior conduct'. He is especially important in the Japanese Buddhist movement founded by Nichiren.

K
Kagyu Order – translates to 'Oral Lineage' and is one of the main schools of Tibetan (or Himalayan) Buddhism.
Kalaratri – is the personification of the night of all-destroying time.
Kamadeva – also called Kama or Manmatha, he is the Hindu god of love or desire.
Kanha – one of the two main students of the mahasiddha Virupa.
Kannon – the bodhisattva of compassion and mercy.
Karma – the force generated by a person's actions held in Hinduism and Buddhism to determine the nature of the person's next existence.
Khadira Forest – goddess Tara's domain, particularly in her form as Khadiravani, 'dweller in the Khadira forest', generally associated with plant life.
Khakkhara – originally used as a noisemaker to announce a monk's presence, the *khakkhara* came to symbolize monks in Chinese literature, serving as iconography.
Khatvanga – or tantric staff is a ritual instrument held in the crook of the left arm of advanced Tantric Buddhist practitioners during ceremonies.
Kinnara – a kinnara is a creature from Hindu and Buddhist mythology described as part human and part bird.
Kirtimukha – guardian of the doorway, this monstrous face is used extensively in various Hindu, Buddhist, and Jain temples.
Komainu – statue pairs of lion-dog creatures guarding the entrance of many Japanese temples.
Kongara Doji – an attendant of Fudo Myoo.
Ksharpana – an esoteric form of Avalokiteshvara.
Kumagai – a Jōdo-shū Buddhist priest and a disciple of Honen.
Kumbhandas – one of a group of dwarfish, misshapen spirits among the lesser deities of Buddhist mythology.
Kurukulla – semi-wrathful yidam in Tibetan Buddhism associated with rites of enchantment.

L
Lama – an honorific title applied to a spiritual leader in Tibetan Buddhism.
Lokeshvara – the bodhisattva of compassion (Avalokiteshvara) in his role as the lord of the six realms of existence (hell beings, hungry ghosts, animals, humans, demigods, and gods).
Lotus Sutra – one of the most influential and venerated Buddhist Mahayana sutras.
Luohan – a Buddhist sage who has achieved enlightenment.

M
Maha Maya – also called Maya, the mother of Gautama Buddha.
Mahabala – the conqueror of the lord of death and, by extension, of death itself.
Mahakala – the menacing and powerful embodiment of the bodhisattva of compassion.
Mahasthamaprapta – a bodhisattva mahasattva who represents the power of wisdom. His name literally means 'arrival of the great strength'.
Mahavairocana – the Great Sun Buddha, is the cosmocratic emanation of the historical Buddha, Sakyamuni.
Makara – a Sanskrit word referring to the 'great Indian crocodile', an important figure in Sinhala Buddhist culture in Sri Lanka.
Miroku – Japanese for 'Maitreya Buddha', as prophesied by the Buddha before entering nirvana.

Mandala – a geometric configuration of symbols. In various spiritual traditions, mandalas may be employed for focusing attention of practitioners and adepts, as a spiritual guidance tool.
Manjushri – a bodhisattva associated with prajna (wisdom) in Mahayana Buddhism.
Mara – a celestial king and demon who tried to stop Prince Siddhartha from achieving enlightenment.
Marichi – (from Sanskrit 'ray of light') is the Goddess of the Dawn, who is revered in the Buddhist tradition as a heavenly warrior and powerful protector.
Maudgalyayana – one of the Buddha's closest disciples.
Memyo – a deity which protects the production of silk and provides clothing for the humble.
Monju – a bodhisattva who personifies wisdom and the voice of Buddhist law.
Muchalinda – the name of a naga, a snake-like being, who protected Gautama Buddha from the elements under the bodhi tree.
Mudra – a symbolic hand gesture used in Hindu and Buddhist ceremonies.
Myrobalan plant – a plant with extraordinary healing properties found on the Himalayas.

N
Naga – a member of a semi-divine race, part-human, part-cobra in form, associated with water and sometimes with mystical initiation.
Ngorchen Kunga Zangpo – one of the most influential of all Sakyapa masters, and is credited with founding the Ngor subschool.
Nichiren – a Japanese Buddhist priest and philosopher of the Kamakura period.
Nichiren sect – a Japanese Buddhist movement in the Mahayana tradition.
Nikko Bosatsu – bodhisattva of the Sun.
Nimbus – a luminous cloud or a halo surrounding a supernatural being.
Nirvana – a transcendent state in which there is neither suffering, desire, nor sense of self; and the subject is released from the effects of karma and the cycle of death and rebirth.
Nyingma – is the oldest of the four major schools of Tibetan Buddhism.

O
One-Syllable Golden Wheel – a wheel with eight spokes is the divine symbol that represents Ichiji Kinrin Buccho.
Oser Chenma – is the Goddess of the Dawn, who is revered in the Buddhist tradition as a heavenly warrior and powerful protector.
Otsu-e of Uho Doji – manifestation of the Buddha Dainichi Nyorai.

P
Padmapani – bodhisattva as the lotus-bearer and a favoured form of Avalokiteshvara, the embodiment of Buddhist compassion.
Padmasambhava – also called Guru Rimpoche, a legendary Indian Buddhist mystic who introduced Tantric Buddhism to Tibet.
Pali Canon – is the standard collection of scriptures in the Theravada Buddhist tradition, as preserved in the Pali language.
Panchen Chos rgyan – lama, or spiritual teacher, from Tashilhunpo monastery.
Panchika – a yaksha and consort of Hariti.
Pandita – a title in Indian Buddhism awarded to scholars who have mastered the five sciences in which a learned person was traditionally supposed to be well-versed.
Parnashavari – a goddess distinguished by the girdle of leaves she wears; known as 'goddess of all the Shavaras' (a tribe in eastern India).
Phagmo Drupa – one of the three main disciples of Gampopa Sonam Rinchen who established the Dagpo Kagyu school of Tibetan Buddhism.
Phagspa Wisdom text – a group or family of the Mahayana sutras of the Prajnaparamita.
Phra Sankachai – Thai spelling of Mahakaccayanathera, was a Buddhist arhat during the time of the Lord Buddha.
Prabhamandala – an ornament commonly placed behind statues to indicate their hallowed status.
Prajna – transcendental wisdom or supreme knowledge in Buddhism gained through intuitive insight.

Prajnaparamita – (Sanskrit: 'Perfection of Wisdom') body of sutras and their commentaries that represents the oldest of the major forms of Mahayana Buddhism.
Pure land sect – a tradition which is primarily focused on achieving rebirth in a Buddha's 'Pure Land'.

R

Raigo – in Japanese Buddhism, is the appearance of the Amida Buddha on a 'purple' cloud at the time of one's death.
Raijin – is a god of lightning, thunder, and storms in Japanese mythology and the Shinto religion.
Rajalalitasana position – right hand resting on the right knee whilst the left hand is placed behind while leaning back.
Rakta Yamari – a Tantric Buddhist meditational deity; a wrathful form of bodhisattva Manjushri or Yamantaka.
Ratnasambhava – meaning 'born of jewels', one of his prominent emanations is Jambhala, a god of prosperity and wealth.
Rensho – military hero of the Genpei War and disciple of Pure Land School of Buddhism.
Revealed treasure – various forms of hidden teachings that are key to Vajrayana and Tibetan Buddhist and Bon spiritual traditions.
Rigveda – an ancient Indian sacred collection of Vedic Sanskrit hymns.
Rinzai – one of three sects of Zen in Japanese Buddhism.

S

Sadakshari-Lokeshvara – the bodhisattva of compassion (Avalokiteshvara) in his role as the lord of the six realms of existence.
Saigyo – a Japanese Buddhist monk credited with founding the Tendai school of Buddhism based on the Chinese Tiantai school.
Sakra – the ruler of the Trayastrimsa Heaven according to Buddhist cosmology.
Sakya Pandita – a Tibetan spiritual leader and Buddhist scholar and the fourth of the five Sakya forefathers.
Samsara – the concept of rebirth and 'cyclicality of all life, matter, existence', a fundamental belief of most Indian religions.
Sangha – the Buddhist community; it is the men, women and children who follow the teachings of the Buddha.
Sanghati – the outer robe and usually most visible robe among the three pieces. Sanghati is worn over Antaravasaka and Uttarasanga.
Sariputra – regarded as an important and wise disciple of the Buddha, particularly in Theravada Buddhism where he is given a status close to a second Buddha.
Sazang phakpa – a Buddhist monk, said to have pursued his monastic training under forty-two masters.
Seitaka Doji – one of the two boy attendants of Fudo Myoo.
Seon – the Korean name for Chan Buddhism, a branch of Mahayana Buddhism, commonly known in English as Zen Buddhism.
Shadbuja Sita Mahakala – emanation of Avalokiteshvara and principal wealth deity of the Shangpa Kagyu School of Tibetan Buddhism.
Sakyamuni – means the sage of the Sakyas, the latter being the name of Buddha's clan.
Shangpa Tradition – started in the 10th century with the two jnana dakinis Niguma and Sukhasiddhi, who passed their teachings on to the Mahasiddha Kyungpo Naljor.
Shijiamouni – Chinese name for the historical Buddha.
Shinchi Kakushin – Japanese Zen master who did much to establish koan practice in Japan.
Shinto – a Japanese religion dating from the early 8th century and incorporating the worship of ancestors and nature spirits, and a belief in sacred power (*kami*).
Shonnu lodro – a great Sakya scholar who is perhaps best known for being the teacher of Jé Tsongkhapa.
Shuni mudra – fortifies patience, compassion, and understanding by placing the thumb and middle fingers together.
Shun'oku Myōha – a Rinzai Zen monk of the early Muromachi period.
Simhanada Manjushri – a form of Manjushri

depicted in the red-coloured body with a face and four arms.
Sirispata – flaming *ushnisha* or crown protuberance on the Buddha's head.
Sitatara – the mother of all buddhas and an embodiment of the maternal aspect of compassion.
Skull cup – used as a ritual implement (bowl) in both Hindu and Buddhist tantra.
Sonam Choklang – founded Wensa Monastery in Tsang, a Gelug hermitage known for the Wensa Nyengyu teachings.
Songten Gampo – traditionally credited with being the first to bring Buddhism to the Tibetan people.
Sramana– meaning seeker. The tradition gave rise to Jainism, Buddhism, and Yoga.
Stupa – shrine, or a place of worship hallowed by association with some sacred thing or person.
Svabha-Prajna – feminine consort of Raktayamari.

T
Takemikazuchi – the Japanese god of thunder.
Tantra – ancient Tantric doctrine that is influential within the Vajrayana and Mahayana Buddhist traditions.
Tara – a saviour-deity and female Buddha with numerous forms, widely popular in Nepal, Tibet, and Mongolia.
Tathagata – one of the Sanskrit and Pali titles of a Buddha and the one most frequently used by the historical Buddha when referring to himself.
Tavatimsa Heaven – the highest of the Buddhist heavens that maintains a physical connection with the rest of the world.
Thangka – a buddhist painting on a scroll usually from Tibet.
Triratna – a Buddhist emblem that is said to visually depict the three jewels of Buddhism, the Buddha, the Dharma, and the Sangha.
Trishula – esoteric weapon and divine symbol used within Buddhism and Hinduism.
Tushita Heaven – a pure land of bodhisattvas and future buddhas.
Trident – a three-pronged sphere also known as a trishula.

U
Uho Doji – Shinto goddess of the Sun and Vairocana, the Great Solar Buddha.
Ushnisha – a three-dimensional oval at the top of the head of the Buddha.
Ushnishavijaya – a Buddha of longevity.
Utpala lotus – a blue lotus attribute of the goddess Tara.

V
Vaiduryanirbhasa – Pure Land is ruled by the Medicine Buddha, Bhaisajyaguru.
Vairocana – the original of the five Transcendent Buddhas of Vajrayana Buddhism.
Vaisravana – one of the four guardians of the cardinal directions associated with the north.
Vajra – a legendary ritual tool, symbolizing the properties of a diamond (indestructibility) and a thunderbolt (irresistible force).
Vajrabhairava – a yidam, a deity that presides over the great tantras of the highest yoga in Tibetan Buddhism.
Vajracharya – a Vajrayana Buddhist master, guru, or priest.
Vajradhara – a divine manifestation of the totality of Buddhist teachings.
Vajrakila – the wrathful form of Vajrasattva, is the yidam deity who embodies the awakened activity of all buddhas.
Vajrapani – the 'holder of a thunderbolt' (vajra), shares his origins with the Vedic deity Indra, god of storms.
Vajrasattva – important figure in the Tantric Buddhism of the Newar people of the Kathmandu Valley. He represents the ideal guru, and he is frequently invoked in the guru maṇḍala.
Vajravali – a single harmonized tantric ritual system which could be applied to all Tantric Buddhist mandalas.
Vajravarahi – female embodiment of the cognitive function leading to Buddhahood.
Vajrayogini – another name for Vajravarahi.
Vajriputra luohan – one of the 16 luohans, a group of legendary arhats in Buddhism.
Varadan mudra – symbolizes dispensing of boons represented by the palm held outwards, with the fingers outstretched and pointing downwards.

Vedic – the religion of the ancient Indo-European-speaking peoples who entered India about 1500 BCE from the region of present-day Iran.
Virudhaka – one of the Four Heavenly Kings and the guardian of the southern direction.
Virupa – one of the most famous Indian Buddhist mahasiddhas in history, part of Dorje Shugden's incarnation lineage.
Vitarka mudra – performed by joining the tips of the thumb and the index fingers together while keeping the other fingers straight. The circle formed by the thumb and the index finger symbolizes the constant flow of energy and information.

W
Western Paradise – heavenly realm of the Buddha Amitabha, the Buddha of Infinite Light.

Y
Yab-yum – the representation of the male deity in sexual embrace with his female consort.

Yaksha – a class of generally benevolent but sometimes mischievous nature spirits.
Yakshi – another name for yaksha.
Yama – wrathful god or the Enlightened Protector of Buddhism who judges the dead and preside over the *narakas* ('hell' or 'purgatory') and the cycle of rebirth.
Yamantaka – the 'destroyer of death' deity in Vajrayana Buddhism.
Yamari – Rakta Yamari is a Tantric Buddhist meditational deity which is a wrathful form of bodhisattva Manjushri or Yamantaka.
Yeom-ra – Korean god of the dead.

Z
Zao Gongen – the guardian deity of Mount Kinpu in Yoshino, south of Nara, Japan.
Zen – a school of Buddhism which emphasizes the practice of meditation as the key component to awakening.

PHOTO CREDITS

Art Institute of Chicago, Chicago

Pages 38, 50, 54, 80, 106, 107, 132, 140, 164, 178, 179, 190-191, 225 (right), 251, 265, 271, 302

Brooklyn Museum, New York

Pages 52, 315, 339

Freer Gallery of Art, Washington D.C.

Pages 300, 307

Los Angeles County Museum of Art, Los Angeles

Pages 63, 150, 169, 188, 303

National Gallery of Victoria, Melbourne

Pages 198-199

Philadelphia Museum of Art, Philadelphia

Pages 18, 20, 21, 60, 117, 194, 215, 228, 254-55, 256, 258, 259, 279 (right), 287

Rhode Island School of Design (RISD) Museum, Rhode Island

Pages 126, 166

Saint Louis Arts Museum, St Louis

Page 133

The Cleveland Museum of Art, Cleveland

Pages 24, 26, 29, 34, 37, 39, 45, 46, 48, 51, 53, 66-67, 68, 79, 87, 90, 95, 100, 102, 103, 111, 119, 123, 124, 145, 147, 149, 155, 160, 163, 165, 171, 172, 180, 192, 195, 200, 208, 210, 212, 217, 227, 243, 264, 274, 278, 296, 304, 305, 325, 326, 328, 336

The Metropolitan Museum of Art, New York

Pages 17, 22, 23, 27, 28, 30-31, 32, 33, 35, 36, 40, 42, 43, 47, 49, 56, 57, 58, 59, 62, 64, 65, 70, 71, 72, 73, 74, 75, 76, 78, 81, 82, 84, 85, 86, 88, 91, 92, 94, 96, 97, 98, 99, 101, 108, 109, 110, 112, 113, 114, 115, 116, 118, 120, 122, 125, 127, 128, 130, 131, 134, 135, 136, 137, 141, 142, 143, 144, 146, 148, 151, 152, 153, 154, 156, 157, 158, 159, 162, 167, 173, 174, 175, 176, 181, 182-183, 184, 186, 193, 196, 197, 202, 203, 206, 207, 209, 213, 214, 216, 218, 219, 220, 222, 223, 224, 225 (left), 226, 229, 230, 231, 232-33, 234, 236, 237, 238, 239, 240, 241, 242, 244, 245, 248, 249, 250, 260, 261, 263, 266-67, 268, 270, 272-73, 275 (left & right), 276, 277, 279 (left), 280-81, 282-83, 285, 286, 288-89, 290, 291, 292, 293, 294, 295, 298, 299, 308-09, 312, 313 (left & right), 314, 316-17, 318-19, 320, 321, 322, 323, 324, 327, 329, 330, 331, 332-33, 334-35, 337 (Fletcher Fund), 338, 340, 341

The Rijks Museum, Amsterdam

Pages 93, 211, 246, 247, 262, 306

The Walters Art Museum, Baltimore

Page 44

First published in 2024 by

Interlink Books
An imprint of Interlink Publishing Group, Inc.
46 Crosby Street, Northampton, Massachusetts 01060
www.interlinkbooks.com

Published simultaneously in India by Roli Books, New Delhi

Text copyright © R.M. Woodward 2023

All rights reserved. No part of this publication may be reproduced, stored in a retrieval system or transmitted, in any form or by any means, without the prior written permission of the publisher.

Library of Congress Cataloging-in-Publication Data available
ISBN 978-1-62371-716-2

Editor: Neelam Narula
Design: Sneha Pamneja
Pre-press: Jyoti Dey
Production: Lavinia Rao

Printed and bound in India
10 9 8 7 6 5 4 3 2 1